THE
TEXAS
CHAIN SAW
MASSACRE

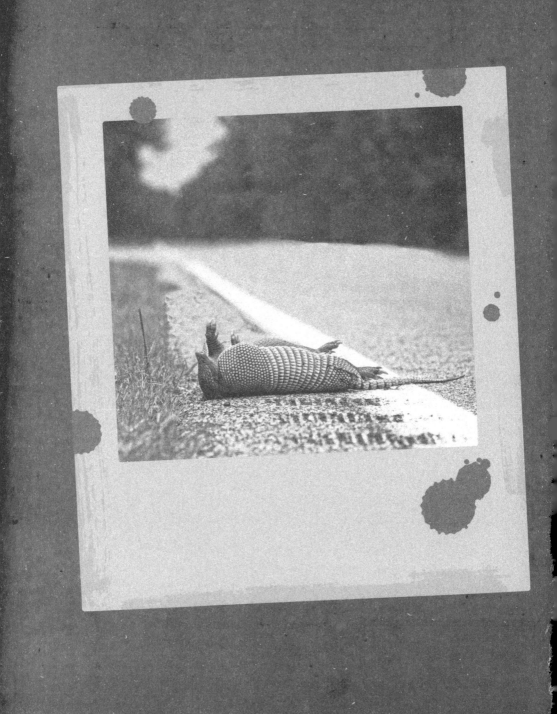

THE
TEXAS
CHAIN SAW
MASSACRE

THE FILM THAT TERRIFIED
A RATTLED NATION

Skyhorse Publishing

Skyhorse Publishing books may be purchased in bulk at special discounts for sales promotion, corporate gifts, fund-raising, or educational purposes. Special editions can also be created to specifications. For details, contact the Special Sales Department, Skyhorse Publishing, 307 West 36th Street, 11th Floor, New York, NY 10018 or info@skyhorsepublishing.com.

Skyhorse® and Skyhorse Publishing® are registered trademarks of Skyhorse Publishing, Inc.®, a Delaware corporation.

Visit our website at www.skyhorsepublishing.com.

10 9 8 7 6 5 4 3 2 1

Library of Congress Cataloging-in-Publication Data is available on file.

Cover design by Erin Seaward-Hiatt

ISBN: 978-1-5107-3790-7
Ebook ISBN: 978-1-5107-3792-1

Printed in the United States of America

Starring the cast and crew of *The Texas Chain Saw Massacre*, plus a supporting cast that includes (in alphabetical order)

The Carpenters

Johnny Carson

Alice Cooper

Wes Craven

Paul Ehrlich

Charles Fort

Ed Gein

Patty Hearst

E. Howard Hunt

Henry Kissinger

Elisabeth Kübler-Ross

R.D. Laing

Norman Lear

Linda Lovelace

Martha Mitchell

Richard M. Nixon

Madalyn Murray O'Hair

The Ray Conniff Singers

Charles A. Reich

Marie Hèlène de Rothschild

B.F. Skinner

The Trilateral Commission

Loudon Wainwright III

The Zodiac Killer(s)

For Nicolas Roeg
(1928–2018)

Special thanks to the University of Texas Press,
Louis Black Productions, and Watchmaker Films for
essential information on Tobe Hooper and his early work.

"From everything that's happened, from the way people act, the threats that have been made, I get the sensation of conspiracy at work. What the nature is, or even the rationale, is a subject I find increasingly fascinating."

—from E. Howard Hunt's 1973 novel, *The Coven*

"All things merge away into everything else."

—Charles Fort, *The Book of the Damned*

"No matter where you're going, it's the wrong place."

—Tobe Hooper

CONTENTS

THE
TEXAS
CHAIN SAW
MASSACRE

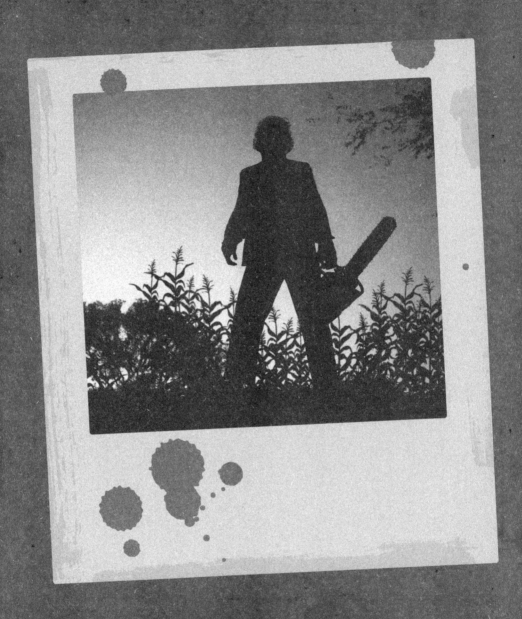

In the early 1970s, before *Jaws*, *Star Wars*, *Saturday Night Fever*, Jimmy Carter, and even the pet rock, America writhed in a pre-disco inferno.

CHAPTER ONE

"THE ZEITGEIST BLEW THROUGH"

*"You don't have to look and you don't have to see 'Cause
you can feel it in your olfactory."*

—"DEAD SKUNK," LOUDON WAINWRIGHT III

One day in Austin, Texas, during a frantic Christmas shopping season in 1972, Tobe Hooper had an epiphany. He stood in a crowded hardware section of a Montgomery Ward, wary of the holiday spirit, and desperate for an exit. Noticing a bunch of chain saws in an upright display, he fantasized about slicing and dicing his way through the consumer swarm. He repressed his dream of a Yuletide bloodbath, but once he escaped the claustrophobic maw and settled back home, visions of chain saws whirred in his head, setting off a chain reaction of story ideas.

Hooper's muse appeared at a wild time in modern U.S. history. In the early '70s, before *Jaws*, *Star Wars*, *Saturday Night Fever*, Jimmy Carter, and even the pet rock, America writhed in a pre-disco inferno. As he told *Texas Monthly* in 2004, "I went home, sat down, all the channels just tuned in, the zeitgeist blew through, and the whole damn story came to me in what seemed like about thirty seconds. The

hitchhiker, the older brother at the gas station, the girl escaping twice, the dinner sequence, people out in the country out of gas."

While Hooper plotted out his narrative, the holiday season of 1972 was already fraught with Hooper-ish gloom. Nixon won his re-election in a landslide the month before, but shadows of scandal stalked him when a grand jury indicted seven of the Watergate burglars months before. Bob Woodward and Carl Bernstein were already on a case that would metastasize, forcing many Americans to perceive their Commander-in-Chief as a mask with two faces: the leader and the liar, the potentate and the scoundrel. Like Hooper in the hardware department, the President grew impatient and sought a violent solution. This time he had an alibi. The North Vietnamese stalled about signing a peace accord, so he ordered the Christmas bombings over Hanoi and Haiphong, with dozens of U.S. airmen becoming casualties, captors, or among the missing.

Also, during the dark December of 1972, the final manned Apollo moon-landing mission returned to Earth as a bittersweet swansong to the "space age."

On December 8, United Flight 553 crashed into a residential area near Chicago's Midway Airport, killing Dorothy Hunt, wife to the infamous Watergate player E. Howard Hunt. Mrs. Hunt (involved in OSS and later CIA activities since World War II) was allegedly carrying thousands in cash at the time. Some conspiracy theorists believe the crash was the result of sabotage, and that Mrs. Hunt might have also been aiding her husband in either blackmailing or exposing the president regarding his connections from Watergate and all the way back to the Bay of Pigs fiasco.

Then, on December 23, the otherwise miraculous discovery of sixteen plane crash survivors in the Andes took a macabre twist when they credited their seventy-two-day endurance to cannibalism. It seems

that Hooper's *Chain Saw* storyline was writing itself, drawing from events and moods in America and sometimes from around the globe. Occasions formed confluences with other occasions: social, political, and personal themes that would make *The Texas Chain Saw Massacre* more than just a movie.

With his collaborator Kim Henkel, Hooper planned a post-'60s version of Hansel and Gretel: lost but blindly optimistic young people wandering into strange places that waited to gobble them up. But instead of gingerbread houses or old-fashioned witches, they looked to grislier serial killers, people like Ed Gein—the Wisconsin ghoul who (though credited with only two official murders) dug up graves to make clothing and furniture from the corpses. Hitchcock had already invoked Gein in *Psycho* (with other films to follow), but Hooper and Henkel knew they had to compete with the standards already laid out by George Romero's *Night of the Living Dead* and Wes Craven's *The Last House on the Left*.

In January of 1973, shortly after his second inauguration, Nixon announced on radio and television that he and Henry Kissinger devised a plan for "peace with honor" to end the Vietnam War. The speech was short, to the point, and shocking to many in the press who expected something direr. Despite cynicism from media talking heads, this proved to be Nixon's final presidential power play, the last moment for the President to save face before a deluge of dirt started leaking from the Oval Office and onto newsprint.

Hooper and Henkel once planned a fairy-tale look with trolls creeping out from beneath bridges, but they instead got a readymade *Chain Saw* muse via Nixon's political transgressions. A doctor that Hooper knew provided more ideas, specifically when he bragged about making a mask from a cadaver during his pre-med days. Like the ensuing events, the movie's title also shifted. According to Robert Burns (who served as

art director, casting director, and taxidermist of dead animals), an early title idea was "Saturn in Retrograde." Then it was "Head Cheese" and "Stalking Leatherface" before condensing into "Leatherface."

Later, a man named Warren Skaaren, who served as the Texas Film Commission's first director, helped them broker a deal to finance the film with the help of another investor named Bill Parsley, who acted as Texas Tech University's vice president of financial affairs and had enough pull with oilman R.B. McGowen. Together, they helped to raise the initial $60,000 to make the film. Parsley's lawyer, another name that would appear in the movie credits, was Robert Kuhn, a buttoned-down type who got skittish when he saw Hooper and Henkel in his office, wondering (from what he judged as their dazed-hippie appearance) if they were up to the task of earning back the money.

Skaaren offered another vital contribution. A week prior to principal photography, he suggested they rename the film as *The Texas Chain Saw Massacre*. Leatherface star Gunnar Hansen claimed to have hated it then but also admitted that its sensationalism alone got thousands of people to donate a slice of their mundane lives to experience what some critics would acclaim with such kudos as "unrelenting horror."

Hooper and Henkel started collaborating on *Chain Saw* in January and February of 1973. That is when Hooper claimed to get additional inspiration from two albums. But here his memory seems to lapse. He told journalists (including the *Austin Chronicle* in 2000) that it might have been Elton John's *Goodbye Yellow Brick Road* or Lou Reed's *Berlin*. Elton John's album and song, however, hit the *Billboard* charts in October of 1973, the same month that Reed's album debuted.

The more likely tune is a folk ditty that nourished the airwaves by the early months: Loudon Wainwright III's Top 40 novelty "Dead Skunk." It was the ideal metaphor that would, for Hooper, evolve into

the visual and implied impact of a rotting armadillo, an Austin mascot, which lay in the middle of the steamy route as a group of five unwary youths crossed its path. The verbal word play between Wainwright's use of "olfactory" and the story's old slaughter factory might also have fermented in Hooper's head.

From the first reeking shooting days in July of 1973 (during one of Texas's hottest summers) and its post-production and reshoots starting in mid-August, to the maneuvers required to get it distributed and finally presented to a viewing public in October of the following year, the film and the circumstances leading up to its public presentation serve as a metaphor for the early '70s mayhem. Many of these connections between art and life might not have been Hooper's conscious intent all of the time, but in retrospect, the film casts an eerie reflection on what Jimmy Carter would later call America's "crisis of confidence," particularly for those of the working and middle classes who started to feel the sting of falling from their post-World War II ascension and seeing their American Dream disemboweled.

Today, *The Texas Chain Saw Massacre* is a work that nearly every age group knows about and whose power continues to reign over many daydreams and nightmares. In the many decades since it premiered to an alternately ecstatic, appalled, shocked, and nauseated crowd, it became part of the Museum of Modern Art's permanent collection. It has earned *Entertainment Weekly*'s scariest film category (second only to *The Exorcist*). *Slant* magazine made it #1 in its Top 100 all-time Greatest Horror Movies. Texas can claim it as its most financially fruitful movie, garnering loads more than its relatively meager production funds, despite much of the loot never entering the creators' pockets. But *The Texas Chain Saw Massacre* has grander historical importance.

This book will explore *The Texas Chain Saw Massacre* as a collection of stories within a story, conveyed through clues, suggestions, and uncanny connections that make its principal characters pawns in a larger game. The solar flares, the desecrated graves, the harrowing radio announcements, the quirky weather, the mumbling drunk at the cemetery who claims to know more than everyone else, the dying cattle in the old factory where Leatherface's family used to slaughter them with a quick plunk of the sledge, the blood-soaked shape that the hitchhiker leaves on the hippies' van, and the voodoo trappings outside the Hardesty grandparents' home—all offer signs that, far from being sappy supernatural lures, are more terrifying for being so mundane. *The Texas Chain Saw Massacre* is secular horror at its best.

Instead of regarding the film as simply a work with actors, directors, producers, budgets, and shooting schedules, readers should appreciate Hooper's masterpiece as a wider visceral experience: a tale engorged with newsworthy analogies. Here is where seemingly disparate ideas and images briefly come together in a world teeming with menace and traversed by souls that have lost their way. "You could feel that things were on edge and had the potential for popping," Mr. Hooper would say.

The Texas Chain Saw Massacre had all of the timely fixings: unprecedented gore, "evil" Southern rednecks, lost and searching youths, hippie chicks, allusions to the oil crisis and economic recessions, unprecedented fixations on death and disaster, and that other morbid interest that accelerated in the '70s—astrology.

Hooper and Henkel's 16mm monster—destined to expand into 35mm—reveled in a stew of gore, oppressive weather, a miserable cast and crew, and many putrid smells that lingered while the world outside also raged. Assaults from the right, the left, and mindbenders in between, left many Americans escaping into hedonism, quaking at

threats of economic collapse, and shuddering at a fusillade of media images reminding them of death, including numerous accounts of real-life ritual murders with a religious taint. With these varying subjects in mind, this book will look at *The Texas Chain Saw Massacre* less as just a movie and more as a multilayered hologram of astounding, confusing, and terrifying times.

For his first feature *Eggshells*, Tobe Hooper found his own group of hippies living in a commune near the University of Texas campus. However, the commune of Hooper's imagination had an added curse. In its basement lurked what he once described as "a cryptoembryonic-hyperelectric presence that managed to influence the house and the people in it." *Chain Saw*, in contrast, abandons the supernatural for a more plausible, secular horror story.

CHAPTER TWO

"CRYPTOEMBRYONIC" JOURNEY

"I had the long hair, and I walked around with a movie camera in my hand, which was kind of a hippie thing to do. But in fact it made me a suspicious character."

—Tobe Hooper

Tobe Hooper witnessed the ghastlier side of the 1960s when, on August 1, 1966, he strolled through his University of Texas at Austin campus and heard gunfire. A cop ran up to him and shouted, "Get in that building. Someone is on the tower shooting." Startled but a bit skeptical, Hooper watched the policeman soon plummet from the impact of a bullet. Hooper took refuge in a nearby building to view the top of the tower, where ex-Marine Charles Whitman, after killing his mother and wife with knives, shot uninterrupted at passersby for ninety-six minutes from the twenty-eighth floor of the Administration Building's Observation Deck, killing over a dozen people, maiming thirty-one, and committing one of the worst mass murders in American history. All of this transpired only three years after Texas was the site of JFK's assassination in Dallas.

Hooper's friend and future collaborator Ron Perryman was also at UT on that day and snapped some photos of bystanders huddling behind cars and trees as they tried to dodge the bullets. One of

Perryman's photos captures the Observation Deck, with Whitman covered by a cloud of police gunfire. Some of his photos ended up in the August 12th edition of *Life* magazine as the issue went into detail about the killings and the bad background of Whitman's seemingly all-American life. For Hooper, as it was for several of his associates, the Whitman massacre was an omen of darker deeds that would sully the '60s counterculture's peace-love clichés.

Despite what some mainstream Hollywood movies of the late '60s such as *Easy Rider* might have led people to believe, the South also had its rebellious youth who smoked the same kind of dope and rallied for the same anti-war causes. By then, Texas also had a modest but productive independent film industry, with Hooper as part of it. He worked on projects that he described to the *Austin Chronicle* in 2000 as stories "about isolation, the woods, the darkness, and the unknown." In 1964, he collaborated with Ron Perryman on a short entitled *The Heisters*, which allowed him to tinker with 35mm, along with Technicolor and Techniscope. Following the disclaimer, "This theater is proud to announce that the following presentation is ridiculous," the slapstick humor suggests a rustic Three Stooges episode, including a number of bizarre treats: a scientist who changes the sizes of a beetle via injections, a carnivorous music box, and a pastry fight with a giant monster pie.

Hooper and Perryman became part of Motion Picture Productions of Texas. In 1970, the two collaborated again on another color film called *Down Friday Street*. It was a graphic comment about gentrification and the haunted spaces left behind, intercutting urban sprawl with a quaint old house about to be demolished by a bulldozer. Hooper clarified some of his resume to Marjorie Baumgarten for the *Austin Chronicle*: "I did a lot of commercials in Austin, we had a commercial house that I was part owner in called Film House. I made about 60 commercials. Then I started making documentaries."

Hooper's most notable documentary was his 1969 *cinéma vérité* treatment of Peter, Paul, and Mary called *The Song is Love.* Hooper and Perryman followed them around the country for about six months as the trio lathered on their sweet chanteys about cruel wars and other timely upheavals. But Hooper approached his subject with a bemused distance, more concerned about developing the right filming techniques than partaking in the fashionable protests.

Hooper and Perryman were both inspired by D.A. Pennebaker, known for *Monterey Pop* and the Bob Dylan documentary *Don't Look Back.* Back then, concerts had to seem "authentic," so they needed a rough look with shaky cams and abrupt zooms. After foraging through about one hundred hours of 16mm footage, Hooper and Perryman salvaged one reasonably cohesive hour, conforming to the style of Pennebaker, as well as such other contemporaries as the Maysles Brothers and Frederick Wiseman. "We originally hoped the film would follow Michael Wadleigh's *Woodstock* in theaters," the film's producer Fred Miller recalled to the *Austin Chronicle* in 1999, "but that was not to be. We released the show to PBS for a 10-year run beginning on Easter of 1970. It is my understanding that PBS nominated it for their choice for PBS Emmy, and it became a major fundraiser for PBS for the next 10 years."

As Hooper told the *Texas Monthly*'s John Bloom, "It was the Vietnam era, and I remember at the end of every concert, Peter, Paul, and Mary would separate and go to different parts of the venue, and their fans would gather around and talk about the war. It was interesting, but I was kind of a nonpolitical hippie. I had the long hair, and I walked around with a movie camera in my hand, which was kind of a hippie thing to do. But in fact it made me a suspicious character. I was FBI. I was a narc. I was with the feds. Why else would I be taking everyone's picture all the time?"

With the help of David Ford, a businessman in Houston who invested

$40,000, Hooper set out, in his first feature, to reveal his reluctance to catch the Aquarian flu. *Eggshells: An American Freak Illumination* reflects lots of topical hippie concerns: Vietnam, the draft, the police, drugs, mysticism, ghosts, and the unprecedented exodus of white kids fleeing their comfy homes for often disastrous attempts at communal living. Hooper seemed bent on recording these trends as the era's Götterdämmerung and found his own group of hippies living in a commune near the UT campus. However, the commune of Hooper's imagination had an added curse. In its basement lurked what he once described as "a cryptoembryonic-hyperelectric presence that managed to influence the house and the people in it."

Eggshells begins with Mahlon, a hippie girl with long brown hair (Mahlon Foreman) riding on the back of a green Chevy pickup truck and destined for Austin to fulfill her flower-child dreams. By the time Mahlon gets to UT, Hooper makes sure to track his camera along the campus motto inscribed on the same tower where Charles Whitman went berserk: "Ye Shall Know the Truth, and the Truth Shall Make You Free." It is the same biblical verse etched into the lobby of the original CIA headquarters—a connection that might make some shudder when they realize how Austin also represented a link between the CIA's LSD experiments and the advent of psychedelic rock. In the year that Charles Whitman bathed the UT campus in crimson, an Austin-based band released their 1966 debut album *The Psychedelic Sounds of the 13th Floor Elevators* and added the term "psychedelic rock" to the pop lexicon.

The stars and stripes fly along with the Texas state flag, as Mahlon witnesses authentic anti-war campus demonstrators, a scene that includes police who might be grabbing at their truncheons in case of emergency but defy stereotypes by being friendly and shaking hands with some of the protesters. The activists lug a coffin decorated in red, white, and blue; members of campus staff emerge from their offices to

smile and flash peace sings. This is, after all, an Austin-style revolution, replete with clean-cut students, many in white shirts and shorter hair, embellishing Confederate statues with vibrant streamers, and doing nothing to elicit tear gas or ammo.

Hooper takes the time to show off his telephoto lens with some close-ups on leaves and other natural ephemera, but the narrative starts going into a more abstruse direction when his signature stealthy tracking shot focuses on a house that has an uncanny resemblance to the one that he would later use for the home of Leatherface and his kin. Another vital character enters: an ethereal and androgynous young man with curly blond hair named Ron (Ron Barnhart). Ron sits down on the front steps, sips on a glass of milk, and gets startled by a paper airplane (adorned in psychedelic designs) that turns into an explosive projectile—the first sign of a placid world getting rattled. Ron, as Hooper states in his audio commentary to the film, is "from another dimension," trying to find his place in the human zoo. He is the outsider, while Mahlon, who finds her way to the UT commune, becomes more of an insider. Like a passive cave girl, she becomes the instant girlfriend to the caveman Toz, an angry, cynical, pot-smoking poet played by Kim Henkel (under the pseudonym Boris Schnurr), who also co-wrote the script with Hooper. Mahlon and Toz are a direct contrast to Amy and David, a couple on the verge of getting married and trying to enjoy their last moments of defiance before reintegrating into the safer embrace of parental approval and ethnic norms.

Compared to the more closely scripted *Chain Saw*, *Eggshells* has lots of improvised acting. Hooper claims he sometimes went to the commune in the middle of the night, waking the actor impersonators from their slumbers to get them to perform. The *cinéma vérité* conversations (when the camera contrives with studied spontaneity to make the environment seem "real") are when the fun really starts. For instance, Amy and David, while still living in "sin," like to sit naked together in the

bathtub to rap about communism, student protesters getting bayonet-ted, how much money they will get from their parents, and other issues clouding the minds of "heads" during that period. As their exchanges progress, they start showing the personality warts of a married couple ready to argue, with Amy doing most of the nagging.

There is another cultural dimension that is subtly layered into the plot. Amy and David will be united in a Jewish wedding, but they seem oblivious to any Kosher dietary rules as they eat a premarital breakfast consisting of not just milk and meat together but bacon. Toz is also on hand to give them a Christian benediction, and David finishes with more invocations to Jesus. "That's enough of this god bullshit," Amy finally declares. "Let's eat."

The scene reveals the commune's eclectic spiritual perspective. This is more apparent when Amy, David, Toz, and another friend played by Allen Danziger (the future van driver in *Chain Saw*) sit around talking about a possible spirit haunting the house, blending references to scrip-tural lore, Eastern mysticism, Freud, theories about thought waves, psychics on television shows, and even Casper the Friendly Ghost.

At first glance, much of *Eggshells* can appear as a freeform late-'60s mess. A discernible narrative nevertheless guides the story, even in its most hallucinatory moments. One of those moments is a flashback to the time when the "cryptoembryonic-hyperelectric presence" had entered the house. Hooper subjects viewers to a high-speed stream-of-pixilated-consciousness detour that flickers and wavers through trees, bushes, the rooms of the house, and finally settles down into the house's basement, where the "presence" plots to influence several of its future inhabitants. Hooper also once planned to use a similar machine to possess the chain saw in his impending masterpiece, but reason reigned, and Hooper made *The Texas Chain Saw Massacre* all the more terrifying for being secular.

This hallucinatory interlude makes Ron's presence more profound, for

he is a "hyperelectric" offspring, eluding the notice of the oblivious commune partiers. At one point, Ron sits in a room and contemplates various self-portraits, some of men, some of women, and some of varying alien identities. He is a fluid being vying for an identity in a place too crude to understand or perceive him. Hooper intended him to be a "spirit of the psychedelic energy," and only when he creeps back down to the basement does Ron start coming to terms with his "hyperelectric" origins.

Ron's reaction to his "hyperelectric" self is reminiscent of Edgar Allan Poe's "William Wilson," the story of a man battling his doppelgänger. Instead of being passive when encountering the otherworldly energy, Ron brandishes a sword that he finds beside a decrepit toilet, using it to smash furniture, cut through cobwebs, and as Hooper intended, engage in an adolescent inner skirmish when discovering parts of his psyche he never before acknowledged. It took Hooper two weeks to perfect this schizoid choreography.

The battle of the doubles subsides when Ron's character sees the transcendent luminescence that beckons him to come closer, giving Hooper the pleasure of subjecting Ron to a cosmic joke: a party-favor tweeter with a feather at the end leaps out of the light to tickle his face. Ron is soon immersed in multicolored helium balloons as he strolls through a park, where he encounters an eccentric woman who gets off on licking tree bark as she walks her Irish Setter. Then, in a flash of abrupt discontinuity, Ron is back to the basement, as the light mutates into flashing pink and protrudes. The "hyperelectric" machine, made from what was essentially the remains of a row of hairdryers that Hooper saw abandoned in front of some North Austin store, sucks Ron up, allowing Hooper to digress into some trippy animation that resembles the splotches on a decorated bowling ball, an effect he achieved by stretching out a large piece of clear film leader that he spattered with specks of multicolored, translucent paint.

In 1967, poet Richard Brautigan came out with a collection called *All Watched Over by Machines of Loving Grace*. Its title poem rhapsodizes over "a cybernetic meadow where mammals and computers live together in mutually programming harmony like pure water touching clear sky." Perhaps sharing such optimism, Ron merges with the machine. Amy and David, meanwhile, get closer to the connubial web, at one point embracing inside of a protective bubble. Toz, the movie's anarchist, seethes at the prospect of his friends' becoming husband and wife, yet he plans to chauffeur them to their nuptials in an old Dodge truck that he paints red, white, and blue. In what is apparently a cathartic fantasy, Toz smashes and sets fire to the car, gambols about the field in full-frontal nudity, and marvels at the combustion that resembles an atomic mushroom. There is also some *Chain Saw* foreshadowing: two clucking chickens, along with animal skulls and bones, are all that remain in the holocaust's aftermath.

"We gotta go castrate David," Toz tells Mahlon as they loll in bed before attending the wedding in the park's bandstand. While friends and family of the newlyweds rejoice, Toz runs from the scene, unable to cope with his pal's transformation and resenting the bride. He returns to the old house and his typewriter, trying to continue his poetry while the ominous "cryptoembryonic" light flickers above him. The cellar beckons, the blinding light pulls him toward a doorway, but he still manages to grab Mahlon down with him to the basement to share in the transformation.

By now, androgynous Ron reunites with the bark-licking lady. She becomes a fourth wheel on this final madcap ride as Toz and Mahlon join them in the search for another world. They resurrect the "hyperelectric" machine in what seems to be a relatively pastoral setting that is threatened by bulldozers (foreshadowing the anti-urban renewal sentiments of *Down Friday Street*). Hooper indulges in another breakneck

POV journey by car through Austin, before the four misfits surrender to the "cryptoembryonic" voltage, sticking their heads into its hairdryer-like electrodes that suck them in and squeeze out their earthly remains into a muddy sludge. Their spirits—or their unraveling DNA strands—drift as a white mist that eventually dissolves into the foliage.

The image in the film of Kim Henkel's snarky character Toz hunched over his typewriter approximates a true-to-life portrayal of his role in his collaboration with Hooper. Hooper had the cinema smarts, while Henkel was immersed in setting the atmosphere and the dialogue, sometimes retreating to his little corner of the set to bolster the script or scribble new dialogue on a napkin. Hooper was left with about sixty hours of footage that he had to compress into a ninety-minute story—a process that took about nine months. The movie had few if any viewers by the time it was ready for the public in 1971, but it did appear at the Atlanta International Film Festival to win a gold award.

Of the Hooper-Henkel duo, Henkel was the doubter, the one more prone to stew in criticism of the world, including himself. And the characters of David and Amy as well as Toz's troubled reaction to them, are also likely part of Henkel's life. As he recalls, "I acted in *Eggshells*—well, after a fashion . . . I wrote some short little pieces for it. It was mainly centered on two friends of mine—and it was because I knew them that I ran into the whole situation. After that, Tobe and I talked about something off and on for several years, and then we finally settled on the *Chain Saw* project."

Hooper, on the other hand, was the mystery man: present during the late '60s upheavals yet not fully part of them. Allen Danziger, who appeared in Hooper's first two features, expressed relief that he was less involved in *Chain Saw* than the other actors. But he has somewhat vivid memories of a distinctive Hooper vibe: "Tobe was like a dark presence; he had this cigar like some Erich von Stroheim lurking in the

background." The "cryptoembryonic" phantasm also suggests that the movie's commune, much like the late-'60s counterculture in general, is a farce of a "festival"—an illusion of freedom trapped inside a controlled world and monitored by unseen eyes.

Eggshells has eerier undertones in the context of its cultural backdrop. In April of 1968, the 13th Floor Elevators, the psychedelic pioneers from Tobe Hooper's Austin hometown, performed for the last time at a San Antonio world's fair. There, the band's twenty-year-old star Roky Erickson started muttering incoherencies and had a nervous breakdown. Once doctors diagnosed him a "paranoid schizophrenic," the musician who was among the first to introduce electric feedback and distortion to rock soon submitted to electro-convulsive shocks. As David McGowan writes in *Weird Scenes Inside the Canyon*, "While hospitalized, he began hearing voices telling him 'horrible things.'"

"Horrible things" were transpiring—both in plain sight and under the radar. The "rebels" of the era ridiculed the middle-class "squares" for being conformists, but the nonconformists were also widgets in their own processed, propagandized world. Many anti-war demonstrators had genuinely humane motives, but others who insisted on America's unilateral withdrawal from Vietnam revealed other plans as they toted red flags and screamed out their love for Ho Chi Minh and Chairman Mao.

All the while, the major Communist nations, so favored by ultra-left extremists and their enablers, had their own gore shows. T-shirt superstar Che Guevara killed thousands during his Castro-led crackdown and sought to confine homosexuals to re-education camps. While American and Western European youth demanded unprecedented liberty, Mao and his "Cultural Revolution" eviscerated its "counterrevolutionaries." Around the time the Beatles were busy recording a cheeky track about wanting to be "Back in the U.S.S.R.," the Soviets led other

Warsaw Pact nations in August of 1968 to invade Czechoslovakia and quash its desire for free expression and other liberal reforms.

The Viet Cong (favored saints among the "anti-imperialists") were not above killing thousands of innocent villagers. About two months before the My Lai Massacre of March 1968, when American soldiers killed hundreds of Vietnamese villagers, the Viet Cong butchered thousands of unarmed Vietnamese civilians in the Battle for Hue during the 1968 Tet Offensive, leaving the survivors to rummage for corpses in mass graves through the fall of the following year. The U.S. Government tried to hush up My Lai for a while, but the Hue Massacre eluded most people's knowledge for a much longer time. Decades later, journalist Olga Dror reflected in the *New York Times* about how "the My Lai victims and the American perpetrators pushed the Hue victims and the communist perpetrators out of the American media and, by extension, out of the attention of the American public and of world opinion."

In May of 1969, while body bags still traveled back home from Southeast Asia, a homegrown malady crept in under the public radar when a teenager from Missouri died in a St. Louis Hospital. He, who had previously complained of swelling in the lymph nodes, neck, legs, lower torso, and testicles, eventually contracted chlamydia and bronchial pneumonia. Disclosing to his doctors that he had been sexually active, he struggled to stay alive as his white-blood-cell count got depleted, and his immune system crashed. After his death, the doctors treating him continued to uncover mysteries. A small, purple spot on his thigh led to more signs of Kaposi's sarcoma lesions in his soft tissues. Fascinated, horrified, and utterly adrift, specialists had his blood and tissue frozen for future research, which decades later would reveal arguably the first AIDS-related deaths in North America.

On July 18, days before America fulfilled JFK's pledge to put a man on the moon, an attractive twenty-eight-year-old secretary named Mary Jo

Kopechne lay in an Oldsmobile submerged at the bottom of a tidal pond, while JFK's little brother Senator Edward Kennedy wandered from the site. By July 25, he minimized legal problems and tried explaining to the public, via the major television networks, the "inexplicable" events and "whether some awful curse did actually hang over all the Kennedys."

By early August of 1969, the mood got creepier when members of a misfit commune in Southern California committed the Tate-LaBianca murders. Soon after, swarms of young, middle-class Americans amassed for the Aquarian Exposition aka Woodstock. It was initially a capitalist enterprise, with an expected high yield in ticket sales, until people jumped fences and forced it to become a free-for-all. Warner Bros. atoned for the unexpected revenue loss by getting the rights to make a slick documentary of the event and released it shortly after. Despite the rain, mud, the passing around of bad acid, and a couple of deaths, *Time* magazine hailed it as "The agape-like sharing of food and shelter by total strangers." Jimi Hendrix, whose blistering rendition of "The Star-Spangled Banner" made him the festival's trickster, also gushed to *Time* over the coming Aquarian revolution: "From here, they will start to build and change things. The whole world needs a big scrub down."

After Woodstock, however, the world seemed dirtier and scarier. On September 13, John Lennon and Yoko Ono hoped to spread peace by helping to organize the Rock and Roll Revival Concert in Toronto. But fans itching to see both the Beatle and a bevy of old-time performers got the shock treatment when the Alice Cooper Band (whom one stage announcer called "a group of the future") managed to be more outlandish than Ono's shriek-a-thon. D.A. Pennebaker captured them jumping around on stage, feigning tantrums, pounding with hammers and other implements, throwing watermelons, and flinging feathers out of pillow cases. Someone tossed a live chicken at them, and Alice, thinking it could fly, threw the creature back into the throng. Apparently burnt

out on peace and love, the audience became a mob and proceeded to tear the chicken to pieces. Alice would go on to boast that he and his band "drove a stake through the heart of the love generation."

The My Lai Massacre became public knowledge in November. A month later, Altamont happened. Festival enthusiasts discovered that the Hell's Angels were just as capable of pounding hippie heads with pool cues as the police had been with billy clubs. Mick Jagger danced to the voodoo rhythms while singing "Sympathy for the Devil," yet registered a look of shock for the Maysles Brothers' cameras in *Gimme Shelter*, as he watched footage of hell breaking loose. *Rolling Stone* magazine described it as "rock and roll's all-time worst day, December 6th, a day when everything went perfectly wrong."

In the final days of the '60s, posters appeared in major cities around the world with the message, "War is Over! If You Want It, Happy Christmas from John & Yoko." Members of the domestic-terrorist group the Weathermen, however, shouted, "We're not trying to end wars. We're starting to fight war." On December 27, the predominantly white Weathermen held a "War Council" in Flint, Michigan, where Bernardine Dohrn declared, "We're about being crazy motherfuckers and scaring the shit out of honky America!" Showing allegiance to "Charlie" Manson and his "family," Dohrn went on: "Dig it; first they killed those pigs, then they ate dinner in the room with them, then they even shoved a fork into pig Tate's stomach. Wild!" Then, in honor of one of the murder weapons (which authorities, in truth, found jabbed in Leno LaBianca's belly on the day after the Tate murder), the Weathermen declared 1969 as "The Year of the Fork." Reports surfaced of participants holding up their arms in a symbolic four-finger-fork salute.

Eggshells was Hooper's somewhat messy but sometimes profound kiss-off to the mania and the menacing omens of the '60s, a decade that started with a presidential assassination, morphed into a campus mass

shooting, and culminated in the year 1969, when the men of Apollo 11 took "a giant leap for mankind" in outer space, three hundred thousand young people wallowed in the Woodstock mud, and the remaining months descended into American gothic horror. Amid these political and social seizures, *Eggshells*, despite four of its characters disintegrating, stayed sealed in a wheat-germ Eden. The film's commune dwellers are only slightly less kempt than the five cleaner-cut lambs driving to their slaughter in *Chain Saw*. Still, Hooper would describe *Eggshells* as "a real movie about 1969. It's kind of *vérité* but with a little push. Like a script on a napkin, improvisation mixed with magic. It was about the beginning of the end of the subculture." He would also call it "a mixture of Andy Warhol's *Trash* and Walt Disney's *Fantasia*."

Jagger played a satanic figure on the Altamont stage, but other cultish events and pranks surfaced. While watching country star Porter Wagoner sing a gospel tune on television, Norman Greenbaum, a Jewish boy from Massachusetts, quickly composed what would become the fuzzy, psychedelic hit "Spirit in the Sky." He sang about dying in godly grace and finding "a friend in Jesus," though he remained an observant Jew and riled some Christian purists with the line, "Never been a sinner." Around the same time, the militant atheist Madalyn Murray O'Hair, an Austin resident transplanted from Baltimore, played the tax-exempt churches at their own game by starting her own with her then-husband Richard O'Hair (a one-time FBI/CIA informant). She called it Poor Richard's Universal Life Church of Austin, Texas. The press and the public were stymied by the thought of atheists having a church. Her choice of Neanderthal Man as its patron saint confounded them more.

Hooper and Henkel had an extra subplot in *Eggshells* that they left out, which also cast a religious shadow. It involved a bearded, traveling prophet, who stalked crowds to share apocalyptic tidings with

protesters and other countercultural fans. Hooper thought it too dark for the kind of mood he was trying to establish, but considering the director's subsequent output and legend, he might have served himself better by keeping the fearsome seer. It would have provided a more accurate glimpse into the times and a better segue into the next feature.

Soon, Hooper and Henkel visualized *The Texas Chain Saw Massacre* as a modern version of Hansel and Gretel, a brother and sister who (in the Brothers Grimm's original version) encounter a cannibal crone after their mom abandons them in the woods. *Chain Saw*'s characters likewise wander out of their proper path and end up in similar peril. The film also includes a species of hippies that *Eggshells* does not address: those who neither slink back into the mainstream nor burn out, but rather become foolhardy wanderers, wannabe reincarnations of wild-west explorers fancying that they will rediscover an America receptive to their good vibes.

Centering on hippie types who wander off their reservation to experience a truly bad day, Hooper and Henkel's second feature was writing itself, due to the events and forces that pushed its creators, crew, and actors into a rabbit hole full of rifled graves, cadavers, assorted human bones, and roadkill. Except for some full-moon and searing-sun shots, voodoo sculptures, and passing references to astrology, *The Texas Chain Saw Massacre* portrays real horror in real time that could happen in real places to real people. This time, there is no "cryptoembryonic-hyperelectric presence" to carry the story. Quoted in Gunnar Hansen's book *Chain Saw Confidential*, Henkel is adamant about avoiding such phantoms: "I took the position, basically, that what really is scary is us. *We're* what is frightening—human beings." *Chain Saw* explores a point in America when the psychedelic Day-Glo faded into what some euphemistically called "earth tones" but that looked more like rust and leftover blood.

Tobe Hooper was also preoccupied with solar flares and manipulative weather shortly after he got home from his Montgomery Ward ordeal. "Then I got out of that mob in 20 minutes," he told the *Austin Chronicle* in 2000. "The structural puzzle pieces, the way it folds continuously back in on itself, and no matter where you're going it's the wrong place. That was influenced by my thinking about solar flares and sunspots reflecting behaviors. That's the reason the movie starts on the sun."

CHAPTER THREE

SCARY WEATHER

"There are moments when we cannot believe that what is happening is really true. Pinch yourself and you may find out that it is."

—PAM (TERI McMINN),

READING THE DAY'S HOROSCOPE TO HER FRIENDS

WHILE ON HER FATEFUL JOURNEY BY VAN

The first pages of Tobe Hooper and Kim Henkel's script specified an exploding sun, the bursting of solar flares, and then a dissolve into a lump of roadkill simmering under ninety-plus Central Texas degrees. The original image was to be of a dog, whose "purple glazed eye" would appear first before the rest of the moldering creature, surrounded by a chorus of buzzing flies, would occupy the entire frame. Another idea was to use a dead horse. But Hooper, with sentimental twinges, thought using a dog, a horse, or any domestic animal, too cruel.

Hooper settled instead for an armadillo, one that Bob Burns, the official art director, production designer, talent scout, fan of the deformed 1940s B-movie actor Rondo Hatton, and all-round collector of dead

things, assembled with some "do-it-yourself" taxidermy to keep it in one piece. The armadillo is also a symbol of Austin, an indigenous creature with a prehistoric, even alien presence that, even when dead, can induce revulsion.

Throughout the film, there are allusions to outside forces moving the destinies of the characters: astrological upheavals, a volatile sun, a full moon, voodoo sculptures, and a nest of daddy-long-legs spiders in a malevolent huddle. These are, however, deceptive red herrings as Hooper ultimately veered away from supernatural subtexts, preferring unfavorable weather patterns and bad people to explain the horror— not spirits. Five young adults travel by way of a van, including Franklin and Sally Hardesty who check to make sure their grandfather's grave was not hit by a rash of desecrations. Franklin, Sally's invalid brother, who cannot even pee into an empty tobacco can without getting jostled by one of the speeding trucks dominating the roads, becomes the sole witness to an elderly drunk who spurts out semi-coherent yet prophetic phrases. And then there are the movie's signature long shots and sidling tracking moves that suggest outsiders watching and plotting.

During these opening scenes, the heat looks unbearable. This is what makes the shots of the solar flares such a potent credits opening. The notion that solar flares influence lives is the one theme that corresponds to some actual scientific information prevalent at (or around) the time of filming. NASA, for instance, had reported massive solar storms in 1972, with sunspots exploding between Apollo 16's return in April and Apollo 17's moon-landing mission in December.

Hooper embellishes his film with such allusions, for example, when he shifts from the exhumed and desecrated corpses to the blood-red sun spewing its anger. He is also entranced by the moon. Just as lunar

activity affects the tides, so might people succumb to the full-moon crazies, or what some call the moon's "negative entrainment frequencies." The flares also suggest that Hooper might have been inspired by a marginal literary figure from the past who also tried to make sense— or at least a sensation—out of seemingly unconnected events.

Decades ago, an eccentric recluse named Charles Hoy Fort, regarded as the *"enfant terrible* of science," demonstrated a knack for finding eerie and comical connections among natural and scientific anomalies—all within specific time periods. Giant snowflakes in Nashville; mud rains in Tasmania; frogs raining over Kansas City; fish falling south of Calcutta; lizards landing on the sidewalks of Montreal; winged creatures above Palermo; "luminous bodies" in the air prior to an earthquake in Boulogne, France; giant footprints, blood showers, green suns—thousands of such deviant data he kept inscribed on file cards and stored in shoeboxes that piled up in his Bronx hovel.

Fort published four books that both recorded and narrated these events, suggesting that coincidence (random occurrences) and synchronicity (cosmic patterns) exist as a blur and that we cannot always tell one from the other. Fort's works call to mind the so-called "Butterfly Effect" (a weather-patterns concept) about the flapping of butterfly wings affecting the rise of a hurricane on another side of the world. Not reducing his findings to a simple theology in which all of the puzzle pieces are supposed to fit, he was more effective at writing out coincidence collages while castigating established scientists for ignoring the anomalies. Fort also had a satirical edge.

Solar flares were another of Fort's obsessions, and he was not alone. Others had been observing them since at least as far back as 1859, when two British astronomers, Richard Christopher Carrington and Richard Hodgson, discovered—independently from one another—brightened

areas of the sun that seemed inexplicable. A century later, some Russians also monitored similar geomagnetic disruptions. Alexander Chizhevsky, a pioneer in these studies, used charts and graphs in an attempt to show how such magnetic fields swayed human destiny, inspiring such unrest as the 1917 Revolution. But Stalin, adverse to any scientific theories that contradicted the Soviet dictum that human will ruled all, sent Chizhevsky to a gulag. Surviving Stalin, he lived until 1964, and his ideas have resonated ever since.

Another Russian researcher named Oleg Shumilov observed sun-spot activity from 1948 through 1997. He, along with the Institute of North Industrial Ecology Problems, eventually narrowed the flare attacks to annual periods from March to May, in July, and in October—when anxiety, depression, bipolar disorder (formerly "manic depression"), and even suicide had hit the troubled city of Kirovsk. Something was amiss, but antiquated Russian folklore and superstitions were not sufficient. One theory is that these solar ejections and magnetic storms play havoc with circadian rhythms, the biological timepiece that alerts people, accustomed to the day-labor rut, when it is bedtime.

Hooper was also preoccupied with solar flares and manipulative weather shortly after he got home from his Montgomery Ward ordeal. "Then I got out of that mob in 20 minutes," he told the *Austin Chronicle* in 2000. "The structural puzzle pieces, the way it folds continuously back in on itself, and no matter where you're going it's the wrong place. That was influenced by my thinking about solar flares and sunspots reflecting behaviors. That's the reason the movie starts on the sun."

Hooper's fixation on solar flares also appears to have some ties to other scientific findings arriving in the shadow of *Chain Saw*'s

production. In May of 1973, an astronomer in India named B.J. Srivastava noticed similar eruptions. From his magnetic observatory at Hyderabad, he had recorded what he described as "unusually large solar flare" activity, "the highest ever recorded since the establishment of the observatory in December 1964."

Likewise, an article appearing in a 1974 edition of *The Observatory* recorded that "1973 was markedly more active magnetically than the preceding few years . . . Most of the activity occurred during the first part of the year, which was rarely quiet. During April and May, there were several magnetic storms with some enhancement of solar activity of the same period."

Throughout the opening and later on in the film, a radio announcer (Kim Henkel's future director of photography, Levie Isaacks) assumes a Charles Fort persona as he delivers one ominous report after another: a Texaco oil refinery explosion; a cholera epidemic in San Francisco; riots in Houston triggered by a young man who, angry at a power blackout during a televised sports event, jumped to his death from his apartment's tenth story window; a collapsed building in Atlanta possibly the result of sabotage; a man and woman killed and mutilated in Gary, Indiana; South American governments in ferocious battles over oil reserves; Dallas police apprehending a couple for chaining their eighteen-month-old daughter in an attic; and a grave-robbing rash in Muerto County where officers discover "at least a dozen empty crypts" and "the remains of a badly decomposed body wired to a large monument."

Also, while riding in the green Econoline van to doom, Pam (the most supernaturally inclined among the five travelers) reads from her *A-Z Horoscope Maker and Delineator* about the sway of "malefic" planets as Saturn goes into retrograde. Later, she throws more shade Franklin's

way by looking in her issue of *American Astrology* and reading his horo-scope: "Long-range plans and upsetting persons around you could make this a disturbing and unpredictable day. The events in the world are not doing much either to cheer one up."

Truth lurked within Pam's desolate horoscope reading, but a fasci-nating and, for many, liberating part of the early '70s tried to add some color and fresh controversy amid the depressing forecasts. Androgyny (and its attendant "glam rock") offered some psychological adventure for younger people weary of the blue-jeaned "back-to-nature" Woodstock fetishes. This fresher crop of teens got tired of that same washed-out hippie uniform that Charles A. Reich had gushed over in his 1970 bestseller *The Greening of America* as "a deliberate rejection of the neon colors and plastic, artificial look of the affluent society."

Economic and social thinkers warned of depleting resources, imminent poverty, and overpopulation, but the glam rockers, inspired and spiteful, advocated extreme color and artifice. Some like David Bowie (all coiffed and gussied up) arrived from England, but Alice Cooper, with his tattered outfits, teased hair, and tarantula eye makeup, reflected more honestly the era's frazzled adolescence. He also gets credit for being among the pioneers whom others copied. Alice claimed to like the sobriquet "Alice Cooper": it connoted "some-thing axe-murderish." His pre-Leatherface allure had its own neurotic beauty.

From the group's experimental debut album *Pretties for You* in 1969 to their slicker production *Love It to Death* in 1971, Alice Cooper's lyrics and music turned Timothy Leary's trippy ideals upside down. "Inner space" became claustrophobic. Instead of basking in the joys of "cosmic consciousness," the subjects of Alice's earlier songs are often fragmented personalities, products of mental rape. They

wander through mirrored halls of distorted memories in tracks like "Levity Ball" or slip from loneliness to madness in "The Ballad of Dwight Fry."

Speaking to *Circus* magazine in June of 1971, Alice Cooper, by then oblivious to America's economic problems, was both sardonic and triumphant about what amounted to the death of Charles A. Reich's utopia: "We're merely the end product of an affluent society. We enjoy getting on stage and showing the public what their world has come to. Only usually they're shocked."

Already by 1972, some audiences grew weary of the *Billy Jack* platitudes and hungered for more sensation and color, even if it had to be bloodred. That is when people like Wes Craven filled the void. And soon, Hooper and Henkel would grind their 16mm camera in the summer heat to make a movie that would be more colorful, more profound, and of course, more violent than *The Godfather*.

In April of 1973, the World Trade Center officially opened to the public, including a ribbon-cutting ritual on a rainy day of April 4th with Governors Nelson Rockefeller of New York and William T. Cahill of New Jersey. Devotees of old neighborhoods such as Radio Row were inconsolable at the sight of these colossal monoliths, while some ecologists dreaded its drain on the already emerging energy crisis. Architecture critic Louise Huxtable dismissed the towers in the *New York Times* as "General Motors Gothic," while Norman Mailer compared them to two giant fangs sucking the lifeblood out of Manhattan's unique skyline. President Nixon sent a letter of congratulations, but both the World Trade Center towers would become dwarfed a month later when Chicago's Sears Tower stole the tallest-U.S.-building title for many years to come.

Then came the May showers, building up to a Watergate bloodbath. By then, Nixon had fired his counsel John Dean, an exodus followed by

presidential confidants and future jailbirds John Ehrlichman and H.R. Haldeman. The two weeks out of May also brought a revolution of sorts to the little screen, with the Watergate Hearings, live from the Senate, occupying televisions on 150 national affiliates. At the same time, the Skylab I Space Station soared overhead, but so many people were more transfixed to the tube, witnessing one testimony after another as "Tricky Dick" got cornered like a scorpion. The solar flares, the social shifts, and the political disruptions were like growing chapters in a larger, increasingly tawdry novel.

The hot July of 1973 ignited at least two notable conflagrations. On July 5, Kingman, Arizona experienced a tragedy called BLEVE (Boiling Liquid Expanding Vapor Explosion), the result of a propane blast when workmen attempted to transfer a combustible substance from a railroad car into a tankard. The catastrophe killed eleven firefighters, but it would become the model for "what not to do" in future fire department training exercises. Seven days later, a fire attacked the Personnel Records Center of the National Archives in St. Louis, Missouri.

Then, on July 20, Bruce Lee was found dead at the age of thirty-two in Hong Kong, shortly after planning to make a film called *Game of Death*. Scotland Yard concluded a "death by misadventure," due to the tranquilizing drugs in his bloodstream. Others continue to suspect foul play. And on the last day of July, Delta Airlines wrought carnage when one of its DC-9 planes missed the Boston Logan Airport's runway and crashed into a seawall, taking the lives of eighty-three passengers and six of the crew.

According to *Chain Saw*'s cinematographer Daniel Pearl, "The film finally began shooting on 15 July 1973, and took anywhere from thirty-two days to eight weeks—it's a measure of how traumatic the shoot

was that most err towards a longer period." Another mishap affected the film just as shooting was about to start. It involved the man who would be Leatherface. The solar forces possibly got the best of the guy slated to play the lead. Instead of showing up on the set, he walled himself away inside a hotel room, in a drunken delirium, reneging on his commitment. Hansen, in *Chain Saw Confidential*, claims that the man got last-minute jitters "about karma and his soul—it was the '70s, after all . . ."

Desperate to find a replacement, Hooper did not take long to realize that Hansen was perfect for the part: not for Hansen's prior acting experience when playing the huge, clumsy, and murderous Lennie Small in a University of Texas production of John Steinbeck's *Of Mice and Men*, but because when Hansen entered Hooper's office, he filled the doorway. The imposing but tender Icelandic-born poet commanded a presence no one would ever forget.

Being a gentle giant, however, was not enough to make Hansen feel sufficiently confident for his new psycho incarnation. He spent some time at the Austin State School, a place that treated the developmentally disabled and where his mother worked in the clinic. He started touring the grounds, studying how the patients ambled, stooped, bent their heads, and made erratic motions. "I found that the key to unifying the character was all in the gesture," he recalled, "the way I moved my right arm, pulling it toward my chest. Then the body followed."

Hansen's body, like the other bodies on the set, was not ready for the rigors of the sweltering days, with outside temperatures approaching the one-hundred-degree range. Yet even with the scorching Texas weather, another life-form thrived. Like the malevolent plants in *The Day of the Triffids* that multiplied despite the impact of the meteorite

from which they spawned, the two acres of cannabis growing in the yard of the house where most of *Chain Saw* took place added one more layer of anxiety. This marvelous and menacing display of nature, this scarier outgrowth of the so-called "greening of America," showed up at a legally inopportune time.

In January of 1973, New York's Governor Rockefeller set more punitive trends around the country by announcing tougher drug laws. The *Daily News*'s front page on January 4th shouted, "Rocky Asks Life for Pushers." Rockefeller also planned to incarcerate even those in possession of marijuana. "I have one goal and one objective," he claimed, "and that is to stop the pushing of drugs and to protect the innocent victim." In July, Nixon signed into effect the Drug Enforcement Administration, which planned to enforce federal drug laws more thoroughly through a single organization. Oregon, however, proved an outlier that year when it became the first state to decriminalize cannabis possession while still imposing a fine.

By late August of 1973, even the hard-nosed Lone Star State reduced the possession of two ounces or less of marijuana to a misdemeanor, but during *Chain Saw*'s July filming, any amount was still a felony. The stewards of the house used for the Leatherface manse were some bohemians who told Hooper and company that they could help themselves to the crop as long as they were discreet about what Hansen called "our landlord's extracurricular gardening." Hansen quotes the film's location-sound recorder Ted Nicolaou: "I thought that was part of the reason for the confused discussions every day of what we were about to shoot."

Even though John Larroquette, who served as the opening narrator, claims to have been paid with only a single joint for his effort, the *Chain Saw* gang was not prepared to see so many potential joints abounding

in their backyard and thriving in temperatures otherwise barely livable. Yet somehow, in the scramble of coping with all of the other production problems and as the chain saw buzzed, the loco weed, baked into brownies, offered a sweeter kind of buzz, affording pleasure to some and supplemental paranoia to others.

When the movie begins, the five youths traveling in their van conform to a quaint, stereotypical memory of the optimistic hippie quest: the impulse that impelled thousands of young, mobile, predominately white, Americans to travel out of their prescribed lanes and into the spooky unknown.

CHAPTER FOUR

"I WAS THE KILLER!"

"That's the last goddamned hitchhiker I ever pick up!"

—JERRY (ALLEN DANZIGER),

DRIVING THE VAN FROM ONE MANIAC TO MORE

Since its appearance, *The Texas Chain Saw Massacre* has left many critics and other viewers scratching their heads to find an overall "moral" with "socially redeeming value." But Tobe Hooper and Kim Henkel ended up with a work that flouted those traditional expectations. Nevertheless, viewers desperate for an overarching message in *Chain Saw* have several options. Some with carnivore guilt can claim that watching it at least got them to stop eating meat, if only temporarily. Ultra-conservative moralists have invoked the movie as a negative lesson: the very fact that such a thing existed and got shown in theaters around the country, and ultimately around the world, offered proof that the popular culture had become too nihilistic, too violent, and (for some) beyond redemption. In contrast, many horror enthusiasts were more optimistic, seeing the film as an augury for more gorgeous cinema to come.

A feminist theory also surfaced, pointing out that Sally Hardesty's survival represents a horror-movie trope: the final girl—one who

could prevail on her own without the white knight to save her. In the case of *Chain Saw*, however, this example is tenuous, given that Sally is good at running, screaming, and jumping out of plate-glass windows to avoid her killers, but she ultimately depends on a man. One man (Ed Guinn) lumbers out from his raging-red cattle truck after running over the Hitchhiker. He at least injures Leatherface by throwing a wrench before fleeing the scene, leaving the killer shrieking as his own chain saw cuts into his thigh (among the movie's more graphic moments). Sally's accidental hero turns out to be a barely visible Chevy-pickup driver (Perry Lorenz), who comes along at just the right moment for her to climb into the back and zoom off. Sally laughs and shrieks as she flees her would-be killer, but a straitjacket seems more in her destiny than a medal.

Notwithstanding the various and conflicting reactions, *Chain Saw* provides one indisputable warning: picking up hitchhikers is neither wise nor safe. When the film got released, hitchhiking was still one more act of rebellion by teenagers seeking to travel in a manner that their parents despised. It was another act of revolution, another excuse to pee on the white-picket-fence of middle-class propriety. When the movie begins, the five youths traveling in their van conform to a quaint, stereotypical memory of the optimistic hippie quest: the impulse that impelled thousands of young, mobile, predominantly white, Americans to literally travel out of their prescribed lanes and into communes.

Through much of the 1960s, attitudes toward picking up road aliens were more relaxed. Let's Go Publications, a travel-book series that started in the early '60s, basked in the romantic afterglow from Jack Kerouac's *On the Road*: a freewheeling spirit that started with the beats of the '50s and continued with the hippies. In 1962, for instance, the guides would advise boys to hitchhike with girls in order to attract more interested drivers, with no hint of potential rape or murder. Such

trusting attitudes toward the strangers on the road go back to the World War II era, when many considered picking up a lonely soldier trying to get back home a civic duty. Even in the early 1930s, Claudette Colbert demonstrated to Clark Gable, in *It Happened One Night*, that the best way to get a driver's attention was to lift up her skirt and tease him into stopping—before the driver realizes there is also a mustachioed cad waiting to tag along.

"Hitchhikers smile at approaching cars, people smile at each other on the street, the human race rediscovers its need for each other," wrote Charles A. Reich in *The Greening of America*. He liked "the growth of the student-gypsy world, a new geography of hitchhikers, knapsacks, sleeping bags, and the open road," but his adoration of this new and noble youth (whom he hailed as "Consciousness III") was already exceeding its shelf life as the '70s kicked in. As road assaults inevitably increased, the once overly trusting guidebooks got more cautious, eventually discouraging hitchhiking altogether. Soon, even the thumb logo that appeared on the *Let's Go Publications* covers disappeared. "It was the demise of the '60s mentality of love and trust and the belief in community," automotive expert Phil Reed reflected to *NBC News.com* in 2013. "Hitchhiking hippies were replaced by hitchhiking ex-cons. Even I wouldn't pick up a hitchhiker today."

Two popular tunes in 1970 reflected leftover attitudes about the plusses of riding with strangers. "Hitchin' a Ride," from the British quintet Vanity Fare, offered a sprightly take on the thoughts of a hitchhiker who is broke, drenched in a downpour at one o'clock in the morning, and hoping some benevolent motorist delivers him into the arms of a lonely lover in waiting. But the Ides of March hit "Vehicle" likely sent shivers through some who might have already made the mistake of hopping inside the wrong car with a so-called "friendly stranger" and lived to tell the tale. The following year, Joan Baez's "The

Hitchhiker's Song" adopted the road solicitors as "sweet children," "the orphans of an age" who rejected "the sorrows" their fathers had bequeathed to them. She rejoiced as a "thousand silhouettes hold out their thumbs" in defiance of tradition. Jim Morrison likely snickered at Baez's sentimental codswallop. He offered a shrewder and spookier vision in "Riders on the Storm," warning against giving a ride to "a killer on the road," while crooning with an eerie electric piano accompaniment that suggested some *Twilight Zone* cocktail lounge.

The shadowy side of thumbing a ride was sketched into movie history decades before. The Hitchhiker was a symbol of misguided pity in the 1944 film *Detour*, as a lovelorn sap (Tom Neal) makes himself more of a victim of circumstance once he allows the nastiest of femme fatales (Ann Savage) into his jalopy. William Talman, so jarring as Perry Mason's courtroom foe in the renowned television series, was all the more menacing as the ride-soliciting demon in the 1953 thriller *The Hitch-Hiker*—the same year that AAA used the slogan "Thumbs Down on Thumbers" to discourage what had already become a public hazard.

Into the early 1950s, a campaign raged on to warn well-meaning motorists about roadside slashers waiting to pounce. The FBI included J. Edgar Hoover's signature in a poster with the headline reading "Death in Disguise." It depicts what appears to be a husband in the front seat with his wife and daughter in the back. The right door is open to the nattily dressed hitcher with his thumb out, but the near-subliminal contours of a human skull dominate the frame. The message is direct: "To the American Motorist: Don't pick up trouble! Is he a happy vacationer or an escaping criminal—a pleasant companion or a sex maniac—a friendly traveler or a vicious murderer? In the gamble with hitchhikers, your safety and the lives of your loved ones are at stake. Don't take the risk!"

By 1973, as the *Chain Saw* cameras rolled, the mood got gloomier. The ethics of the '60s revolt tried convincing America's youth that life on the road was a more trustworthy—even loving—place, but with the help of FBI agents, Jim Morrison's "killer on the road" became the crime-fighters' archetype. The term "serial killer," prompted partly by the hitchhiker mishaps, got bandied about in the press by the mid-'70s. In 1974, FBI agent Robert Ressler was among the first to bring "serial homicide" into law-enforcement jargon after giving a lecture to a police academy in Bramshill, England.

Ressler was particularly fascinated by how so many crimes through history, primarily in recent history, occurred in a series, similar to the way "serial adventures" like *Batman* and *Flash Gordon* played out in the movies. And just as each episode ended with a cliffhanger, making viewers apprehensive about the lack of a solid conclusion, so did the outbreak of murders he had studied. A "serial killer" committed each killing with the same sense of a suspended climax: a grappling for a more perfect crime with each successive murder. Ressler would go on to brave face-to-face interviews with the likes of Ted Bundy and Jeffrey Dahmer, who both scouted out hitchhikers among their prey.

True-crime cases invalidated Reich's enthusiasm when he wrote in *The Greening of America* about a "new consciousness," wherein freeway entrances are "festooned with happy hitchhikers." But in order to further stigmatize hitchhiking, the authorities and the press had to reverse the roles, due to the fact that some of the worst examples of hitchhiker horror emerging from the early '70s involved homicidal drivers. The hitcher, often female, became the victim instead of the perpetrator.

Among the more grievous cases occurred between 1972 and 1973. The so-called "Santa Rosa Hitchhiker Murders" started in February of 1972, when two thirteen-year-olds from the Santa Rosa, California area had vanished. Some had witnessed the two thumbing a ride

beforehand. Authorities found their bones ten months later in a hilly patch north of the area. The body of a nineteen-year-old last seen hitchhiking in Larkspur, turned up a month after: naked, strangled, and left to decompose in a creek. Several other young women hitchhiked, got abducted, and were left to decay in various Santa Rosa weeds and woods. In July of 1973, a fourteen-year-old's body turned up—this time a victim of poisoning.

That same year, female students at the University of California in San Diego reacted to this dangerous climate via a "Sisters Share a Ride" program, encouraging women to travel only with women. The Santa Rosa case left both the law and the public frustrated. Police were able to recover seven bodies, but an eighth likely victim—like the killer or killers—remained unknown.

Then, there was Edmund Kemper, who between 1972 and 1973, cruised on California's freeways and roads, where he lured, captured, and mutilated up to six young women, all students. The "free and easy" reputation of the Santa Cruz area was, from then on, tainted with similar scandals previously associated with worldlier places like Los Angeles and San Francisco. Ocean waves once associated with tanned, peaceful surfers were suddenly littered with washed-up body parts.

Those familiar with the area's post-'60s unease thought the killer might have been a Manson stereotype, but when authorities faced Kemper in April of 1973, they found the perfection of a clean-cut conservative, with an affable personality, who was also a great raconteur at the watering holes that local cops also frequented. Even before his '70s killing spree, however, Kemper had grown horns. Some might have seen warning signs when, at ten, he claimed that he would kill his teacher if he ever had to kiss her. As the product of a broken home when his parents divorced, without a caring dad and left with an overbearing mom, Kemper cultivated a violent streak. He had sisters, and

his mother feared he would assault them, so she locked him in the basement at night—gruesome evenings he later described as fraught with the sound of scampering rats.

The parental crimes rested not only on the mother's shoulders; Dad was far from an ideal role model. When he got to his teens, Kemper left for Los Angeles with the sad dream of finding refuge in the arms of a loving father and instead found a cold stranger. His grandparents became his only haven, but they also could not help him in the end. In 1964, at fifteen, he argued with his grandmother and then shot her with a .22 caliber rifle; he then fired on his grandfather in order to, as he claimed, protect the man from the grief of finding a dead wife. The slayings were not enough to strap him to the hot seat. He was instead snuggled away in Atascadero State Hospital after being diagnosed as a paranoid schizophrenic.

At Atascadero, he ingratiated himself to his captors, as well as to sympathetic psychiatrists who tagged him as more of a withdrawn, passive-aggressive type, and who believed that his 145 IQ was evidence he could be saved. He aided psychiatrists in giving tests to fellow prisoners and was particularly skillful at grasping the Minnesota Multiphasic Personality Inventory, which used a questionnaire to estimate degrees of mental illness.

Kemper administered these MMPI tests to sex offenders in the prison who, as he later admitted, provided inspiration.

By 1969, he thwarted the objections of some psychiatrists by getting parole. He started living in Santa Cruz, again with his mother, and as usual, he continued to quarrel with her. Mom's hectoring had an uncanny parallel to Norman Bates's mother in *Psycho*. The 285-pound, 6' 9" Kemper was also close enough to the way Robert Bloch, in his novel *Psycho*, describes Norman Bates: ". . . his plump face, reflected from his rimless glasses, bathed in the pinkness of his scalp beneath the thinning sandy hair . . ."

Still, Kemper was acting as such a model citizen that, by 1972, Atascadero expunged his records so that he could approach life anew, and he took advantage of this fresh chance by developing a fetish for picking up girls. In the beginning, he resisted the urge to kill them. Alas, just like Bates, his urges got stronger after arguing with mom. He started to carry out his "little zappies," as he called them, later in 1972, when he drove his Ford Galaxie through Berkeley and offered a ride to two eighteen-year-old girls who were attending Fresno State College.

Taking the advice of his Atascadero pals who told him that a rapist should never leave witnesses, he drove the girls to a secluded area in Alameda, knowing he would have to kill them after having his way. He kept one of them locked in the car's trunk, making her listen to her dying friend before killing her too, leaving the dissected remains of both in the nearby mountains.

From there, Kemper's "zappies" were unquenchable: he continued to pick up more girls, and at least one was a high school student. After raping, smothering, strangling, and mutilating them, he would bring them back home, using their corpses as subjects for dissection and sex rituals. Authorities in the Santa Cruz area started alerting the public about this killer on the roads, but in between the murders, Kemper enjoyed knocking down a few drinks with the local cops, honing his storytelling skills by speculating about the atrocities that everyone was talking about and whose secrets only he knew.

In September of 1972, Kemper picked up a fifteen-year-old hitching a ride to San Francisco, trying to get to her dance class. Tied, gagged, and left literally breathless, the girl (like most of his other victims) became Kemper's cadaverous guest, whom he took back to Mom's apartment. There, he performed his erotic rites, particularly with the decapitated head. He was methodical enough to scatter the body parts in different areas, so the police found him elusive.

Kemper (after offing six co-eds) soon committed a horror to rival those of Ed Gein and his fictional spinoffs, including Leatherface. His mother came home late one night in April of 1973. When she finally went to sleep, Kemper crept into her bedroom, pounded her with a claw hammer, slit her throat, cut off her head, had intercourse with it, stuck it on a shelf, screamed at it, used it as a dart board, and removed her vocal cords before throwing them into the sink's garbage disposal. Sensing that Mom's best lady friend would soon discover what had happened, he invited her over so that he could kill her as well and then bolt from the scene worry-free.

Three days later, dazed and running out of gas, Kemper telephoned the police and surrendered. When they went back to the house, police discovered he had left a note near the blood-soaked bed: "Sorry gents for the mess, but really had no time." He was indicted with eight counts of first-degree murder, and tried to kill himself a couple of times to help reinforce his insanity plea. But psychiatrists judged him sane, despite one truth-serum session that revealed he had performed cannibalism, allegedly by fileting a victim's flesh into discrete slices for a casserole. By November of 1973, the jury declared him sufficiently sane and quite guilty. He did not fight his fate; in fact, he wanted the authorities to torture him to death. He instead got to sponge off tax-payer dollars with a life sentence.

Dubbed the "Co-Ed Butcher," Kemper also achieved cinematic fame in a scene from the 2000 film *American Psycho*, when its homicidal protagonist Patrick Bateman (Christian Bale) misattributes a quote of Kemper's to Ed Gein. Sitting smugly in a posh restaurant with his equally smug, cigar-toting Wall Street chums, he brags about his bifurcated attitude toward the opposite sex: "When I see a pretty girl walking down the street, I think two things. One part wants me to take her out, talk to her, be real nice and sweet, and treat her right." When his

pals ask about the other part, he responds, "What her head would look like on a stick!"

Another notable hitchhiker nightmare occurred in July of 1973, just as Hooper and Henkel started stitching together their pieces of celluloid history. A fifteen-year-old Kentucky girl and her sixteen-year-old boyfriend were thumbing for a ride in Miami, when a man picked them up. He drove them to his home, promising some kind of work with decent remuneration, and instead coerced them by gunpoint to perform sex acts while he photographed them. The boyfriend, who tried to take away the gun, ended up getting shot three times in the head. For twenty-four hours, the girl languished: chained, raped, and tortured inside the man's specially designed soundproof chamber. Exhausted, he later let her go, so long as she promised not to divulge what happened, leaving her to fend for herself somewhere in Fort Lauderdale.

She, of course, ran straight to the cops. As the *New York Times* reported on July 23, "The girl reported the story to the Fort Lauderdale police, but a Dade County detective said that the police did not believe her and did not investigate the case further until the bodies were found." The police doubted her, thanks to her mother. The problem was that the girl was a runaway from home, and the resentful mom managed to convince the authorities that her daughter was a teller of tales. But the girl soon found her redeemers. The killer's neighbors in the Miami suburb, who described the man as "a loner and a chronic complainer," had previously noticed his fitful behavior and concluded that he finally went over the edge when he sat for two whole days, motionless on the chair of his front lawn, despite a wicked thunderstorm.

He was Albert Brust, a building inspector who was approximately forty-four years old. When the police arrived to search the Brust home, the bathroom told it all: pornographic pictures lined the walls, while lodged behind slabs of concrete in the shower stall lay the festering and

dismembered corpse of the girl's boyfriend. According to Colin Wilson and Donald Seaman in *The Serial Killers: A Study in the Psychology of Violence*: "The head had been obscenely placed between the thighs, and the hands and feet were found embedded in the concrete." The girl had been right all along, and her story became gospel when authorities discovered, along with an exotic book collection including volumes by the Marquis de Sade, Brust's private journal, where he confessed his sadism. His final entry was brutally honest. He admitted that committing the atrocities did not live up to fantasies. Unable to cope with his failed sex-master experiment, he killed himself by drinking cyanide with a chocolate-milk chaser.

Building on or coinciding with such tragedies, an article in *Reader's Digest* by Nathan M. Adams in July of 1973 entitled "Hitchhiking— Too Often the Last Ride," warned, ""In the case of a girl who hitchhikes, the odds against her reaching her destination unmolested are today literally no better than if she played Russian roulette." The San Diego police department issued the pamphlet "Hitchhiking: Easy, Fun, Deadly." Even though the California Highway Patrol came out with a much more modest estimate of hitchhiker crimes in a 1974 study, public perception and shattering anecdotes kept the hitchhiker taboo intact. Putting emphasis on the driver as the killer rather than the hitchhiker presented authorities with a bigger challenge: the hitchhiker would be easier to track, out in the open and sometimes subject to an all-points bulletin, but the random driver could stay concealed, also change cars, and was a much harder catch.

Hooper and Henkel, however, needed to create a villain and stuck to the more traditional notion of the hitchhiker as nut job. They turned him into the "nap-haired idiot," the "bitch hog" with the oddly shaped facial mark (birthmark, face paint, or tattoo), the unnerving tics, and the uncanny knack for manhandling sharp objects. Edwin Neal, who

plays the Hitchhiker, was up to the task of traumatizing the characters and the viewers. He claims to have gotten psyched up for the role by channeling someone whom he described in the documentary *Texas Chain Saw Massacre: A Family Portrait* as his "brain-damaged, paranoid-schizophrenic nephew." When Neal wanted more counseling from the director, Hooper simply advised him to do more Strother Martin. Neal was so effective that Hansen claims in *Chain Saw Confidential* that the scene's "weirdness was too creepy for Paul [Partain], who said that he never picked up a hitchhiker again." Partain's character, the invalid Franklin, was also the most vocal against picking him up, predicting, "The son of a bitch is going to smell just like a slaughterhouse."

Franklin is sometimes annoying but is mostly sympathetic, especially when they pick up the Hitchhiker against Franklin's wishes and threaten to have the stranger sit next to him. He appears to feel the heat in the van more than the others and is the prime target of the movie's initial foul play. Before the Hitchhiker's arrival, Franklin is almost an aggressor, boasting as they pass the fetid slaughterhouse about his grandfather who used to kill cattle the old way with a sledgehammer, a method that often took several licks to finish the job and left the animals squealing. Sally, who professes to "like meat," tries to shut up Franklin as he repeats the modern airgun's violent motions. Skittish Pam reveals herself as the vegetarian of the group, while Jerry, the driver and boyfriend to Sally, is at first glib about Pam's morose obsessions with astrology, implying that her mystical prattling could be a result of her dipping into the *Reader's Digest* "Word Power" section. Soon, he will be screaming.

The claustrophobic moments when the Hitchhiker enters the scene also reveal clever features of both the story and the camerawork. This is when Franklin, who previously bragged about the airgun as an alternative to the old-fashioned sledge, comes face-to-face with a phantom

of another time and place: when the sledge was the abattoir's sacred utensil. Poor Franklin: he did not want the guy there in the first place, yet he has to take the brunt of the Hitchhiker's wrath.

The Hitchhiker initially appears gracious, inviting them to dine with his family on their specialty headcheese. "I was the killer," he boasts as he shows them pictures of recent cattle slaughters. When Franklin implies that the airgun is an improvement over the old hammer, the Hitchhiker starts getting hostile, insisting the animals died better with the sledge and that the airgun put people out of work. From there, the Hitchhiker exhibits the traits of a white voodoo wizard, slicing his own palm with Franklin's jackknife, capturing Franklin in a Polaroid, taking the Polaroid, demanding payment for the picture, and then setting fire to it on a mound of gunpowder when he doesn't get his way. The regretful hippies, already freaking, finally kick him out when he takes out the straight razor and slides it across Franklin's forearm.

Once jettisoned back into the outdoor heat, he kicks the van and uses blood from his hand to inscribe an ambiguous shape (or symbol) that resembles his facial mark on its side door. He then spits and sputters as the van zooms beyond his reach. Some see the scrawl on the van resembling the symbol for Saturn; others see it as a sign for the Cook at the gas station to recognize the youths as a mark—a gourmand's alert that fresh meat has arrived.

Accounts of the circumstances during the filming of the scene are almost as intriguing as the screen drama. The temperature in the van was insufferable. Hooper was crouched in the middle, shooting the activity from both ends. In contrast to the shaky camera they used on *Eggshells*, Hooper and Henkel were much more conscientious about having steady and disciplined shots, particularly in this difficult interior. There was no phony back projection. The camera, however, was so steady that it posed a different kind of problem. The shifting landscape

outside the windows was so bright and overexposed that they had to find another way to show that the van was moving along the sun-blinding road.

One solution was to show the wind from the open window blowing on Sally's hair at the front end of the car, while the back end focusing on the Hitchhiker needed a white, folded umbrella at the lower left side, fluttering ever so slightly to convey the outside breeze.

There are a few moments when Kirk's displeasure at the Hitchhiker's antics could have been more audible, but the Hitchhiker's increasingly threatening presence gets an extra boost by the song that plays in the background, presumably on the radio that had previously aired the doleful news accounts during the film's opening.

"Fool for a Blonde," written by Roger Bartlett, is harmless on the surface: musings of a laid-back guy who spends "most every day in the sidewalk café, drinking coffee, watching women passing by." Just as Hooper and Wayne Bell psychologically manipulate the entire movie by using such unusual instrumental maneuvers as the scraping of a pitchfork along a table's edge for that teeth-rattling squeal, the film also makes this regional country song more foreboding than the composer likely intended.

In an interview from the website Classic-Horror.com, Bartlett told John Wisniewski that Hooper chose the song "because he thought the hitchhiker was a fool for Sally." During the scene, however, the Hitchhiker spends more time gazing on the flabby brunet in the wheelchair, but he does take delight (along with his brother) in fondling Sally's hair later on when she's bound up at the dinner table. Bartlett's song is more powerful by establishing the ill will intensifying in the van. Listen closely enough to the lyrics to imagine how Hooper and Henkel interpreted it as a stalker's serenade. This is a fine example of how a piece of original-artist source music, incidentally issuing out of a

car radio, can function as mood music, contributing to the story's conflicts as if it were written as part of an original score. The effect gets eerier when the song goes into outbursts of non-verbal jive, suggesting voodoo chants that get louder as the Hitchhiker prepares to slice into Franklin.

Just as they invaded the ears and minds of the counterculture's youth, voodoo rhythms and symbols also lured (albeit without their conscious knowledge) *Chain Saw*'s feckless five, who wandered out of their lane into the spooky regions of the rural unknown. The myths of the happy hitchhiker and the intrepid mini-van voyagers were among other bromides about America's "greening" that *The Texas Chain Saw Massacre* spiked with venom. However, Hooper and Henkel would encounter a true-crime Texas horror story that would somehow bleed into the film's post-production phase.

When *Chainsaw*'s principal photography finished in early August of 1973, reports flashed throughout the country about a wave of mass murders that started way back in September of 1970, when an eighteen-year-old student from Hooper's alma mater, the University of Texas, stuck out his thumb to get from Austin to Houston. He accepted a ride from someone who seemed to be "a friendly stranger," but he never lived to see his loved ones again. He was the first victim in what would become one of the worst serial murder cases in American history.

The dilapidated gas station/barbecue shack in *Chain Saw* reflects a time of oil and other energy shortages, an impending OPEC crisis, and fears that the bounteous resources fueling the American Dream were depleting. Instead of a place where motorists refresh and refuel, the service spot functions more like a slaughterhouse.

CHAPTER FIVE

"THE COST OF ELECTRICITY"

"Well, there's good news and bad news. I'll give you the bad news first: the cost of living has reached an all-time high. The good news is the cost of dying is still within everyone's reach."

—JOHNNY CARSON, THE TONIGHT SHOW
MONOLOGUE, JANUARY 23, 1974

In July of 1973, as principal filming on *The Texas Chain Saw Massacre* started, the Trilateral Commission also materialized; its chief founder was Standard Oil scion David Rockefeller. The Trilateral Commission envisioned a more "cooperative" world where previously separated nations shed their "chauvinism" in order to unify for a "common good." In terse paragraphs, it all sounded cozy, but skeptics took this as another ruse for a power transfer from nation states to a select few overseeing a world court. Trilateral proponents believed that the planet had become resource hungry and ecologically imperiled. And though it was a global problem, the greatest guilt and the heaviest duty was conferred upon the most developed countries, especially the U.S.A. In concert with the Commission's arrival, new terms and expressions started sneaking into civil discourse and textbooks:

"zero-population growth," "non-renewable resources," "global equilibrium," "global governance," and that daze-inducing brain worm called "sustainability."

The Trilateral Commission was, however, just one symptom of a concerted effort to reshape minds, particularly those of the West, and again, more specifically America, into settling for less. A primary focus was on world pollution, at a time when America was considered the supreme polluter. For the world to get cleaner, Americans would have to compensate by consuming fewer luxuries and burning less fuel. The old vision of the American Dream, with its sense of unlimited resources, was morphing into, at best, a quaint indulgence and, at worst, an imperialist conceit. Charles A. Reich's *The Greening of America*, though a component of this trend, put less stress on austerity and more on what Reich perceived as a plethora of new possibilities: "Today, we are witnesses to a great moment in history: a turn from the pessimism that has closed in on modern industrial society; the rebirth of a future; the rebirth of people in a sterile land. If that process had to be summed up in a single word, that word would be freedom." Reich was so devoid of irony when making such statements that he seemed destined to provoke a less-sanguine observer like Tobe Hooper into pouring cinematic napalm on the freedom parade.

Four years later, *The Texas Chain Saw Massacre* rearranged Reich's vision of history, implying that the word "freedom" got overshadowed by words like "loneliness" and "terror." The film assaulted the public by reflecting as well as foreshadowing the pangs of a nation (and much of the Western world) bedeviled by specters of gloom, guilt, scarcity, violence, and fears of impending extinction.

"But driving home I was thinking about it," Hooper told Kate and Laura Mulleavy for *Interview* magazine in 2014. "I'd been working on this idea of young people, college students, in isolation. We were going

through a gasoline shortage in the country at the time. People had to queue up in their automobiles at gas stations, sometimes for miles. There was gas rationing. And I was hearing a lot of lies on television. Politically, the times were interesting; they were kind of amplified. So the idea came to me in the car of how to pull all of these elements together. It came really quickly—the whole configuration of the characters—and the loop, the way the story loops inside itself."

Among the many speculations over the years about *Chain Saw*'s meaning, beyond the blood and the shrieking, are the references to the oil and other fuel hardships—major factors in America's early-'70s history.

"Oil-rich regions . . . today erupted into violence," says the radio announcer during *Chain Saw*'s opening. By early 1973, as Hooper and Henkel scripted these words, the energy threats loomed, even though the actual embargo imposed by the OPEC crisis did not occur until October of that year. Then, Saudi oil magnates inflated prices and reduced their production to protest America's support for Israel's struggle against Egypt and Syria during the Yom Kippur War. Facing petroleum prices that quintupled, the U.S. had to make sacrifices.

Starting as early as April of 1968, as Richard Nixon campaigned to tidy up the Johnson Administration's muddle, a group called the Club of Rome formed in Italy, assembling representatives from countries around the world as a "global catalyst" for what they called "The Project on the Predicament of Mankind." The Club of Rome's chief concerns were overpopulation, climate change, decreasing arable land, and the need for, again, "global governance." They envisioned a future of more international interdependency, ideas running counter to those of the more tradition-minded nationalist who would become the president-elect the following November.

To add to the scarcity themes, Dr. Paul Ehrlich published *The Population Bomb* in 1968, warning of a coming Malthusian nightmare

of too many people crowding into a world that seemed smaller than it might have in the past, with the births outnumbering the resources to keep them alive. In his first edition, he offered a prologue that projected human suffering on a grand scale: *"The battle to feed humanity is over. In the 1970s and 1980s, hundreds of millions of people will starve to death in spite of any crash programs embarked upon now."*

Ehrlich's colleagues and disciples started appearing on national television talk shows and even visited high schools to herald the hell on earth that awaited Americans (and others of the Western world) who continued to live in their accustomed manner. The buzz term "zero population growth" spread like a thought virus, giving the impression that limiting two kids to a family would be a moral obligation that the entire world would share. In time, the First-World countries would see their populations decline, while populations in Third-World countries increased—an imbalance resulting, in part, from those in the West being the ones most likely to heed Ehrlich's falling-sky warnings.

To be fair, Ehrlich also had his sights on the developing world, to the point of advocating that Indian males be sterilized (by government decree, of course) after siring three or more children. But Ehrlich, even if unwittingly, facilitated an early '70s trend that placed the burden on America. Despite America's role in leading the Industrial Revolution, many started to believe that Americans were consuming more than their fair share of resources and should, by ethical obligations, cut back. "Atone" might have been a more accurate term in the eco-encyclical, as the accompanying ecology movement developed what was essentially a pious creed, with its faith in a "balance of nature" and ultimately a green goddess called Gaia.

Ehrlich also toyed, but realized he could never follow through, with the notion of spiking public water systems (as well as some foods)

with "temporary sterilants." He proposed taxing families with too many kids, giving financial perks to men agreeing to vasectomies after two children, and even prospects of a gender-selection technology that would secure the birth of a male child for those families who would otherwise continue to conceive until a baby boy arrived. Amid these thoughts of human blobs raiding Mother Nature's pantry, stories still abounded about heating shortages and other days of reckoning.

The Population Bomb concluded with suggestions on how to lean on politicians to enact laws for averting his dismal predictions. Word must have eventually spread to the desk of President Nixon, for this conservative, who usually thought of government interference as the least favorable and the last resort, received some kind of information that altered his state. By December of 1970, Nixon gave birth, via executive order, to the Environmental Protection Agency to regulate matters affecting ecology.

These new one-world utopians did not all think alike. Charles A. Reich looked forward to an age when machines no longer ruled over people, but others appeared to operate under opposite assumptions. One of the Club of Rome's adherents was the computer theorist Jay Forrester, whose specialty in feedback loops and connections between machines and living beings, enticed him to believe that the world, going at its then-present pace, would suffer a catastrophic ecological collapse. His goal, along with the help of other social planners and "system theorists" was to try and save it by reconceiving the planet as one huge cybernetic structure that would, in turn, be easier to regulate.

By 1970, as if scripted by the Lord and the Illuminati combined, the United States showed, for the first time in many years, a decline in production, particularly of real goods and services. Spikes in inflation and unemployment rates in major cities helped to fulfill the Club of Rome's

prophecies. Like vultures, metaphysicians soon circled. In the shadow of these shifts came a revival of old oracles: astrology, sorcery, card divinations, idol worship, and other signs that the Whore of Babylon, from the Book of Revelation, was loose upon the land. "It is a mystic time," Hal Lindsey warns in his 1970 bestseller *The Late Great Planet Earth.* "Famous movie stars and wealthy socialites are traveling to countries of the Far East to consult with 'holy men.' The influence of spiritualism in our popular songs, jewelry, and even clothing is obvious."

Extreme Christians like Lindsey waited for this Whore to arrive, predicting the Great Tribulation, wars, pestilence, the Antichrist, the return of a "savior," and the accompanying Armageddon. Lindsey's writings goaded tensions between Israel and Egypt to invite what he described as the "last act in the great drama which will climax with the finale, Christ's personal return to earth." In this regard, the Club of Rome's title seems to be a sassy joke on apocalyptic prophecies about a second Roman Empire rising again before the Second Coming. Lindsey cites the Book of Daniel and the Book of Revelation to conjure the specter of a "great beast" comprising a "ten-nation confederacy," akin to what was then the European Common Market and precursor to the European Union.

Though Lindsey would seem to regard "global governance" as a sign of the "end times" and a harbinger of the "one-word religion" that he warns against, his book too cites Paul Ehrlich's dire statistics on overpopulation and environmental duress. He was not dependable as a super patriot, either, when claiming that "the U.S. cannot be the leader of the West in the future." For Lindsey, neither globalism nor nationalism mattered, anyway. He cared only that his god's armies arrived on time to deliver the "believers" and trash all the rest.

In the worldly cloisters of finance, the closing months of 1970 challenged old business models. An article in the November 22, 1970 business section of the *New York Times* entitled "Youth Buyers" detailed the problem: *"The 1960s illusion about the rich, recklessly spending, and rapidly multiplying segment of the under-twenty-five population has given way to a fear of a turned-off generation that keeps its money in its faded jeans. In the somber seventies, business attitudes toward youth as a customer and an influence on adult buying runs from re-evaluating concern to confusion and disenchantment."*

The article went on to quote Hugh Edwards, then serving as director for the Research Guild of Chicago: "The big youth bubble has busted. The myth of what the youth market could be—for a while they were saying it was $45-billion—has been kicked to death." Some products did continue to sell, including Levis, do-it-yourself sewing and crochet kits, sex manuals, cheap wines, records, sound equipment, and all of that still-illegal and therefore tax-free ganja. Anxiety accompanied this sense of lost luster. Many white working-class and middle-class youth, for example, grew more fascinated with the occult, the ultra-violence of *A Clockwork Orange*, and with rock warlocks like Ozzy Osbourne and Alice Cooper.

"It isn't his queerness and transvestism—traditional devices of fun— nor his queasy sadomasochism . . . ," rock critic Albert Goldman declared in 1971 in a somewhat favorable review for *Life* magazine. "What gets everybody uptight with Alice Cooper is the sacrifice he makes of shame. Confessing fantasies most people would sooner die than reveal, he becomes a scapegoat for everybody's guilts and repressions. People project him, revile him, ridicule him, and some would doubtless like to kill him. . . . What the young seem to overlook is the fact that all of Alice Cooper's psychodramas turn on death. He

imagines death, enjoys death, looks like death, and courts death at the hands of some enraged motorcycle hoodlum."

However, the so-called "adults" in the room forging public policy, who would cringe at an Alice Cooper show, expressed their fatalism with a stodgier approach. In 1972, the Club of Rome garnered more international recognition when collaborating with an MIT research team to publish *The Limits to Growth*. The title alone suggests that the America fostered on dreams of boundless options was about to endure a season of penance. Bolstered by an "invisible college" of worldwide thinkers, mostly from academia, government, and industry, the study saw the future facing what it called a "world problematique."

The Limits to Growth was two-hundred-plus pages of computer-generated figures, graphs, "exponential growth curves," and statistics interlarded with a message about the world on the brink of calamity unless it adopted new restrictions. To get a sense of its language, the volume stated that the task was "the initiation of new forms of thinking that will lead to a fundamental revision of human behavior and, by implication, of the entire fabric of present-day society." It initially sold around thirty million copies as its message grew more powerful. Though the Club of Rome's founding father was an Italian industrialist and Fiat affiliate named Dr. Aurelio Peccei, the group preached that the mass consumption of oil with its accompanying dream cars was about to be tapped out.

The way-back machine traces this oil and energy problem to 1945, when an ailing President Franklin Delano Roosevelt foresaw a future when American oil independence would end and foreign sources would be vital. Saudi King Abdul Aziz (flanked by slaves and at least one astrologer) made a pact with FDR to sell the U.S. Saudi oil to fuel the American Dream in exchange for military protection and the promise

not to meddle in their Wahhabism. But the consequences of this dark deal would bite back once that supply started to trickle.

These messages about impending paucity and disaster were seeping into numerous Hollywood films of the time. Robert Wise's 1971 adaptation of Michael Crichton's novel *The Andromeda Strain* told of a satellite falling to earth and spreading a devastating virus. In 1973, *Soylent Green* conjured fears of the "greenhouse effect," ravaged natural resources, and overpopulation with its future society that resorts to cannibalism—neatly packaged as a manufactured food supplement. In the same year, *Sssssss* starred Strother Martin as an obsessed herpetologist who, among other quirks, converses with Harry, his boa constrictor. At one point, he tells the snake, "You know, I saw an intriguing article yesterday that at our present rate of consumption, we can expect worldwide fuel shortages in less than fifty years. The world is going to belong to the cold-blooded species. But we already knew that, didn't we, Harry?"

John Waters's 1972 midnight-movie smash *Pink Flamingos* satirized the age of shortages. Though cult audiences flocked to watch Divine perform the gross-out poodle-pudding finale, a more delectable interlude occurs earlier in the film, when Divine (a criminal under the alias Babs Johnson) attempts to show a nurturing side as her playpen-bound, egg-addicted mother (Edith Massey) lapses into an existential crisis. Mother cries out to Babs about fears of a world where chickens disappear. Like an infantile version of a Club of Rome analyst, she speculates about the fate of her trusted "egg man" being out of a job and the end of her dream of consuming "100 eggs a day." "There will always be chickens; you can be sure of that," Babs replies, trying to ease mom's "egg paranoia." Outside the family trailer, however, lurks a cruel reality. Babs's son (Danny Mills) drags his "date" (Cookie Mueller) into a shed,

submits her to rough sex, and climaxes voodoo style by slaughtering a live chicken over her body. To accommodate squeamish viewers, some theaters gave out "Pink Phlegm-ingo Barf Bags."

Back in August of 1971, as Nixon was seduced by the green glare, the term "stagflation" had already entered the popular lexicon: a Lewis Carroll-style hybrid of inflation and stagnation, to account for the simultaneous rise of prices and unemployment. For thirty years before-hand, America experienced relative prosperity and cultural innovation with its "mixed system"—a free market with fetters attached. But Nixon was getting pressure from free-market enthusiasts from the Chicago School of Economics to govern the country by Adam Smith's "invisi-ble hand."

On a Sunday evening that month, Nixon made the Ayn Rand purists cringe when he interrupted an episode of *Bonanza* to stare into the faces of American viewers and impose what some would call the "Nixon Shock": "I am today ordering a freeze on all prices and wages through-out the United States." He intended this to be for ninety days, but the edict, like a bad hamburger, repeated. Nixon reinstated a temporary freeze on prices in June. But despite his good and practical intent, he faced unforeseen consequences—and once again, chickens were among the victims. "Ranchers stopped sending cattle to market," author Daniel Yergin recalls in the 2002 PBS documentary *Commanding Heights: The Battle for the World Economy*, "farmers started drowning their chickens. Instead of controlling inflation, they were creating shortages."

Nixon also put the final kibosh on the gold standard, severing the U.S. dollar's link to gold in matters of international commerce. Since World War II, Europe and Japan maintained and adjusted their cur-rencies to the American dollar; the U.S. controlled most of the world's gold reserves and, therefore, fixed the exchange rate to gold's value. But as America's gold supply and currency dwindled, Nixon claimed to

take these emergency actions against what he called "international speculators."

Nixon's war on prices got him re-elected, but the plan fell through as the economy faltered more. In the face of such dour times, Charles A. Reich, ever the optimist, could have been one of the happier commune dwellers in Tobe Hooper's *Eggshells* and was prepared, like a pickled museum creature, to remain there. "This is the revolution of a new generation," Reich declared in his opening chapter. "Their protest and rebellion, their culture, clothes, music, drugs, ways of thought, and liberated lifestyle are not a passing fad or a form of dissent and refusal, nor are they in any sense irrational. The whole emerging pattern, from ideals to campus demonstrations to beads and bell bottoms to the Woodstock Festival, makes sense and is part of a consistent philosophy."

Woodstock, nevertheless, was already over a year old: ancient history for the turned-on and restless barbarians. Instead, some university students, besides protesting the war and demanding more freedoms, also delved into darker places involving voluntary starvation and even death. In February of 1971, the University of Louisville was the site of one of these morality meltdowns. To experience and demonstrate the condition of what they imagined an overpopulated world would be like in the year 2000, forty-eight students attempted to stage a hunger strike, but some failed to hold out for the entire fifty-four-hour marathon. The twelve students who got too hungry and gave up became examples of those likely to die first in a real-life famine; the others might survive but would remain glum.

In contrast, behaviorist B.F. Skinner dismissed the era's indulgence in "consciousness" and "vibes"—internal states that lacked objective measure. After practicing his brand of psychology for several decades, he became a new kind of iconoclast with his 1971 bestseller *Beyond Freedom and Dignity*. "What we need is a technology of behavior," he

wrote in his introductory chapter. "We could solve our problems quickly enough if we could adjust the world's population as precisely as we adjust the course of a spaceship."

Those basking in the post-'60s orgy of "self-expression" were high on the illusion of "freedom" but oblivious to the positive "reinforcers" that fed them this illusion through peer approval in shared fashions, music, and drugs. In Skinner's world, a better way to understand the counterculture was not by analyzing its idealism but by examining its simple, animalistic appetites.

In an age when psychotherapists dug deeper into a neurotic's past, and when gurus dwelt on inner spirits and "karma," Skinner sought the physical sciences to help solve people's problems: popular fare from the early '70s like *The Exorcist* fooled movie audiences into taking demonic possession seriously, but Skinner rejected any belief in what he called "indwelling agents." He instead recast the old metaphysical concepts of "hell" with dryer expressions like "aversive stimuli."

For Skinner, the world needed to survive by avoiding aversion and seeking positive reinforcement or, as he put it, "operant conditioning." Slot-machine enthusiasts at a casino, for example, are compulsively pulling levers not as masochists (as psychoanalysts might say) or just to catch the buzz (as hedonists might say) but by complying with the reinforcing schedules already built into the gambling devices. The compulsion got more feverish by 1974, when Massachusetts customers clawed into the first State Lottery scratch-off tickets.

Often taking Skinner at face value, humanistic psychologists and sky-gazing theologians alike expressed outrage at his blasphemy against the "human spirit." His call for "schedules of reinforcement" based on "stimulus-response" goaded detractors into accusing him of reducing people to programmed chunks of meat. Oddly enough, and through no

direct fault of Skinner, people tended to get more meat-like as the '70s progressed. Many enjoyed "feeling" autonomous but behaved more like fleshy commodities, making up for the countervailing mood of austerity by overindulging.

Hooper and Henkel portray a Skinnerian notion of hell—a man-made misery. Leatherface and his cannibal family are extreme examples of "operant conditioning." The jollies they get when bludgeoning strangers amid the security of surrounding kin (no matter how dysfunctional), coupled with the joy of cooking and eating human kill, ease the trauma of losing their livelihood. They are much more headstrong than the Hardestys and their hippie-ish friends who begin the search for a gravesite but end up wandering aimlessly, not realizing they will be the goods restocking the freezer.

By the early '70s, the notion that personal and political issues were intertwined gained traction. The loss of oil in world commerce, the loss of blood in war, and the loss of life splattered across newsfeeds in the wake of widely publicized serial murders, were making more and more people feel endangered. This period was also opportune for the Swiss-American psychiatrist Elisabeth Kübler-Ross, who enchanted young searchers with her courses and seminars on death, dying, near-death, and the complicated process of transitioning to the "other side." She advised the living to adhere to her "five stages of grief": denial, anger, bargaining, depression, and acceptance.

Courses in Thanatology, the science of death, allowed healthy specimens of youth to sit inside coffins for a more visceral sense of their mortal future and to contemplate the advantages of a "death with dignity." Though the news reports of Vietnam fatalities were a nightly *memento mori*, many of the rebels, particularly rock aficionados, got closer to death in 1970 while mourning the sudden losses of Janis Joplin

and Jimi Hendrix. Then, Jim Morrison, the rock icon who wanted to be remembered more as a poet, and who obsessed about death like no other, who sang about "bodies confused" and "memories misused," and whose dad was an Admiral during the 1964 Tonkin Gulf Incident that inveigled the U.S. into putting American ground troops in Vietnam, departed in July of 1971 during a supposed rest cure in Paris. Newspaper accounts claimed his death remained a secret for seven days before he got interred in Père Lachaise Cemetery.

As more "experts" extolled the wonders of death and the "near-death experience," they sounded noxious to others still trying to thrive in the secular here and now. Visions of heaven and hell were more blood-curdling when otherwise vigorous individuals got browbeaten into contemplating the humility of the hereafter. Humanists, on the other hand, regardless of their differing views, shared disgust for the super-natural and were, therefore, a bit easier to bear.

B.F. Skinner, psychotherapist Albert Ellis, and author Isaac Asimov were among those who signed the 1973 "Humanist Manifesto II." In places, it seemed agreeable enough: "Promises of immortal salvation or fear of eternal damnation are both illusory and harmful." But it also echoed the Club of Rome's anti-nationalist creed: "We have reached a turning point in human history where the best option is to transcend the limits of national sovereignty and to move toward the building of a world community in which all sectors of the human family can partic-ipate." On the subject of death, the Manifesto II also made the human-ists come across as crêpe hangers in the name of "progress" and "science," as they called for the "recognition of an individual's right to die with dignity, euthanasia, and the right to suicide."

Once in a while, a humanistic voice of clarity walked onto the media landscape. One such force, who stood apart from the more

overly academic "freethinkers," was Madalyn Murray O'Hair, atheist extraordinaire. She went by Madalyn Murray back when she was among those who prompted the 1963 landmark Supreme Court decision: an 8-to-1 vote that banned Bible reading (along with prayers) in public schools. The country was already prepared a year before in June of 1962, when the Supreme Court ruled that a daily school prayer, which the New York Board of Regents forced on its public school students, was unconstitutional. Billy Graham and Strom Thurmond were outraged, but a calmer President Kennedy urged the grieving faithful to continue praying on their own.

After the June 1963 case ruled in her favor, Madalyn Murray became the camera-ready personality behind the decision (although other, more sheepish, plaintiffs were involved). She survived bullying and death threats to herself and her two sons from those she called "Christers," and the more they taunted her, the bolder she got. In April of 1963, *Life* magazine published a letter she wrote to the editor, where she exclaimed, "We find the Bible to be nauseating, historically inaccurate, and replete with the ravings of mad men . . . We find the Lord's Prayer to be that muttered by worms groveling for meager existence in a traumatic, paranoid world."

The *Life* article conferred upon her the title, "The Most Hated Woman in America." She relished the notoriety, gave college lectures, and appeared on talk shows to debunk godly notions of every kind. In 1971, she held her own against a petulant William F. Buckley on *Firing Line*. A favorite guest of Phil Donahue, she once shocked his studio audience of mostly god-fearing, middle-aged women by declaring that there is no afterlife, no ascending to pearly gates for a reward, no cuddling in the arms of a lord or prophet after kicking the bucket. She flatly declared, "People are *dead!*" It was harsh, yet considering the

slobbering succotash of metaphysical speculation clogging up the ether waves, her candid heresy brought tidings of comfort.

Fears of food and fuel shortages continued to play out as extended metaphors for death. In early August of 1973, just as Hooper's cast and crew were in the final throes coping with the rotting blood and flesh on the set and the peeling of the fake and real blood from their clothes and skin, authorities outside Houston were exhuming actual body parts from a real mass murder. Around the same time, hordes of American carnivores, panicky over talk of a beef shortage, swarmed to the south of the border (as well as Canada), where pounds of choice meat were available for a limited-time discount.

On August 13, the *New York Times* posted a front-page alarm: "Thousands Bring in Meat from Canada and Mexico." One couple that waited for hours at Tijuana customs bragged about acquiring "$87 worth of sirloin steaks, filet mignons, ground beef, and veal chops." This hoarding of beef was particularly rampant in Southern California. Also, electricity costs intensified in these areas as sellers of refrigerators and other freezer appliances ran out of stock.

The months following the October OPEC crisis brought a return to the now-legendary days of gas lines and government-sanctioned pleas to start conserving energy, even if that meant putting up fewer Christmas lights as the holiday season approached. By November, Americans were forced to re-examine their fuel-powered pleasures. Congress turned these concerns into legislative sanctions with the Emergency Petroleum Allocation Act. Americans and their leaders started thinking about alternative energy sources like solar and wind. The first Earth Day in 1970 had already set the tone for a rising green contingent.

Considering this backdrop, *The Texas Chain Saw Massacre* is both a reflection of the times and a warning about the future. While in the van

and approaching the service station, Pam reads from her *American Astrology* magazine, its cover including such topical subheadings as "Shocking Results of Food Pollution" and "Common Market: Menace or Blessing?"

Shooting one of the key scenes in the remains of a real American gas station needed no set designer. In many gas-station scenes from movies past, the symbols, signs, and subtexts are hidden in plain sight: maps; soda-pop, candy, and cigarette machines; pay phones; and conspicuous corporate logos—all indicating places where people "on the go" need to absorb just the right amount of goods, propaganda, and gasoline before moving on to the next destination.

This is apparent in *Chain Saw*, when the Hardestys and their friends drive into and out of the dilapidated service spot, and the camera serves as an invisible commentator. The gas station appears during an overcast afternoon, as a mentally challenged window washer sits beside his pail and stares upward at a jaundiced sun glaring through the clouds. According to Gunnar Hansen, the script described him as "a dwarfish, moon-headed man with idiot eyes." The actor was Robert Courtin, a friend of Marilyn Burns, whom Burns described as "sharp as a tack and that's what was devious about him, too. Because he looked one way and was smart enough to shut up." When the camera moves out to establish the window washer sitting beside a Coke machine, the corporate subtext takes over. The Econoline moves into the scene from the right, but the camera makes a turnaround to show the youths exiting the van from the side where the Hitchhiker's blood stamp complements the Gulf sign looming at the extreme left.

Here, the Gulf logo suggests both the Persian Gulf and the Gulf of Mexico. It also entices some historical speculation about the history of gas stations in America and their ties to oil magnates. Festoons of oil shot out from Texas soil by the early twentieth century, but eastern

business sharks—represented by companies like New Jersey's Standard Oil, Pittsburgh's Gulf, and Philadelphia's Sun—ended up controlling much of the gush. Bickering occurs as to which company provided the original service spot, with Standard Oil claiming to have erected the first one in 1907 in Seattle. Others claim the first true "drive-thru," with such amenities as air-filling pumps, materialized in Pittsburgh in December of 1913, run by the Gulf Refining Company.

The "Old Man," hereafter referred to as "the Cook," informs the Hardestys and company that he has no gas until the transporter arrives, but once he discovers they want to visit the old, abandoned Franklin house, he gets leery and encourages them to hang around and enjoy some of his homemade barbecue. Courtin's memorable slouches to and from the van, while splashing soapy water and staring somewhat malevolently into its window, offer moments of funny relief that are rare (despite Hooper's occasional tendency to refer to the film as a horror comedy).

As the Cook, Jim Siedow (the only actor in the troupe with SAG credentials) is a seemingly genial codger with quizzical, squinting eyes and troubled teeth, who would prove to be the movie's most complex character. Siedow and Hooper had worked previously on a film in 1969, a variation on the *Easy Rider-Billy Jack*, biker-rebel story called *The Windsplitter*, directed by J.D. Feigelson. (Other *Chain Saw* names appear in the opening credits, including Kim Henkel as "grip," Sallye Richardson as "assistant director," and Ron Bozman as "key grip.")

In *The Windsplitter*, which got released in 1971, an actor named Bobby Joe (Jim McMullan) returns from a successful Hollywood career to his hometown of Columbus, Texas. He meets with local fanfare and looks forward to crowning the homecoming queen, but his longer hair, regulation suede-fringe jacket, and Peter Fonda-style motorcycle make him an instant pariah among the crustier citizens.

Hooper has a bit part as one of the "Wilson boys," three roughnecks who persecute the biker and bully the rest of the community.

Siedow plays Bobby Joe's uptight dad, looking less disheveled with a white shirt and black tie, gazing askance on his hippie son, telling him he looks like a girl, and pressuring him to leave Columbus to avoid further trouble. In this film as well, Big Oil hangs over the community with shots of Mobil, Phillips 66, Shell, Sinclair, and Texaco signs along the barren, petrol-stained roads. The oil theme has its best moment, however, when an intolerant and self-righteous reverend (Paul Lambert) declares, "Isn't it too bad we can't instill the spirit of god in a man as easily as we put gasoline in a gas tank?"

The service station in *Chain Saw* also includes a Coke machine that is defective. The sight of Sally and Pam struggling to operate it suggests the wanderers cannot find assurance even in the "pause that refreshes." Coca-Cola—a prime symbol of American demand and corporate supply—sold its drink internationally for many years beforehand, but by the early '70s, the company revamped its brand in order to cultivate more global glamour.

The famous jingle "I'd Like to Buy the World a Coke" was composed by England's Roger Cook and Roger Greenaway, but Billy Davis (Coca-Cola's musical director) helped them to Americanize the title. First it was "Mom, True Love, and Apple Pie," but then they collaborated with Bill Backer (Coca-Cola's creative director) for a more universal theme that removed America from center stage. An art director named Harvey Gabor then conjured a visual concept and a storyboard: "The First United Chorus of the World."

This led to the historic ad, premiering in July of 1971, featuring five hundred or more people singing on a hillside (located in Rome, of course) about buying the world a Coke and living "in perfect harmony." But the "redneck" Cook and the working-to-middle-class "kids" who

cross his path might not be welcome to stand on Coca-Cola's Elysian hillside. They appear to be outcasts from this global workaday world fraught with trucks that either forget them at the filling station or literally push them off to the side of the road in the race to greater international commerce.

For others, some of the dour socioeconomic news hit other cultural soft spots. As early as 1969, journalist Pete Hamill wrote in a *New York* magazine article about the white working class (in places like South Brooklyn and East Flatbush) feeling alienated and the establishment's failure to address their concerns. He, in fact, ridicules the scoffing elites: "The White Lower Middle Class? Say that magic phrase at a cocktail party on the Upper East Side of Manhattan and monstrous images arise from the American demonology. Here comes the murderous rabble: fat, well-fed, bigoted, ignorant, an army of beer-soaked Irishmen, violence-loving Italians, hate-filled Poles."

Impressed by the article, President Nixon scribbled a note asking his cabinet about a solution to the problems Hamill posed. Within a year, Jerome M. Rosow, an Assistant Secretary from the Department of Labor, issued "The Problem of the Blue-Collar Worker." The report acknowledged how these workers tended to regard themselves as "forgotten people" but stopped short of limiting them to a particular racial niche. "Economic insecurity," the report states, "is compounded by the fact that blue-collar workers are often the first to feel the effects of an increase in unemployment, feel most threatened by automation, and are also more dependent on sheer physical health for their livelihood than white-collar workers."

The Cook, a "redneck" caricature, is predictably wary of automation, but he comes across initially as a protective elder of sorts, even if he fails to sway Sally and her clan from driving to their doom at

Grandpa Franklin's old place. Giving up on the idea of waiting for the tankard, they prepare to leave the station. Sally is the first to notice the cryptic blood sign that the Hitchhiker had scrawled, warning the rest about what it might mean as she re-enters the van. The window washer sits in the foreground, still gazing through the clouds. On limited fuel but bound for the old Franklin place, the Econoline drives away as the camera establishes their exit in long shot. A slow pan leftward exposes the grim composition: the departing youths, the towering Gulf sign, the empty gasoline tanks, and a habitat left to rot in rusty oblivion. All of this represents both the abandoned yokels and the throwaway idealists of an old and hollowed-out world. The sun-shaped Gulf sign signals a new order eclipsing these human relics.

Whether the film's creators intended it or not, another subtext simmers in *The Texas Chain Saw Massacre*: the Hardestys and their three friends represent young whites who, while comprising a hefty percentage of America's population, felt increasingly alienated, due to the corrosive impact of the early '70s on the '60s pipe dreams. Open-air rock festivals like Woodstock celebrated brotherly and sisterly love, but soon cadres of academics, activists, and legislators likely flinched at photos and footage of the peace-and-love revelries for a more dubious reason: the humongous sea of white faces exposed a demographic reality they sought to alter.

"The white race *is* the cancer of human history," Susan Sontag hissed in a 1967 issue of *Partisan Review*. By the early '70s, her words trickled down from the ivory-tower and seeped (sometimes unconsciously) into the minds of many average American high school and college students, addled and rightfully defensive when told their country "was founded on genocide." Working-class and lower-to-middle-class whites were likely among the most rattled. They became the new left-behinds of the

New Left, sporting long hair down to their slumping shoulders, seeming bereft of their so-called "privilege," assuaging their frustrations by clinging (sometimes bitterly) to their bongs or bottles of Boone's Farm, head-banging to heavy metal, or roaring vicariously as Alice Cooper placed his head in a guillotine.

The Cook's dilapidated gas station/barbecue shack is the opposite of the sparkling, clean, Christmastime Esso station depicted in Jacques Demy's 1964 French-German musical *The Umbrellas of Cherbourg*. Though inspired by American musicals, the film appears at times to be a smug European lampoon about an era when the U.S. exported its culture and logos with swagger. This ideal gas station seems like a Disney confection compared to the peeling "realism" that Hooper depicts a decade later.

In later interviews, Hooper elaborated on his Montgomery Ward anecdote with the equally frustrating experience of waiting in the gas lines that already started by the summer of 1973. News reports throughout that year echoed these concerns about America's limits. The most absurd example occurred in December, when Harold V. Froehlich, a Republican congressman from Wisconsin, issued a press release about possible toilet-paper shortages.

Johnny Carson used the subject in one of his *Tonight Show* monologues in December of 1973, and the next day, gullible viewers scrambled across the country to stockpile their rolls. After getting deluged with complaints that stores had to either ration or endure weeks of empty toilet-tissue shelves, Carson publicly apologized. A month later, Nixon rang in the New Year with more austerity measures by signing the Emergency Highway Energy Conservation Act that imposed a national speed limit of 55 mph. In addition, Detroit's Big Three carmakers faced competition from smaller, more fuel-saving foreign

models—one of many signals that America's auto industry faced stages of decline.

Earlier, when Kirk and Pam run off to go swimming but instead rush over to the danger house to negotiate for some gas, the red generator rumbling outside is both a lure and a symbol of the Leatherface family's desperate attempts to stay self-sufficient. The abandoned or captured autos under camouflage netting are also an apt wartime analogy. A fuel shortage in a state noted for its oil magnates and its "Texas tea" is the movie's signal that the United States had entered a geopolitical boondoggle. This angle also makes the Leatherface clan perversely sympathetic: defiant isolationists, whose outdated slaughterhouse sledge is ironically the greener alternative. Leatherface's gas-fueled weapon becomes a revenge tool, exploiting the kind of technology that allowed the airgun to decimate his family's business.

When the Cook reappears later in the film, he still seems to be a grungy but kindly father figure, coddling Sally when she runs from Leatherface and into the gas station's adjacent barbecue room. He assures her that all will be fine and instructs her to sit still while he gets the truck to take her to the closest town. However, the contents on the nearby shelf, meticulously aligned with the labels visible, are like prototypes for an Andy Warhol silkscreen but hint at the Cook's ulterior motive: cans of Campbell's tomato soup and various condiments (on the top) to make the barbecue sauce and plastic bottles of Clorox bleach (on the bottom) to cover the blood evidence.

Traumatized, she waits, sweats, shakes, and essentially acts out the energy crisis in human pantomime. Hooper kept the camera on Burns for a longer time than she had anticipated, making her performance in these moments all the more riveting. Here, he forces her to drain every drop of perspiration and grief from her face and body. As counterpoint,

the radio emits the final strains of a regional country song before reporting weather updates of a ninety-eight percent humidity and more reports of Sheriff Jesus Maldonado and his search through the Muerto County cemetery: "opening crypts and mausoleums where there was evidence of tampering . . . a dozen reported coffins robbed of all or part of their contents . . . instances in which only the heads and extremities were removed, and others in which only a hand or foot were removed, with the remainder of the cadaver left intact." In a darkly funny non-sequitur, he then announces that "the ladies of the Muerto County Historical Society will hold a bake sale tomorrow . . ."

Soon, Sally notices the mystery meat dangling from the barbecue pit and the rumble of the Cook's truck approaching. The Cook returns with a new monster personality as he forces her into a burlap sack and smacks her with a broom when she resists.

In the scene that follows, the visual maneuvers to and from the truck's interior make Sally's shanghaiing all the more unsettling. The camera disorients viewers as it vacillates, moving slowly toward the truck's open window when the Cook drags Sally in, then retreating when he shuts the door to take the driver's seat but realizes he needs to return to the shop. When he gets back to the truck, the camera slyly moves in again, closer and closer as he retakes the steering wheel to mouth his infamous line: "Had to lock up and get the lights. The cost of electricity is enough to drive a man out of business." At that instant, the energy crisis and its many social ills are inescapable. Oil had been America's lifeblood, its conversion to energy via steam and turbine power somewhat akin to pulmonary circulation and the digestive system. Now, it was being slashed and drained.

In January of 1974, on the same show that he delivered his "cost of dying" monologue, Johnny Carson continued to mock the era of what George Orwell might have called *shortage-speak.* Counterpointed by

Ed McMahon's calibrated chuckles, Carson read a list of snarky suggestions for beating the January blahs. One of them brought down the house: "Invite an oil company executive to your home, and when he asks for a drink, take him out to your car and siphon four gallons of gas down his throat."

As *The Texas Chain Saw Massacre* prepared to become a movie "classic," the Trilateral Commission fueled on. Its members of elite public-policy wonks from North America, Western Europe, and Japan claimed to be just an educated discussion group. Still, few average Americans knew about it, and many who did know tended to lump it into the miscellany of secret societies and other conspiracy theories.

By 1973, many of Alice Cooper's songs became the unwitting soundtracks to another cruel coincidence. The finale of the group's 1973 tour was "I Love the Dead." As Tobe Hooper's principal filming grinded away during that hot summer, and the Candy Man Murders in Texas became international news by August, the band was still performing the song. Millions of stereo turntables were spinning this homage to necrophilia: the touch of "bluing flesh" and the lure of "cadaver eyes."

CHAPTER SIX

"GRISLY WORK"

"... a vaporous cauldron where tempers are short and murder rates are high."

—JACK OLSEN'S DESCRIPTION OF HOUSTON,

FROM *THE MAN WITH THE CANDY*

On August 7, 1973, several perplexed CB radio operators picked up a little boy's hysterical plea. The voice seemed to issue from somewhere in the Red Rock Canyon area of New Mexico, but another CB operator from all the way over in California reported hearing the same boy. The boy called himself Larry, and he claimed to have been speaking from the inside of an upturned pickup truck and that his dad, who lay beside him, might be dead from a heart attack.

Soon other CB operators reported hearing Larry transmitting from coast to coast, with even Canadians picking up the panicky cries. Operators gathered that he was seven years old and had been on a rabbit-hunting trip with his dad when they got into a road accident. Then, Larry's story started changing: his father, instead of dying, was knocked unconscious due to a bump on the head. Some heard Larry claim that he was calling from outside rather than inside the truck. Others heard him call himself "David," not Larry.

Despite the inconsistencies, and the fact that no one could get Larry's last name, a helicopter rescue team flew over the Manzano Mountains for signs of Larry, the truck, and the questionably dead dad. A ham radio operator in Albuquerque reported that Larry told him of seeing search lights from an airplane that was trying to locate him. For several days, Larry's voice continued to vex those trying to answer this humanitarian call.

While Larry cried from a wilderness in the radio ether, the sweltering August had an even more perplexing effect on Houston the day after the boy screamed out for help. On August 8, authorities discovered the results of a ritual carnage that transpired for years as many boys and young men screamed out, but any outsiders who might have helped could not hear them.

According to Gunnar Hansen, news of what became the Candy Man Murders, or the Houston Mass Murders, hit the front pages around the country and the world at just about the time when Teri McMinn, as the beleaguered Pam, dangled from a makeshift meat hook and screamed in the middle of nowhere—a scene so excruciating that it later became the choice moment when squeamish *Chain Saw* viewers fled theaters.

John Larroquette's opening voiceover telling of the terrible, impending events, adds a "true crime" angle. Larroquette intones "Chain Saw" in a deliberate manner to show how each word (usually regarded as one) needed separate accents for extra dramatic effect. Hooper, however, claimed the introduction was a parody of the alarming news reports he kept hearing that he perceived as televised lies. But the date of August 18, 1973 that flashes on the screen, though officially fiction, would get tangled up in the dog days as police found the Candy Man killers and dug in various places for the bodies. On a happier note, August 18th was also Teri McMinn's birthday.

The nightmare started about three years before, when in September of 1970, a University of Texas student hitchhiked from Austin and was bound for Houston. He got into the wrong car and vanished. The following December, two friends, one fourteen and the other fifteen, attended an anti-drug seminar at a Houston Evangelical church. During the service, they sauntered up the aisle and left the premises, as if possessed, and never returned home. The parents scoured the streets of Houston, posting flyers with pictures of their sons and even a newspaper ad promising one of the boys a motorcycle if he just came home. The other boy's father got a tip and drove all the way to Monterrey, Mexico but got nowhere.

The police responded to the disappearances with a similar dismissal they gave to the other missing youths: they were just two more sufferers from runaway-hippie wanderlust. This was the early '70s, when the rebellious messages of the late '60s devolved into tragedies when so many working-class and middle-class youths attempted to live out the Woodstock dream and ran into snags. This is when communes became second homes for many guys who wanted to keep their hair long or could not tolerate their bossy parents.

Patterns multiplied in January of 1971, when two brothers, one fifteen and the other thirteen, were headed toward the local bowling alley but appeared in their community for the last time. The father submitted missing-persons reports and, as he later told the *Houston Chronicle,* "camped on that police department door for eight months. I was there about as much as the chief was. But all they said was 'Why are you here? You know your boys are runaways.'"

In March, a fifteen-year-old rode on his bicycle to his gas station job. When the fatal car drove up, he apparently knew the drivers well enough to agree to toss his bike in the back for a final ride. In May,

a young man said goodbye to his mom to join his pal for some swimming. His pal's mom received a call from her son that evening, telling her he knew she would be worried and that he was sixty miles away at a swimming spot near the Gulf of Mexico in the town of Freeport. Besides being alarmed that he had wandered so far away, she was also perturbed that he had to whisper to someone near his phone to ascertain exactly where he was. The other boy failed to return, so his mother contacted the police, who did little to help, leaving her with the impression that he too was likely among the fugitive rebels.

The spree continued into 1972, when in April, a blue-eyed and dimpled seventeen-year-old made a final exit from his front door. His parents and younger brother sought clues from his classmates and pals, drove through the neighborhood to search streets and alleys, phoned the local hospital, and finally went to the police. They eventually got a letter from him, informing them that he got a job in Austin for what was then a generous hourly rate of $3.00. But the family remained suspicious, for he had left his cherished Honda C70 motorcycle behind.

All of the missing boys were still lost by May of 1972. That month, two more friends disappeared after telling their parents that they were simply going out to get a Coke. The parents tried in vain to see if neighbors, friends, or casual acquaintances saw any sign of them. One of the families got a letter from their son three days later, apologizing for his departure and informing them that he got a trucking job and would return in about a month. Little did the parents of one of the boys know that years ago they had already met the person or persons responsible for abducting him. They had encountered the chief kidnapper when their son was just eleven years old, and he ran home one day excited about a man up the street giving away free candy.

One of the boys missing on that May day had a younger brother, on whom the family counted to fill the void. But roughly a year after his older brother disappeared, he too vanished after his mother gave him money to get a haircut. He ran away from home several times before, but this time his parents could not understand why he left his best belongings behind. The police were again not sufficiently responsive, considering the whereabouts of a boy who had cried wolf before. His dad went on a search, checked the Coast Guard to see if he might have taken another summer job at shrimping, and contacted Social Security to see if his son had cashed his regular account checks.

The vanishings continued when, on Monday of June 4, 1973, a fifteen-year-old asked his dad to drive him to the corner. That evening, he phoned his dad, pleading for permission to go fishing at a place called Lake Sam Rayburn. Reluctantly, the father said yes, even though the boy said he would not be back home for about two or three days. On Saturday, June 9, with his son still gone, the dad, who worked at the *Houston Post*'s mailroom, got another of those hollow letters, mentioning an Austin job offer and promising a safe return. The letter closed with, "Daddy, I hope you know I love you. Your son, Billy."

These continual disappearances seemed like some version of the "Rapture," that religious scare tactic that has some believing in the "end times," when certain favored souls get swept up from their earthly existence into heaven, leaving all of their loved ones behind to languish in hell. The real story, at least the "heaven" part, would prove to be the opposite.

By the early morning of Wednesday, August 8, the fragmented puzzle that tormented parents, friends, and at least some of the authorities, started coming together. Television stations interrupted normal programming to begin relating the tortuous narrative involving what the

New York Times would call "the largest multiple murder case in United States history."

The central figure was a thirty-three-year-old named Dean Arnold Corll. In the beginning, he enjoyed hosting hedonistic parties at his home in the Houston suburb of Pasadena that included lots of free candy, booze, drugs, shooting pool, and sessions that involved inhaling acrylic paint fumes (or "bagging"). As reports of missing boys and young men multiplied, most of the victims were from the Heights, a neighborhood in Northwest Houston where Corll once lived as a boy when he helped his mother operate the Corll Candy Company.

Corll's neighbors found him to be a likable and helpful fellow; his relatively good looks, broad shoulders, strong build, and dense mane of black hair made him handsomer as he got older. He became an electrician at the Houston Lighting and Power Company and appeared to be leading the life that his surroundings considered "normal." Love for his mom (who had married several times) was so strong that he finagled an honorary hardship discharge from serving in the military (where he was stationed at Ft. Hood) just so he could care for her.

Continuing to seek the company of younger men, Corll offered them rides in his van and more pecan chewies, pralines, and other assorted caramel delights without any outward sexual overtures. But by the early '70s, the Heights became another of those once-fine communities that deteriorated and developed a seamy reputation. The place was also the site of several of those routine runaways: kids alienated from their parents and the economically depressed environment. The situation made the police jaded about pursuing missing-kids reports: so many seemed to be following a variation on Timothy Leary's dictum to turn on, tune in, and finally drop out of sight.

When moving from the Heights to Pasadena, Corll endeared himself to youths like the eighteen-year-old David Owen Brooks, a rather retiring and fey figure who wore wire-rimmed glasses. By 1971, Corll also found a fan in Brooks's pal Elmer Wayne Henley, Jr., a seventeen-year-old acne-plagued, high school dropout with disheveled hair, but with lots of aggression and a reputation for smoking weed and getting fresh with the local girls. Once the three joined forces, boys started vanishing at a regular rate, often seduced by promises of a good party as they entered Corll's Plymouth GTX or sometimes a white Ford Econoline van.

The game changed, however, on the evening of August 7, 1973. Henley joined Corll, along with two others: a nineteen-year-old misbegotten party animal named Timothy Cordell Kerley and a fifteen-year old named Rhonda Williams, who had ironically sought refuge at Corll's place after her drunken father beat her up. Williams had a previous boyfriend, whom Corll had raped and strangled over a year beforehand after tricking him into submitting to a "handcuff game." Corll, without even realizing any connection to Williams's former boyfriend, got enraged when Henley brought a girl along, and this is when the real tensions flared. Henley managed to sweet-talk Corll into tolerating her presence, and they all commenced with another of Corll's Pasadena bashes that involved the usual escapist thrills.

Then, Henley woke up early the next morning, handcuffed by the wrists, mouth taped shut, ankles tied, and lying on his stomach. Kerley and Williams were also bound and gagged beside him. Like a horror movie ogre, Corll stood over them, vowing to kill them all with his knife and gun, but Henley (freeing his lips from the tape) was successful at plying his sweet talk one more time, convincing Corll to free him so that he could help him immolate the other two. Strapping Kerley and

Williams to both sides of a plywood torture board that Corll had used numerous times, Corll believed he would brutalize Kerley and leave Henley to do the same to Williams.

Suddenly, Henley grew a conscience. Holding a .22 caliber pistol to Corll, he shot him six times. He then called the Pasadena police, who were at last shaken from their doldrums. The police now faced the culmination of three years fraught with reports of what they had previously written off as the misdeeds of alienated punks. When they arrived at 2020 Lamar Drive—Corll's house of horrors—they found Henley, Kerley, and Williams, waiting outside.

Henley advised the cops to go inside to see the corpse of the man he had just killed. They found Corll naked in the hallway, lying facedown with six bullet holes in his back and shoulder, his feet bound with a phone cord. Inside the bedroom lay the plywood body board, a plastic sheet covering the floor, various types of sexual paraphernalia, and a supply of petroleum jelly. There were also several sets of handcuffs, pieces of rope, and binding tape. Moving into the garage, police found what looked like a casket, along with traces of quicklime.

Once taken into custody, Henley laid out for the police a narrative of how he and Brooks helped Corll conduct his sadistic, three-year "white slavery ring." Henley and Brooks would act as the procurers for their master's erotic twinges, with the incentive of getting $200 for each person. At one point, Corll had the two boys believing he was obtaining fresh performers for a California gay-porn ring.

When Henley and Brooks took their quarry to one of Corll's several rented places, Corll would get the newcomers drunk until they passed out; then, he would bind, molest, and murder them. In the April 2001 issue of *Texas Monthly*, journalist Skip Hollandsworth wrote of Corll "pulling out the boys' pubic hair, inserting a thin glass rod into their penis, or sticking a large rubber dildo into their rectum."

Not yet revealing his complicity, Henley spoke to police of a warehouse full of dead bodies and started giving out the names. He then led them to a metal boat-storage shed in South Houston, where several of the bodies were buried. Moments after police, detectives, and trusties from the nearby jail started digging, the stench of rotting tissue was everywhere. They disinterred several cadavers: severed parts half decayed, some coated in lime, sometimes with genitals in separate plastic bags.

Jack Olsen, in his book *The Man with the Candy*, designated the Corll death scenes as "the wholesale transfiguration of rollicking boys into reeking sacks of carrion." The death tally came to at least twenty-seven—strangled, tortured, raped, and often eradicated by Corll's trusty .22-caliber. Corll would sometimes force his victims to telephone or send hasty letters to their parents, cryptically indicating why they were gone, often with excuses of finding out-of-town work. Eleven of the victims had attended the same junior high school.

Brooks also provided another side to Henley's narrative. He admitted to helping Henley acquire the boys, but that Henley was Corll's sole homicidal helper. But Brooks, who had introduced Henley to Corll in the first place, was far from innocent. Police were baffled to see both youths rattle off like clockwork the names of the victims and the times of the tortures, as well as the places where the bodies were buried.

Henley and Brooks agreed to let all of the secrets into the light of day, and detectives discovered that the boatshed had hid nine more bodies. Some of those bodies started acquiring identities from dental x-rays and other personal possessions. Parents of other missing kids started phoning authorities, horrified to know of any news linked to the discoveries.

In the meantime, homicide detectives got more ambitious. They started gathering files on a staggering number of missing boys, fifty of

whom were from the Heights. So, they dug on, and more body parts turned up wherever the shovels ventured. They found eight more by midnight. At one point in his book, Jack Olsen summarizes the experience of those burdened with the task: "With three men now digging, they soon uncovered the naked body of a blond boy, twelve or thirteen years old, encased in plastic and lying on his back. Loops of masking tape pinched tightly into the covering of the neck, waist, and ankles. The body looked as though it had been in the ground about a week."

The police unearthed additional bodies at the Sam Rayburn Reservoir. Another turned up in Jefferson County, and six more got excavated on a beach at High Island on the Bolivar Peninsula. Deke Slayton, a Mercury astronaut still at NASA, got a helicopter to patrol the beach with an infrared detector. It was at High Island where they discovered the remains of the University of Texas hitchhiker who, in September of 1970, tried thumbing from Austin to Houston; authorities deemed him as one of Corll's very first victims, raising the body count.

As Hollandsworth summarized in his *Texas Monthly* piece, "Some of the bodies were covered with a layer of lime powder and shrouded in clear plastic, their faces looking up at the men uncovering them. Others were nothing more than lumps of putrefied flesh. A few still had tape strapped across their mouths; others had nylon rope wrapped around their necks or bullet holes in their heads. One boy was curled up in a fetal position."

By September, authorities concluded their search, suspecting however that more bodies might still be underground. In 1974, Brooks was convicted of murder after pleading guilty of killing at least one of the young men and got one ninety-nine-year term, while the more

media-mad trial of Henley (despite an appeal) rendered six consecutive ninety-nine-year terms. Not until 1994 did yet another victim surface, thanks to the work of a forensic artist who did drawings from a skull to extract the likeness of a seventeen-year-old who had disappeared in April of 1972.

For the rest of 1973, however, the slaughter had an aftermath that rattled different institutions and media. The Candy Man Murders became Houston's "crime of the century." The tally of the dead made it America's worst case of serial murder, exceeding the twenty-five killings that were discovered in a California peach orchard and attributed to Juan Corona in 1971. Decades later, Sharon Derrick at the Harris County Institute of Forensic Sciences did some DNA tests to discover another fatality.

The Houston and Pasadena areas incurred a media circus. Reporters, journalists, and politicians shared their scripted perspectives. Truman Capote arrived at the scene, hoping to pen another murder epic. Oddly, as soon as the diggers surpassed the serial murder record, the sheriff of Chambers County, who oversaw the search, ordered it to end, leaving many wondering how many more bodies could have turned up and whether or not the sheriff succumbed to pressure from higher authorities to prevent Texas from an even fouler place in the nation's infamous-murder archives.

Some local politicians got defensive. Hollandsworth, in his 2011 *Texas Monthly* article writes, "police chief, Herman Short, held a press conference in which he suggested that the boys were mere runaways whose parents didn't do their best to look after them. He angrily declared that reports of 'links' among the victims and the killers were a myth 'created by the media.'" The mayor agreed that "the police can't be expected to know where a child is if his parents don't."

Forces as diverse as the Vatican and the Soviet Union converged to vent their spleen on what the Corll murders symbolized. For the Vatican, in its daily paper *L'Osservatore Romano*, the Houston hell was the "devil's domain." This compelled many to believe that the murders were signs of the same Satan whom audiences would soon see possess little Regan in *The Exorcist*, the blockbuster slated to invade American theaters on the day after Christmas. (They would have found more damnation when, decades later, patrons of the arts were willing to purchase some of Elmer Wayne Henley, Jr.'s prison paintings.) The Soviets, via their government-sanctioned *Izvestia* paper, blamed the drawn-out ritual on American laws, or what they termed as a "murderous bureaucracy."

More politicians took notice, specifically about the problem of America's teenage runaways. One was Texas Governor Dolph Briscoe, who pleaded with them to contact their parents to assure that all was okay. Another was Walter Mondale, still a relatively fresh Minnesota senator when he requested that Congress earmark a three-year dispensation of $30 million to set up halfway houses for disillusioned youth.

The Candy Man Murders also threatened to sully a then-new political movement in America. The summertime gay pride parades that got larger each year since the late '60s got a scant amount of media exposure compared to the Corll murders, which stressed the killer's sexual predilections and threatened to implicate the homosexual world at large. At the same time, the Houston area was under a kind of lockdown. Minors were subject to curfews that kept them safe at home after dark, while some police conducted raids on gay bars.

Some gay activists took umbrage with the way several media sources focused on the killer's choice of victim, despite the spate of

"conventional" serial murders when men target women. Notwith-standing this added pressure on a group already demonized, the American Psychiatric Association finally eliminated homosexuality as a "mental illness" from its Diagnostic and Statistical Manual by the end of 1973. Still, psycho killers of every sexual persuasion rampaged as the '70s progressed.

As the moon displayed its phases and the solar flares mutated, Alice Cooper focused less on complex psychology and more on simpler mass-market horror and Grand Guignol gags execution by hanging and later by beheading. Alice might have offered the caveat that the song "Dead Babies" was really a cautionary tale about parents abandoning their children, but thousands of fans likely cared little to nothing about such nuances as Alice grabbed an axe to chop up baby dolls, sending audiences into cathartic rapture.

Alice Cooper's "dead babies" theme also resonated across the seas when, on December 12, 1972, Marie-Hélène de Rothschild, the French socialite and offshoot of the powerful banking dynasty, wore a Baphomet-style, horned mask as she greeted guests at her Surrealist Ball. This ornate meeting of elites occurred at the Château de Ferrières, a Rothschild-owned mansion outside of Paris, with a building facade lit up for the occasion in hell-fire glow. Evoking *Alice in Wonderland*, the backwards writing on the invitations required mirrors for deciphering.

The guests included Salvador Dali, who in April of 1973 (just days before the death of Picasso), announced at New York's St. Moritz Hotel his newest masterpiece. He called it his "First Cylindric Chromo-Hologram Portrait of Alice Cooper's Brain": a rotating display of Alice wearing $4 million worth of diamonds and holding a miniature Venus de Milo. Complementing Alice was a sculpture consisting of a plaster

brain, a chocolate éclair, and ants. Also on the Rothschild guest menu was the "ethereal" Audrey Hepburn who, in contrast to the glitzy "grace" she assumed in such Hollywood confections as *Sabrina* and *Breakfast at Tiffany's*, posed for photographers with a birdcage over her head. These guests, an international mélange of fame and wealth, sauntered through a maze before entering the ballroom, where they feasted at a table adorned with mutilated dolls, smashed skulls, and cadaver mannequins.

By 1973, the Cooper band became the unwitting stagecraft for another cruel coincidence when their album *Billion Dollar Babies*, the group's best-selling record up until then, could have almost functioned as a Candy Man Murders soundtrack. The final number, which also closed the group's 1973 tour, was "I Love the Dead." As Tobe Hooper's principal filming grinded away during the hot summer, and the Candy Man Murders became international news by August, the band was still performing the song, while millions of stereo turntables also spun this homage to necrophilia: the touch of "bluing flesh" and the lure of "cadaver eyes."

However, it was amid the season of unheard cries and piling bodies that Hooper and Henkel got trapped in an inter-zone between their make-believe movie massacre and the actual events. Hooper and Henkel might have been retelling a variation on the story of Hansel and Gretel, but Dean Corll enacted a more nightmarish subplot from Walt Disney's *Pinocchio*, when Pleasure Island's "happy land of carefree boys" becomes a death trap.

Much of *Chain Saw*'s power comes from the efforts Hooper and company made in the weeks following the official shoot. The post-production editing and rethinking allowed the Candy Man Murders to sink in. The film was originally to start with the solar flares dissolving

into the dead animal in the road, but Hooper shot the more morbid cemetery and body-digging for the movie's opening during post-production.

On an audio commentary for a DVD release from Dark Sky Films, Hooper claims that he intended the shots as "a piece of the puzzle that you are about to assimilate and to kind of freak you out a little bit and give you some disturbing, foreboding clues as to what you are about to see." Even so, the flesh-and-bone camera flashes share an uncanny likeness to the descriptions of Corll's victims and their exhumed remains.

Warren Skaaren, who takes credit for the movie's sensational title, was responsible for creating the one-cadaver-mounted-on-the-other sculpture that fills the screen after the opening flashbulb shots of the bones and other body parts—accompanied by that unforgettable soundtrack of metallic screeches. Skaaren's cadaver, accented by Ron Perryman's chilling crane shot, remains one of the movie's most disorienting images, more so when paired with the eerie radio announcer's news of the Texas grave robbers and the "grisly work of art" consisting of "the remains of a badly decomposed body wired to a large monument" discovered in a rural Texas cemetery.

In an in-depth interview for the 2004 *Texas Monthly* article "They Came, They Sawed," Kim Henkel alluded to the impact of the Corll crime, which did not reach the public knowledge until August but seem to have inspired the re-shoots. As Henkel recalled, "I saw some news report where Elmer Wayne Henley, Jr. was identifying bodies and their locations, and he was this skinny little ol' seventeen-year-old, and he kind of puffed out his chest and said, 'I did these crimes, and I'm gonna stand up and take it like a man.' Well, that struck me as interesting, that he had this conventional morality at that point. He wanted it known

that, now that he was caught, he would do the right thing. So this kind of moral schizophrenia is something I tried to build into the characters."

Henkel must have also been fascinated by the 10:00 local news broadcast that evening on August 8, when a television crew allowed Henley to use their radio phone: "Mama! Mama! I killed Dean!" He seemed to be such a charmer that a female police reporter described him as "a kind of folk hero who had slain the dragon." The following day, they questioned Henley more, only to realize why he could spout off the names of all of the other victims: he was in on the abductions, the rapes, and the killings.

The Texas Chain Saw Massacre ended its production phase in the torrid Texas summer, while Hooper, Henkel, the cast, and the crew felt drained and near death. Some were wary about what they had done, and some even doubted their artistic efforts, anticipating an unsuccessful movie while the world around them experienced so many real-life spasms. President Nixon was getting closer to impeachment, more serial murders grabbed the headlines, and several cast members were too caked up in fake blood and the stench of rotting meat to realize they were in the process of making movie history.

As the days passed, and the *Chain Saw* crew finished up while the Houston authorities uncovered more atrocities, little Larry's CB signal grew weaker. Practical jokers began mimicking his voice over the airwaves, adding to the chaos. After about 150 people joined in the hunt on the ground, and over 30 aircraft (both military and civilian) failed to track him, most stopped searching or even trying to speak to the phantom child. A UPI article from Albuquerque quoted State Police Chief Martin Virgil: "We have not come up with any information to say that there actually is someone out there and where this person might be."

By August 12, no one on the search could find any sign of an over-turned pickup truck, a dead dad, or a missing boy. Larry's signal finally disappeared for good, and authorities felt more comfortable, yet not fully certain, with the belief that the CB broadcasts were a hoax.

Tangled in a time loop, the fictional date of August 18, 1973, that flashes at the film's opening haunts the *Chain Saw* legacy—too close to the true story.

Sally and Franklin Hardesty are a milder version of the dysfunctional Leatherface family. One of the film's more terrifying moments occurs when night arrives, and their friends do not return. Brother and sister fight. Sally wants to venture out into the woods, so concerned that her boyfriend Jerry is missing, but Franklin, burdened by his wheelchair, wants to remain where they are, hoping that their friends will return. He also keeps a grip on the flashlight; it is his only emblem of control while Sally gets more petulant as she tries yanking it from him. They scream at each other, a tension more effective because the two actors—Marilyn Burns and Paul Partain—did not get along on the set.

CHAPTER SEVEN

"A WHOLE FAMILY OF DRACULAS"

"His body was a sort of mausoleum, a haunted graveyard in which the ghosts of several generations still walked, while their physical remains rotted away. This family had buried their dead in each other."

—R.D. LAING, THE POLITICS OF
THE FAMILY AND OTHER ESSAYS

In the beginning, they were the Slaughters. Unlike with the 1986 Hooper sequel, which called them the Sawyers, or later productions, which identified them as the Hewitts, Hooper and Henkel meant their 1974 film to include sledgehammer-subtlety wordplay on the family's identity and livelihood. As Gunnar Hansen recalls in *Chain Saw Confidential*, "Bob [Burns] made the [W.E. Slaughter] sign. He said that Tobe and Kim were 'mighty proud' of coming up with 'we slaughter.' Unfortunately, no one seeing the movie notices it."

The Texas Chain Saw Massacre is literally a family film, albeit a shattered one. The Slaughters share a home, albeit with no conventional parents; eat dinner together, albeit a cannibal feast; and also seem to share some kind of spiritual bond, albeit fraught with voodoo symbols and putrid effigies. Those rock-faced critics who had scorned it for having

"no socially redeeming value" apparently were obtuse about the film's message regarding family politics, and how "home sweet home" can also be the place where the more abled wield power over the less abled.

There were previous movies that prepared viewers for the link between family dysfunction and horror along with the ripped flesh and the walking dead. Audiences were still recovering from George Romero's 1968 *Night of the Living Dead*, which incited Roger Ebert to spout moral outrage to the *Chicago Sun-Times* and get it reprinted in the June 1969 *Reader's Digest*. Ebert was such a killjoy that he declared, "I would be ashamed to argue for the 'right' of those little girls and boys to see that film."

Though a 1966 Hammer film called *Plague of the Zombies* had already shown the undead rising from cemetery plots in a voodoo-infested Cornish village, Romero broke more hallowed ground by having them eat body parts (including in one instance a parent). Most notable is the role of the father, depicted as pig-headed, at times cowardly, but not always wrong, especially during the final moments that prove him right when he insists that the cellar is the safest place, at least from the flesh eaters.

In 1972, Wes Craven wallowed in gore, sadism, and a chain saw predating Hooper's in *The Last House on the Left*. Based on Ingmar Bergman's *The Virgin Spring*, the tale was essentially about a loving mother and father seeking vengeance for their defiled and dispatched daughter: extremely bloody yet traditional in its attempt at moral balance. The vengeful family in *Last House* provokes instant audience sympathy. Craven's film, like *Chain Saw*, also has the advantage of leaving out supernatural fluff and depicting homicidal crimes that could really happen. The protagonist Mari Collingwood is on her way with her friend Phyllis to attend a rock concert to watch an Alice Cooper-ish band called Bloodlust. Instead, Mari and Phyllis run into

criminal lunatics who drag both girls into an earthly hell much like the gruesome crimes appearing in the daily papers or on the nightly news.

A film that got much closer to the mood and theme of *Chain Saw* is a more obscure, low-budget entry from 1972: William Girdler's *Three on a Meathook*. Here, unlike Hooper's film, the story lapses into sexploitation with female frontal nudity, but the theme of cutting people and selling them for food is the plot's entree. There is that spooky quality that comes with amateur films. Their limited budgets free them from the slick Hollywood camera maneuvers in favor of a grittier style. Most crucial is the film's chronic psychological pathos between a gullible son and his manipulative, troubled father. There are no supernatural ghouls, no devils or holy ghosts, and no witches or Tarot prognosticators creating havoc with minds and destinies: only messed-up parents siring messed-up offspring.

Among his many visions for his film, Tobe Hooper intended to make *The Texas Chain Saw Massacre* about an entire family of Ed Geins. The Gein murders, of which Gein himself is credited with merely two, got notoriety for the manner in which he robbed graves and got creative with the remains. His mother left such an impression on him that he stitched together a female costume that he would occasionally wear to feel closer to her. Hollywood wasted little time from 1959, when Robert Bloch published *Psycho*, based on the real-life Gein horrors, and when Alfred Hitchcock soon turned it into black-and-white butchery a year later.

Then, in 1973, *The Exorcist*—that holiest of the uber-hyped—erupted, fresh from the novel by a true believer in the Roman Catholic church's supernatural power to cast out demons. Director William Friedkin had many of his viewers believing as well, at least according to the press-release gospel, replete with flash photos of theater viewers grimacing in the dark at scenes of a prosthetics-laden Linda Blair making a 350-degree head turn, shouting blasphemies, hurling something green,

and masturbating with a crucifix. When the film had its initial run in December of 1973, David Sheehan, reporting for the CBS affiliate KNXT-2, went to the National Theater in Westwood, California to get responses from traumatized viewers. Many of them waited for up to six hours in the ticket line, only to walk out during the screening, at times fainting, sobbing, or literally blocking their mouths to avoid spewing in front of the camera. They expressed their nausea and terror for the television but also took media-generated hysteria to new extremes, assuring that millions more would be buying tickets for *The Exorcist* in order to exhibit similar fits.

Ellen Burstyn possibly terrorized many viewers just as much by portraying a big-screen, affluent, and outwardly respectable career mother who utters variations on "goddammit," as well as several obscenities, including the f-bomb. The marital separation, the absent father, and other hints of the MacNeil family's emotional baggage might have engendered a more feasible story about how children display symptoms of being "possessed" when their parents are already screwed up.

More than a decade after *Psycho*, and years before *Silence of the Lambs*, Gein's ghost haunted theaters in February of 1974 with the well-crafted *Deranged*, later subtitled "Confessions of a Necrophile." It came closest to summarizing the real Ed Gein story while lavishing out lots of dark humor that its directors Jeff Gillen and Alan Ormsby lash out with a steady pace as the psycho killer attends to his affairs. Atoning for the death of his overbearing mom, a rural farmer digs her up and keeps her semi-preserved in his home. In the meantime, he bludgeons and skins one luckless female after another.

Deranged was filmed in Ontario, Canada and has that lachrymose and leafless look so common to such Canadian Gothic thrillers as David Cronenberg's *Rabid* and *The Brood*. It got released several months before *Chain Saw* and has eerie similarities with the laying out

of corpses at a family dinner and the ghostly parent as the phantom manipulator.

Hooper and Henkel left details of *The Texas Chain Saw Massacre* open ended, partly because they rewrote and re-edited the script as they went along, possibly leaving some information out. These backstory omissions, however, make the film appealing, inspiring viewers to form their own interpretations. The film's connection to Gein's symbolic attempt to literally unite with his mother is evident with the human masks, specifically the "Pretty Woman" face that Leatherface dons during the dastardly dinner-party. The mark of Gein also appears with a sofa (or altar) constructed from human skeletons: one of the furnishings that makes Pam wretch as she falls into the forbidden living room. Hooper also claimed to have relatives in the Plainfield, Wisconsin, area where Gein dwelled. They told him all sorts of stories about Gein-style mutilations that included human lampshades. However, the "Wisconsin" logo on the Slaughters' red generator is, according to Hooper, just a coincidence.

In *The Texas Chain Saw Massacre Companion*, Robert Burns (with a chuckle) throws a bit of doubt over Hooper's childhood tales: "Tobe creates his own believable reality, and thereby he can tell it to other people, and they'll believe it because he's not lying to them! Tobe tells people these stories about being terrified by tales when he was a small child—but this happened when Tobe was fourteen years old! But Tobe has *himself* convinced of that!"

Family ties and hostilities are a main narrative thread—not only between Sally and Franklin but between the Hardestys and the Slaughters. Both families have the specter of an absent or mysterious father hovering over them. Fatherly identity gets confusing when Franklin says that his dad owns the "old Franklin house," where Franklin and Sally's grandparents once lived. There are easier reasons

for the different names: the Franklins were the maternal grandparents and that the Hardestys' father took over the estate, or Grandpa Hardesty's first name was also Franklin and that the grandkids refer to the old house by that name as well. A more venturesome idea is that Sally and Franklin were raised, at some point, by a different dad, a prospect that hampers the already-invalid brother with the added handicap of being called Frankin Franklin. Whether an additional layer of parental confusion to perplex viewers, or just a script glitch, the question rebounds later when the Cook also appears as an ambiguous father.

In place of *Eggshells*'s "cryptoembryonic-hyperelectric presence" that flutters about like a pie-eyed poltergeist, *Chain Saw*'s sly tracking camera suggests an unseen observer who could be Leatherface himself wandering about the premises or also the visual metaphor for an undying blood feud between Sally and Franklin's kin and the Slaughters that lingers into the present day—a trap that Sally and Franklin sidle into unaware. The film is sneaky when augmenting this notion. At one point, after the Hitchhiker terrorizes them and they encounter the Cook at the service station, the young travelers drive to the old Franklin place area. It is a chilling moment that highlights Hooper's paranoia-inducing tracking technique.

As the van slowly approaches and comes to a stop, the camera's movement upon them from a distance suggests a watcher in the woods. This is also when Franklin wheels out of the van to study the cryptic script that the Hitchhiker scrawled in blood. In a few scenes to come, this also establishes that the Hardestys' grandparents lived quite close to the Slaughters, a detail that is clearer when Kurt and Pam take their fateful stroll toward the arid waterhole. During this scene, Vail claims to have hurt his ankle, an extra dose of agony making it more effective as they end up hobbling to the Slaughter home that is just across the way.

Somewhere lodged in the back-burner of Hooper's narrative is the idea that the Slaughters left voodoo hexes at the entrance to the Franklin house for an undisclosed reason—the same types of hexes that multiply in the Slaughter house. It is as if the van of hippies got tagged, and the Hitchhiker left a blood-soaked sigil on their vehicle for an upcoming ritual.

Hooper might have had "cryptoembryonic" ambitions in the early phase of his script, but he and Henkel turned *The Texas Chain Saw Massacre* into excruciating realism. That does not mean that the story avoids the supernatural quirks of its characters, as the Slaughters appear to put some stock in voodoo and other magical hexes. The movie flirts with full moons and talk of Saturn being in retrograde, but like *Psycho*, the carnage conjures only the stuff of true crime.

There's another memorable shot that occurs just after Leatherface slaughters Kirk and the infamous slamming of the steel door with that malevolent thud—the moment when most viewers realize that the movie is indeed serious. "When you look at it," Levie Isaacks (the voice on the radio) observes in *The Texas Chain Saw Massacre Companion*, "all the violence is implied, and there's really not that much blood. But that steel door slamming shut—what a great image—it makes your mind shoot into all kinds of possibilities that you could never create in a person's mind by showing it to them."

Leatherface shuts viewers out by slamming the door in their faces, but the scene pulls them further in—as trespassers. The Hardestys, their friends, and ultimately the audience, pose a threat: what the Slaughters see as fair game in a battle that possibly extends to a warring family legacy. Eliminating any direct reference to a feud in the dialogue, the idea insinuates itself visually.

Henkel, when interviewed by Hansen, confirms some kind of transgressed bloodline: "People set out. They violate a code, in this

case they trespass on private property, so they violate some fundamental underlying . . . they unleash the forces of opposition against themselves, and it goes from there. . . . The family can also be seen as victims. They were being trespassed on, another insult after having their livelihoods taken."

Pam, the second trespasser, is nervous that Kirk is not coming out from what they only know as a mystery house. As she gets up off the swing (tailored for someone as large as Leatherface), she cautiously walks toward the house's entrance. The low angle following her is more than just a few seconds of cheap titillation; it ultimately makes the house appear larger and larger the closer she gets—an angry manse waiting to swallow her.

Hooper and Henkel recall getting into a professional tussle with the producers over including this shot, which took extra time to lay out what was only about 40 feet of dolly track. They won the battle and created one of the best examples of how to make camera angles and movements enhance the menace of inanimate objects that are at war with humans. Here, Pam is about to enter the film's infernal bowels, and once inside, her viewpoint reignites the movie's opening flash shots of dug-up flesh and bones. She faces a menagerie and cannot know what is happening, but she knows something evil is afoot—and so she regurgitates.

McMinn, who cringed for years at memories of the movie, recalls being so physically exhausted by her struggles with Leatherface that her voice got hoarse, and she could barely scream. Shots of Jack Daniel's between takes helped her to relax. When McMinn had to hang by the meat hook, Dorothy Pearl devised a chastity-belt-type device comprised partly of sewn-up panty hose. To be more realistic, McMinn decided that the best way to portray someone hanging from a meat hook was to try and get off of it. This is what makes the scene so

convincing as she grabs the hook, hoping in vain to escape. Viewers might walk away thinking a hook really entered her back, but the magic of editing and shooting from different directions created an illusion. Apart from the bucket of gore under her feet, the only significant blood in the scene appears smeared on the wall behind her, and that is likely from a previous kill. As Hansen would say about the film's special power, "the unseen is much greater, and gorier, than the seen."

Once off the hook, into the freezer, and finally out of the picture, McMinn found herself still glued to the production: Hooper needed pickup shots. She was also performing at the Austin Dinner Theater, playing alongside cowboy comic Andy Devine. When she told him about her *Chain Saw* commitment, the Hollywood veteran, as quoted in Hansen's book, reacted like a disapproving father figure: "Oh, Teri, that thing will never come out of the can." Andy might have been doling out this Devine wisdom due to flashbacks of his own cameo appearance in the 1970 sexploitation film *Myra Breckinridge*.

After storing Pam in the freezer, Leatherface kills Jerry, a scene all the more authentic because Danziger was blindfolded up to the moment when he sees Leatherface for the first time. On the initial take, Danziger was so terrified he ran out of the room. Even with the final try, Danziger is still scared enough to be truly screaming before the hammer hits him. The interior scenes of the Slaughter home, even after Leatherface starts killing off its visitors, elicit a twisted sympathy for this moron with the mallet. He fidgets about the house like a bipolar housewife startled by unannounced intruders. ·

Again, a composition shot summarizes the character's inner thoughts: in the foreground is the saw (what Hansen describes as a "yellow Poulan 306A, modified with the fuel tank from a Poulan 245 and a muffler from a 245A") that sits and waits to claim its next victim, but Leatherface is in the background, looking out the window, slapping

the chicken's cage, and appearing apprehensive about the next alien visitor, despite his deadly weapon waiting nearby. A close-up on him as he sits by the window, gazing nervously while licking his deformed teeth, exposes a villain who is imposing but not at all confident.

As the story switches to the full-moon evening, and the Hardestys panic that their three friends have not returned, the battle between Sally and Franklin becomes one of the movie's most horrifying scenes. *Chain Saw* establishes the contrasts and subtle similarities between the relatively sane Hardestys and the lunatic Slaughters. Both come from slaughterhouse backgrounds, and the psychological war between brother and sister foreshadows the Slaughter family mania.

Of the five woebegone travelers, Franklin and Sally Hardesty stand out: their family conflict—implied more than overtly addressed—is a vital part of the story. Kirk, Jerry, and Pam, on the other hand, conform more to how Allen Danziger described Hooper's character approach: "This was not an actor's movie. We were there to fill the time till we died."

Sally and Franklin realize they are helpless and yell "Jerry!" over and over again as they look out into the pitch-black wilderness, depending on the van's headlights to make out whatever they might see. They fight about what to do: Sally wants to venture out into the woods, so concerned that her boyfriend Jerry is missing, but Franklin, burdened by his wheelchair, naturally wants to remain where they are, faithful that their friends will return. He also holds the flashlight and keeps a grip on it; it is his only emblem of control while Sally gets more petulant as she tries yanking it from him. They scream at each other, a tension more effective because the two actors—Marilyn Burns and Paul Partain—did not get along on the set.

Hooper also fanned those personality flames. Hansen's book quotes Marilyn Burns: "Tobe would come up and tell me that Paul said

something about me. And then Tobe was going to Paul, saying 'Marilyn said something about you,' getting us really upset with each other, so we're doing this scene that didn't require any acting at all. I was ready to kill him."

Blistering as it is, theirs is a relatively "normal" example of family clashes: a battle of power and wills with the sister trying to lord over her crippled brother. Many might complain that Paul Partain's Franklin is obnoxious or whiny, but he foreshadows the horror that his sister will eventually face when she too ends up confined to a literal arm chair, left to the merciless taunts of people who savor her anguish. Yet despite all of the bitching about Partain's annoyances, Franklin turns out to be the most soulful of the bunch. He is the first in the film to experience pain, the one who feels the hottest when confined to the van, the one who sees and hears the prophetic old drunk, the one to get attacked in the van, and the only one to see the feather-and-bone sculpture at the old Franklin place doorway.

Trying to maintain some kind control amid a hopeless near-future, Franklin takes the horror to another level. Partain also alienated just about everyone on the set. Of the crew, he was the self-proclaimed method actor who refused to get out of his role. Able to walk to the nearby refrigerator to grab a Dr. Pepper or a beer, he preferred to call a fellow player by his or her movie name and request that person wait on him while he remained in his wheelchair. Remembering how his grandfather had languished in a wheelchair for seven years, Partain converted that agony into a sense memory that he inflicted on himself and his surroundings.

Many *Chain Saw* fans regard Sally as the movie's martyr: the prototype for the "final girl" who would suddenly become the survivor in a possible franchise of sequels. But in the first part of the movie, she seems rather shrewish, concerned only with herself and her boyfriend

while caring little about her brother's discomfort. Franklin must contend with an oppressive environment and a kid sister who is the typical self-indulgent teenager. This tension builds early on, when they arrive at the Franklin home where the Hardesty kids spent part of their childhood. Sally enters the room where she used to play, rambling on about her happy past by examining the peeling wallpaper and its vestiges of animal designs, giggling as she recalls her grandmother's death. Franklin, meanwhile, left alone downstairs while the others snicker away, goes into a tantrum, sputtering (like a chain saw motor) and contorting his lips, just as the Hitchhiker had done when kicked out back into the heat and left to ransack another graveyard.

Franklin's fit is an example of how Hooper laces his narrative not so much with explanatory dialogue but with gestures and impulsive mannerisms. Franklin and the Hitchhiker become distorted mirror images of one another. It's a technique Hooper would use again in his follow-up film *Eaten Alive*, when different characters mimic one another through contagious noises and spasms.

The camera continues to take advantage of the limited amount of dolly track as it moves along with Sally and Franklin as they wander through the woods. While Sally pushes Franklin in the wheelchair, still shouting for Jerry, Franklin clings to the flashlight that will illuminate the face of the beast that slices him. Here, Franklin's flashlight is a bright, silver symbol of guidance. Hooper apparently did not regard it with such reverence by the time he made the 1986 sequel, for in a scene when the characters stumble upon Franklin's skeletal remains, he is still in his wheelchair and holding onto a flashlight that seems just a bargain-bin throwaway.

Some might ascribe the term "Southern Gothic" to its theme, but *Chain Saw* offers an exaggerated, and more universal, look into contemporary problems of family malaise, a subject that had become, by

the early '70s, a factor not only across America, but in other parts of the world, including Britain, where a renowned psychiatrist characterized the typical modern family as a hidden horror tale.

Since the 1960s, the Scottish psychiatrist R.D. Laing had been voicing some radical and inflammatory remarks about the scary side of family life. Laing likened such domestic units as psychological combat zones, where parents and siblings play power games with one another, often without realizing. Laing's "anti-psychiatry" promoted the idea that schizophrenia was not so much a medical illness but an elaborate method for individuals to deal with a society that was already fragmented and crazy. Instead of focusing on genetics or neural chemistry, he put the onus on dad, mom, and siblings. With help from Britain's Tavistock Institute of Human Relations, dedicated to studies of human behavior and, according to some, methods of mind control, Laing had prestigious backers.

Laing also became a pop celebrity in America, loved by the likes of Jim Morrison. This was the era of the "Human Potential Movement." Casual shoppers in the early '70s could find books on drugstore shelves by authors like Arthur Janov, who believed that his "primal therapy" could force neurotics to relive their traumatic pasts and, usually with piercing screeches, become "normal." The Beatles, who had already taken a shining to gurus and others who promised salvation, liked Janov. John Lennon hailed Janov's book *The Primal Scream* by dramatizing how such a caterwaul might sound on his 1970 song "Mother."

Hooper, however, proved more of a Laing man, deploying his Slaughter family to exaggerate the nightmarish households Laing addressed in his 1971 book *The Politics of the Family and Other Essays*. "In our society," Laing writes, "many of the old rituals seem to be losing much of their power. And new ones have not arisen." He describes a young patient's problems as a tortuous gambit: "The family set-up, under the one roof, consisted of father and mother, mother's father and

father's mother, ranged against each other, father and his mother against mother and her father: mixed doubles. She was the ball in their game."

Family life, for Laing, was often a passing down of neuroses from generation to generation. Children of such families grow up in emotional hothouses only to be haunted by past selves they often forget about as they saunter about in adult life, tied in psychological knots. "Dilemmas abound," he writes. "If I do not destroy the 'family.' The 'family' will destroy me. I cannot destroy the 'family' in myself without destroying 'it' in them. Feeling themselves endangered, will they destroy me?"

Laing continues:

> "The most common situation I encounter in families is when what I think is going on bears almost no resemblance to what anyone in the family experiences or thinks is happening, whether or not this coincides with common sense. Maybe no one knows what is happening. However, one thing is often clear to an outsider: there is concerted family resistance to discovering what is going on, and there are complicated stratagems to keep everyone in the dark, and in the dark they are in the dark."

Laing likens these psychological hitches to being hypnotized from childhood, not knowing we are hypnotized. His language evokes a bad dream scripted by Luigi Pirandello: "We are acting parts in a play that we have never read and never seen, whose plot we don't know, whose existence we can glimpse, but whose beginning and end are beyond our present imagination and conception."

Within Laing's verbal convolutions lurks the dynamic interplay between the Hardesty (or Franklin) and Slaughter bloodlines, both

overshadowed by significant granddads, and whose predecessors lived in one another's proximity. One reason for this subtext could be due to Hooper himself, who experienced a relatively tumultuous upbringing. He and his family lived in hotels, and by the time his parents divorced, the definition of "home" got even more tentative: he had to divide his time between two battling factions.

In the 2000 documentary *Texas Chain Saw Massacre: The Shocking Truth*, Hooper shared some Laing-like thoughts: "Our get-togethers, reunions, whatever, holidays, I've seen more dysfunction and more hell in the riddled-through families than I would like to have and wish I haven't seen that much weirdness in family behavior. So, I kind of always wanted to do something that's about a dysfunctional family."

As a student at the University of Texas, Hooper, at least by osmosis, absorbed some of the early '70s psychology. Around the time the *Chain Saw* ideas appeared on paper, divorce rates were rising. A microcosm of the problems got documented in a twelve-part series on PBS called *An American Family*, which aired for the first time in January of 1973. This pungent antidote to *The Brady Bunch* involved the real-life Louds, a motley flock from Santa Barbara, California whose members grow more disturbed with each episode. Highlights of the series include Mrs. Loud's demand for a divorce and son Lance, the most famous of all the Louds, moving to New York City to live at the Chelsea Hotel, reveling with the Andy Warhol crowd, and indulging in the era's newfound sexual liberation.

The Louds' relative affluence made them not quite a typical American family of that time, but their problems, the varying personality clashes, and pre-reality show displays of self-indulgence, unmasked how families of many backgrounds partake in "psychodramas" (a then-fashionable term). *An American Family* also raised problems that would surface in future "reality television" shows, begging questions

about how the camera's mere presence encourages subjects to "act out" more than they might have without the intrusion.

Laing would probably see the Louds, though tragic in their exhibitionism, nowhere near as horrific as the family relationships he had studied. Family disorder was no longer a subject relegated to PBS documentaries, talk shows, or Eugene O'Neill plays; it had invaded everyday conversations. Norman Lear attempted to turn this into comedy as the 1970s dawned with shows like *All in the Family* and *Maude*—episodes filmed before live studio audiences for the laughter but larded with unprecedented scenes of bickering and bitching, touching on previously taboo subjects like abortion, homosexuality, and menopause.

According to Dr. Alexander A. Plateris, in a study padded with institutional lingo for the National Center for Health Statistics, "During the decade 1964-73 the number of divorces and the divorce rate increased rapidly. This increase continued through 1976 but less rapidly than in the late '60s and early '70s. Rising from 2.2 per 1,000 population in 1962, the divorce rate had doubled by 1973 and reached 4.9 per 1,000 population by 1975." The study continues:

> *"The increase in divorces took place during a period in which there was a trend toward liberalization of divorce laws . . . Some States abandoned the concept of divorce granted to the innocent party because of the objectionable behavior of the guilty party, and adopted the concept of marriage dissolution, where neither party is recognized as guilty and a list of legal grounds for decree is not given in the statutes. Such no-fault decrees are granted for what the laws describe as 'irreconcilable differences' or 'marriage irretrievably broken.'"*

Some counterculture cadres preached against the traditional American family in favor of family alternatives, oddly oblivious to how the term "family" was already expanded to include Manson and his followers as well as the Moonies and their Unification Church. One nuclear family replacement was the commune, a trend that had thousands of mostly white, middle-class kids hopping into vans and traveling to places that promised an ideal of true egalitarianism and, in some instances, group marriage. Life in some of those communes, however, turned out to be more like mini-dictatorships, with the domineering parties browbeating and sometimes physically abusing the more passive. They became another version of the nightmare household, where each member had his or her place in a pecking order that was at times more draconian than anything the parents, whom many hippies routinely railed against, could have devised.

One example was "The Family" in Taos, New Mexico, which made the commune in *Eggshells* look like a swell vacation spot. The Family was founded on Gestalt Therapy principles; this partly meant that individuals had to address their problems with an often-judgmental group. In 1970, an eager twenty-five-year-old named Margaret Hollenbach, captivated by the fashionable talk of "alternative lifestyles," left graduate school to join. She got to Taos but discovered that she was among fifty-five others confined to an adobe house with only five rooms. There were also strict rules: no drugs, no personal possessions, no birth names, no loner-type behavior that could alienate the group, but a resounding yes to group marriages, "free love," and enforced eye-to-eye contact with everyone that ironically prevented individuals from truly living out the hip cliché "free to be yourself."

Hollenbach, zealous about early '70s feminist ideals, was flabbergasted to find that she had to take orders from a man with a messiah complex who demanded everyone call him Lord Byron. He was older,

like a father figure, but unlike the vast majority of fathers in America, stipulated that all of the women in the household be his sexual subordinates. "The first or second day," she recalls in a 2005 interview with the *Gazette-Star Reporter,* "I said, 'This is really sexist. Women wore skirts and worked in the kitchen.'" Her protests fell on deaf or hostile ears, as she felt bullied to conform. What seemed like an "alternative lifestyle" was a cult. She managed to escape, clear her head, and go on to write about the tribulation as both a master's thesis and a book.

The trend for surrogate, collective families entered a more exotic dimension in the early '70s when Marshall Applewhite, a music teacher in Corpus Christi, Texas, forfeited his sixteen-year marriage. Bonnie Nettles, a Baptist from Houston, had a twenty-three-year marriage that also ended, partly due to Bonnie's fondness for séances and claims of contacting a nineteenth century monk. When the two orphans of matrimony met in 1972, Nettles was so impressed after doing Applewhite's astrological chart that she forged a platonic, spiritual bond with him. They went on the road in early 1973, and by that summer, they were certain about their cosmic mission to fulfill the prophecy of John the Divine's Book of Revelation.

Applewhite, however, had to spend six months in a Kansas jail after attempting to make off with a rental car. In confinement, he developed his space theology, so that upon release, he and Bonnie were ready to meet Hayden Hewes, a UFO aficionado who inspired them to devise a theory whereby they could transmute their human forms into transcendent beings. Their new group was "Human Individual Metamorphosis," and while giving themselves nicknames like "Bo" and "Peep," Marshall and Bonnie gathered across the country a new family of devotees, people who had previously tried such routes as Transcendental Meditation.

Combining his Presbyterian roots with Ufology, Applewhite believed the world was facing "end times" and that he was akin to Christ's

reincarnation, able to communicate to others through telepathic codes. The Luciferians were the enemies, and the holy war would be interstellar. To show their fealty to the battle, members were allowed scant access to their biological families for fear of deprogrammers waiting to snatch them away. Together, Bo and Peep, sometimes calling themselves "The Two," absorbed the trending pop philosophies: from R.D. Laing to the popular novella *Jonathan Livingston Seagull*, about an outcast bird trying to find himself in a "higher plane of existence." They collaborated on their own thirty-page work entitled, "I Can't Believe That—But You Must." It reflected their love of Eastern philosophy, particularly their belief in "karma," which for many Western appropriators often means the universe's revenge on people with whom they disagree or hold a grudge.

In September of 1975, they and their followers grabbed lots of attention with a lecture inside a motel in Waldport, Oregon. "The Two" regarded the lecture's attendees as among the saved, but relatives and friends thought they had vanished, as if lifted by unearthly forces. There, The Two spoke about their pre-Spielberg dream of UFOs making godly contact with humanity. Some thought it was a goof, others figured they were imaginative druggies, but eyebrows elevated when some members went missing. On the *CBS Evening News*, Walter Cronkite related the bizarre tale to households coast to coast: "A score of persons from a small Oregon town have disappeared. It's a mystery whether they've been taken on a so-called trip to eternity—or simply been taken." Applewhite's mystery members were still on *terra firma*, taking refuge at a congregation in Grand Junction, Colorado and waiting like saps for a space savior who never arrived. In the future, Applewhite's group would mutate into Heaven's Gate.

The Slaughters in *Chain Saw* were also a nuclear-family alternative who wallowed in mortal misery. The most confounding part of the

story is Jim Siedow's ambiguous role as the "Cook." When Leatherface guts the entrance to their home, and Siedow's character shouts out the funny line, "Look what your brother did to the door," it does not seem like something a sibling would say to another, but rather a father trying to maintain a sense of "pride in his home" despite a motherless household gone mad and insubordinate young'uns. Was the Cook, who is supposed to be an older brother, sired from another father from a previous generation, or (to bolster hillbilly stereotypes) did he mate with the now-dead mother to spawn the two reprobates?

The Cook's ambivalence about killing Sally enhances the dinner-time friction. "You're just a cook! Me and Leatherface do all the work," the Hitchhiker yells as Sally continues to scream. It's a family squabble that reflects the one that previously transpired between Sally and Franklin, only of course, it's much worse and more demented. Now, Sally is the one confined and subject to the untender mercies of belligerent scoundrels while looking directly at a 100-something-year-old codger eager for at least one last crack at the sledgehammer. On top of all this, one of her tormenters gets dolled up with lipstick and a woman's mask.

Leatherface's Alice Cooper-ish gender-bending raises questions about the role he is trying to assume. If he is playing out the missing mother, she might have been either domineering or a retiring figure that had succumbed to the abuse of the others and perhaps was another of their prey. Laing expressed the notion that families, whether nuclear, extended, surrogate, or communal, tend to live out shadow plays, where members act out what others, particularly the elders, expect of them without the elders or other dominant members even realizing their influence. "We very seldom ever entirely relate absolutely to the other," he writes. "And indeed very seldom is there another there to whom one could."

Actor Doug Bradley, who has portrayed Pinhead in the *Hellraiser* films, shared with Hansen some of his own feelings about Leatherface's complex image: "There's a childlike quality to Leatherface. I don't know whether this is where people's identification comes in. There's an innocence to him. It's not that he's just the crazed killer; there's almost a feeling that he's not quite sure why he's doing what he's doing, maybe isn't even comfortable with what he's doing. Also in the context of family, he's the obedient child."

Hooper and Henkel edited out one of Leatherface's campy drag scenes, but the documentary *Texas Chain Saw Massacre: A Family Portrait* includes some footage: Leatherface takes a break from torturing Sally at the dinner table by strutting into an adjacent room to add more makeup. He at one point tries on a blonde wig before returning to the family and the rotting carcasses. As Hansen, who had to endure odiferous hours of wearing the same costume, recalls, "He powders his face grotesquely, the powder flying everywhere in a caricature of some feminine cliché of an earlier time. Then he applies fresh lipstick, doing it with some delicacy, as if sometime in the past he watched his mother putting on her lipstick."

Again, Hooper and Henkel's script has loose ends ripe for speculation. The only hint of any kind of matrilineal origins is the sight of the woman's corpse who sits beside a deceptively dead Grandpa. Though she was not written into the initial script, Bob Burns decided to add her to indicate that at least one woman had to exist at some point in the family's history. But who is she? The most facile answer is that she is what remains of Grandma, but the script never makes this clear.

This ambiguous material should inspire sequels and prequels that add more salacious detail to a partly told story. Most of the subsequent *Chain Saw* entries to issue from the franchise have fallen short. Forty-three years later, however, on what would be the final *Chain Saw* entry

that Hooper and Henkel would produce before Hooper's death in 2017, the film *Leatherface* interprets her as Leatherface's harpy mom, aunt, or both, who once ruled the family roost and was responsible for turning her son into the thing that he became. Again, the father is absent or ambiguous. Julien Maury and Alexandre Bustillo, two young French directors, make a worthy attempt at rearranging the tale, using narrative tricks regarding Leatherface's identity, including a red-herring character who is not whom viewers would initially expect. It also rescinds the original notion that Leatherface was always an asocial "retard."

The driving theme is still "family," but *Leatherface* remains stuck in the weaker notion that the Cook is an older brother. It also makes the mistake of presenting the Slaughters (here they are the Sawyers once again) as a happily demented brood. (The original *Chain Saw* had them fighting from the get-go.) At a little boy's birthday party (filmed in gorgeous, emotional-hothouse red), they all sit around the table loving and smiling at each other. Their criminal side comes out only when they vent their spleen on a captive who is also at the dinner table: tied, gagged, and waiting to be sliced and smashed for supposedly trying to steal their pigs. The story would have been edgier had it dropped hints that the older brother (supposedly the Cook) was also the father of the two smaller kids and, instead of being obedient, fought with the mother/mistress at the table, the same way that the Cook fought with his family in the original film.

The friction so splendidly laid out in the first movie, to which the *Leatherface* directors apparently wanted to adhere as much as possible, could have had a more complicated backstory. Maury and Bustillo's film does get more daring when presenting another phase of Leatherface's boyhood: confined to a mental hospital for youths who must submit to mind-gouging ECT. The ominous presence of a wheelchair in the hall (and later tossed out the window) of the institution

suggests, to those daring to stretch their reading of the film, that Franklin (and possibly Sally) Hardesty might also have spent time in a similar place—manhandled by outside forces that brainwash the experience from adult memory.

Hooper and Henkel's original is so open-ended that the Slaughters could have a variety of pasts: some real and others delusional. Siedow's Cook does manage to exert some influence over Leatherface and the "nap-haired idiot" when going into a brief but harrowing monologue about brighter Slaughter days. As Sally screams beneath her gag after realizing she is slated to be Grandpa's cattle, the Cook reminisces: "Why, old Grandpa was the best killer there was at the slaughterhouse. Why, it never took more than one lick, they say. Why, he did sixty cattle in five minutes once. They say he could have done more if the hook and pull gang could have gotten the beeves out of the way faster."

This moment of sadistic nostalgia is all the Slaughters have left to keep their version of the faith. The Slaughters are an extravagant metaphor for life in what *The Limits to Growth* repeatedly referred to as "a finite world." They are cornered, outmoded, and on their own with only the emotional comfort of reliving whatever they imagine was the family's past glory. The Slaughters are castoffs from the abattoir elite, pressured to upgrade their former trade by killing and cooking their perceived adversaries. All the while, they hold on to an illusion of a past, incubating and moldering in their isolation. Nostalgia becomes their key to ritual murder, and both the Hardestys and the Slaughters enter a negative feedback loop with nowhere to go.

Like Jekyll and Hyde, the Cook and the President are not so much doppelgängers as they are variations of one man who switches in and out. The Cook is at times so chameleonic that his presence suggests Nixon on a bender, a darker and uglier Nixon looking back like a Dorian Gray hidden in a murky gallery, away from the rest of the official presidential portraits.

CHAPTER EIGHT

THE COOK AND THE "CROOK"

"People react to fear, not love; they don't teach that in Sunday school, but it's true."

—RICHARD M. NIXON

Kim Henkel once described *The Texas Chain Saw Massacre* as a movie mired in "moral schizophrenia." It slams into the viewers' minds without conventional character motivations, high-minded messages, or closure. Hooper and Henkel supply instead a volley of visceral assaults (and a few dark laughs), with messages and themes that are more indirect. For fans, these factors are its main appeal (and for others its source of frustration). Viewers must watch a story designed to make them feel as scared and disoriented as cats reacting to abruptly rearranged furniture.

Through the years, *Chain Saw*'s political and social messages got more tempting the more they were implied. One of horror's more profound effects is to take bad traits that many people possess at varying degrees and then create a demon, maniac, or monster that exaggerates those traits. What better time to make a horror film than to have Richard Nixon as the readymade monster trying to fend off his demons? "The influences in my life were all kind of politically, socially

implanted," Tobe Hooper told the *Austin Chronicle* in 2000. "And then there was Watergate."

As Hooper and Henkel toyed with the script, they were also making the dynamics of the Slaughter family a caricature of Nixon's ethical mire. Most everyone during those days talked about Nixon and his debacles; the stories hogged news cycles due mostly to the contrasts between Nixon's appearance of integrity and the hidden crimes that culminated in what Jonathan Schell in a June of 1973 issue of the *New Yorker* referred to in sci-fi terms as "the shapeless, growing thing called Watergate."

There is one *Chain Saw* character who embodies that moral schizophrenia. He is the Cook, the proprietor of the decrepit filling station, the barbecue gourmet with bad teeth, and the head of the household of shambling psychos. Hooper too described the Cook as a character "not altogether sure where the moral line is drawn." Played by Jim Siedow, he is a man lost between his baser instincts and those vestiges of decency that have slipped away from years of neglect and having been wronged by life's misfortunes. This horrible side to his nature surfaces as the story intensifies and grinds to its climax.

Siedow also provides a Nixon caricature—something Hooper and Henkel might well have realized during filming. To inspire them, they had the real Nixon, who liberated his Mr. Hyde side as the summer of 1973 wore on. Like Jekyll and Hyde, the Cook and the President are not so much doppelgängers as they are variations of one man who switches in and out. The Cook is at times so chameleonic that his presence suggests Nixon on a bender, a darker and uglier Nixon looking back like a Dorian Gray hidden in a murky gallery, away from the rest of the official presidential portraits. Both men even have crossover facial features and tics: the dark eyebrows, the scowl, the protruding nose tip, and the perturbed expression that a grin cannot camouflage.

As a father figure, however, the Cook is more effective than as an older brother. This makes him the keeper of a deteriorating household, just as Nixon tried to keep an orderly facade for a threatened White House, when old, bedrock rules crumbled, and officials in the government cannibalized one another politically and personally.

Thoughts of the Cook put thoughts of Nixon in sharper funhouse clarity. Despite helping to lower the voting age to 18, eventually eliminating the draft, helping to start the EPA, issuing an executive order to end biological warfare, extending governmental largess that Reagan-era Republicans would have dismissed as too liberal, and arguably the only force who might have offered an eleventh-hour negotiation to prevent North Vietnam from taking over the South, Nixon withstood layers of accusations piled up on him. He was still burdened with the confounding and ongoing war, income tax discrepancies, the scandal of clandestine cash from Howard Hughes, and the specter of Watergate and its bungling "plumbers." With scandals that dragged him into a toxic maw following the break-in of the Democratic headquarters during his 1972 re-election campaign, he had to prove to the country and perhaps to himself that the armored smile he liked to flash on camera could conquer the inner demon.

Nixon's greatest moral ambiguity of all involved Vietnam. Spoonfed wisdom might leave the impression that it was simply a civil war between the Vietnamese and nobody else's business. Though vowing to get the U.S. out of the tangle, he knew the solution was not so simple. The U.S.S.R. and China were also involved, and there were many ordinary South Vietnamese citizens who, despite their corrupt government, were horrified of an invasion from the North and grew dependent on the U.S. for help. Many anti-war crusaders in America thought the world would be better if the North Vietnamese and the Viet Cong won.

But Nixon thought there were some fights he had to pursue even if he did not like them.

On January 23, 1973, to correspond with his 60th birthday, Nixon signed his so-called "peace with honor"—an agreement loaded with bonus doses of moral schizophrenia. It essentially allowed the Viet Cong to remain in South Vietnam, guaranteeing a win for the North: what one communist called "half war and half peace." After the Christmas bombings of Hanoi and Haiphong, the North Vietnamese returned to the peace table. But the conditions of the peace accord (that put North Vietnam at a strategic advantage) were identical to the ones that instigated the Christmas conflict to begin with.

Later on, Nixon realized this dilemma and tried to get more aid to Saigon, but Congress, sensing the president's growing Watergate weakness, turned him down. The estimated body count was 58,000 American soldiers and a total of two million Vietnamese soldiers and civilians from both sides of a country that would be "reunified" in name only. When Nixon took power, the war had become such a quagmire that his goal was to settle for a secured South Vietnam along with American troop withdrawal. Nevertheless, Nixon faced another schizoid dilemma. As Vice President Nixon, he and the Eisenhower Administration could have avoided the problem back in 1957, but there was a catch. He would have had to heed the advice from the dreaded Soviets who, in truth, offered a sensible solution: partitioning the country and allowing the United Nations to recognize a North and a South Vietnam.

No time better captured Nixon's complex problems and growing angst than January of 1973—a month crowded with coincidences. On January 22, former President Lyndon Johnson, who spent his final days exhibiting guilt about his Vietnam war escalation, and even grew his hair longer in a frail gesture to the counterculture he had either alienated or sent on perilous journeys to Southeast Asia, passed away

on his ranch in Stonewall, Texas. That same day, the U.S. Supreme Court handed down its landmark *Roe v. Wade* decision, granting women the right to choose an abortion. Though such states as Alaska, Hawaii, and New York had already passed their own variations on pro-choice laws, *Roe* gave blanket consent in an issue that had previously harbored a variety of nuanced viewpoints.

In 1971, Nixon shared his opinion: "From personal and religious beliefs, I consider abortion an unacceptable form of population control." But he reacted to *Roe* with no public comment. In private, he was ambivalent, thinking that abortion might be necessary in cases such as rape but also feared it would encourage promiscuity. Yet despite its being illegal for so long in many states, most Baptists (before joining Evangelicals in their anti-abortion crusades) believed that life begins not at conception but at birth and, while not condoning abortion, sought a more liberal approach by the early 1970s. The conservative Southern Baptist Convention had pledged in 1971 "to work for legislation that will allow the possibility of abortion under such conditions as rape, incest, clear evidence of severe fetal deformity, and carefully ascertained evidence of the likelihood of damage to the emotional, mental, and physical health of the mother."

The conservative W.A. Criswell, a leading Southern Baptist minister, had (at least in 1973) concurred with the gist of the *Roe* decision: "I have always felt that it was only after a child was born and had a life separate from its mother that it became an individual person, and it has always, therefore, seemed to me that what is best for the mother and for the future should be allowed."

Peeved by *Roe v. Wade*, the anti-abortion crusade, spearheaded mostly by the Catholic Church and its sympathizers, encouraged public hectoring, to the point of intimidating women entering abortion clinics and terrorizing citizens with propaganda pamphlets depicting

what was supposed to be abortion's gruesome aftermath. One memorable piece of "fetal photography" depicted two tiny human feet between an adult's thumb and forefinger—an attempt to shock and traumatize more people into becoming anti-choice. Even if some cringed, more Americans were prone to defend a woman's right to choose, and the fetal gore photos might have aroused the morbidly curious more than they inspired any *Roe* reversals.

Abortion, like the ravages of his own political scandal, became one more challenge to Nixon's ethical poses. Before April of 1973, when the press at last found the link between the "plumbers" and some of Nixon's main aides, Nixon seemed almost invincible. Still riding the high of an historical landslide re-election, and basking in the glory of being the Cold Warrior who sat next to Chairman Mao, Nixon's Quaker ethics about putting on an honorable appearance, and finding peace at the center, were working even as the politics got sleazier.

The contrasts between the hope he had inspired for many at his first inauguration in 1969 with the malaise that dogged him as he resigned five years later were startling. In January of 1970, as part of the celebration of Nixon's first year in office, Dan Rather of CBS News summarized the president's public image:

> *"In twelve months, Richard Nixon proved himself to be underestimated. He has emerged as a shrewd political manager, with a chance to be remembered as a consummate politician in the mold of Woodrow Wilson and Franklin Roosevelt. Nixon: the supremely disciplined, introspective loner. His mind: methodical, cautious. Given to worry? Yes. But never, never let the worry show. Control— the byword for every public appearance. Calculated non-flamboyance. Makeup to cover the beard, special hair*

tonic to cover gray at the temples, and a ready smile to cover worry."

Yet in the previous year, Nixon ordered the secret bombing of Cambodia after learning that the North Vietnamese Army and the Viet Cong were using the neighboring country as a sanctuary for guerilla training and arms storing. The bombing did have a rationale, but it foreshadowed more horror shows as the increasingly anti-war and anti-Nixon press used the furtive act as one more example of "tyranny." In May of 1969, another U.S. "search and destroy" foray, this time into mountains about a mile from the border at Laos, ended up putting so many American soldiers through a military meat grinder that the mission earned the derisive nickname "Hamburger Hill."

As part of what he liked to call his "madman theory," Nixon wanted the Communist bloc to perceive him as a potential lunatic, volatile enough to press the nuclear button at any moment if foes did not approve of peace on his terms. At the same time, he faced down what Vice President Spiro Agnew (reciting the words that William Safire wrote for him) called "the nattering nabobs of negativism" and "the hopeless, hysterical hypochondriacs of history."

The simple will to survive impelled Nixon to despise Daniel Ellsberg and the *New York Times*'s release of the *Pentagon Papers* in 1971. Though the publication was more an indictment of Johnson, Nixon was in the line of fire. This did not stop him and his henchmen from combing through them for clues that would expose John and Robert Kennedy's roles in killing South Vietnam President Ngo Dinh Diem.

Diem, whom LBJ once hailed as a reincarnation of Winston Churchill, was brutally offed three weeks before JFK's elimination. Controversy continues over whether or to what extent Kennedy outsourced the assassination of Diem to avoid being designated as a direct

agent. Once Diem was gone, Saigon never fully recovered as rival Buddhist and Catholic factions dragged the government down, along with corrupt and craven politicians, student dissidents, and others within South Vietnam's territory plotting along with the local Viet Cong who, in turn, carried out orders from Hanoi.

Nixon wanted to demystify JFK's mystique. JFK, the martyr whose wife went on to publicize the days of her and her husband's White House reign as a modern-day Camelot, the Irish-Catholic Lothario who moonlighted as a plumber to starlets and harlots, while a fawning press turned a blind eye, proved too much of an unfair contrast to "Tricky Dick."

Unlike the natty mannequin JFK, whom Nixon oddly tried to imitate by posing with some stupid dog by his side, or trying to look casual with a cocktail in hand, Nixon remained stoical, still convinced that he could uphold some old-school etiquette. As U.S. presidents go, this product of Quaker decorum was, besides being a bit of a lush, relatively straight-laced, particularly on sexual matters, except when cracking a dirty joke now and then. He projected that same aura of wholesomeness onto "the Silent Majority" he sought to represent, trying to preserve a stable climate when many Americans thought they were, to quote from that lachrymose finale in the musical *Hair*, "facing a dying nation."

By the end of April of 1970, Nixon had announced his plan to expand the war theater into Cambodia (where the North Vietnamese had continued to set up base camps). Nixon called for calm, but pandemonium followed. At Kent State, protestors set fire to a campus ROTC center; days afterward, four of its rock-throwing students got gunned down by National Guardsmen.

Though he cursed and moaned about the protesting "bums" and what he perceived as the communist plants corralling them, Nixon was sometimes tempted to face his callow adversaries head-on.

In early May, during the wee hours, Nixon tempted fate on one of his many sleepless nights. He requested a limousine escort to the Lincoln Memorial, where he faced a group of anti-war students preparing for a protest later in the day. He was likely sincere in his awkward attempt to reach out to the enemy, but when the students wanted to address the war, Nixon would sidestep the issue by talking about college football or California surfing. "He looked like he had a mask on," one Syracuse University student recalled in Anthony Summers's *The Arrogance of Power*. "He was wearing pancake makeup. He looked scared and nervous like he was in a fog. His eyes were glassy."

By 1972, Dan Rather changed his tone when he confronted Nixon in a televised interview, emitting statistics showing that 50% of the American public thought he "lacked personal warmth and compassion." Tolerating such impertinence, Nixon facetiously informed Rather that it was the reporter's job to psychoanalyze; the president needed only to seek competence and "performance." But in secret, on his tapes, he told Charles Colson that Rather was "just a son of a bitch." "Bitches" and "sons of bitches" were milder fixings in Nixon's behind-closed-doors word salad, but reports of his cussing became red meat for the cannibal journalists. Any day, they hoped the darker Nixon would suddenly raise the *Dr. Strangelove* Hitler hand and blast the Oval Office to smithereens.

Many other presidents resorted to temperamental outbursts in private, but the press heard cacophony even during Nixon's moments of quiet desperation. A painful yet amusing occasion in both political and pop cultural history (and available for viewing in such films as Peter W. Kunhardt's 2014 documentary *Nixon by Nixon*) occurred in January of 1972, a month before his game-changing China visit. Nixon invited the Ray Conniff Singers to perform at the East Room of the White House in honor of DeWitt Wallace, founder of *Reader's Digest*.

Nixon introduced them: "If the music is square, it's because I like it square." The audience applauded as the singers entered the stage.

One of them, however, seemed out of place with her long, straight, "tribal-love" hair and downcast expression, more so once she held up a banner reading "Stop the Killing." She pleaded with the president to "stop bombing human beings, animals, and vegetation," reminding him that he is a Christian who goes to church on Sundays. "If Jesus Christ were here tonight," she continued, "you would not dare to drop another bomb." Conniff had gently reached out to take the cloth from her hands, but she held on. Then, trying to stay a gentleman, Conniff barely skipped a beat when leading his chorus into a rendition of "Ma, He's Making Eyes at Me." Nixon indeed made eyes at her, but with a gaze that inwardly seethed but seemed outwardly unfazed.

Though an interloper, the woman might have elicited a smidgen of sympathy even from a few of the staunch conservatives in the audience who also grew weary of a protracted war with no apparent endgame. Instead, she turned them off, when ending with the hyper-partisan salvo: "Bless the Berrigans, and bless Daniel Ellsberg." As she elicited icy stares, Nixon kept his game-face grin. Attorney General John Mitchell, who sat next to him, also remained calm. But Mitchell's wife, the boisterous and bibulous Martha, was less reserved when reacting to the hippie intruder: "She should be torn limb from limb!"

Motormouth Martha Mitchell merely expressed what Nixon was thinking, and this was evident when he got on the phone to her husband after the incident. Here, Nixon started sounding like a sincere madman, suspecting the protester was a "plant" and "probably communist." He also knew that he could not publicly attack her for fear that the journalist bloodhounds would accuse the Secret Service of investigating her: "They have to be very careful to be sure that we're not persecuting the bitch."

As news of the Nixon tape transcripts surfaced, and far juicier tidbits leaked out, Americans became fascinated to hear a president use foul language, but the president was also adapting to the changing times. "Bitch" became a favorite trigger word that people felt free to utter as one of many challenges to old proprieties. In September of 1974, the character Maude Findlay (Bea Arthur) of Norman Lear's prime-time sitcom *Maude* broke a network television taboo by calling her husband Walter a "son of a bitch." That same fall, Elton John made a hit with "The Bitch is Back." But hearing Nixon say "bitch" was much more subversive—like hearing it from a grandfather or a priest.

"All Presidents swear," Nixon would later utter in his defense, years after releasing transcripts full of blacked-out redactions to hide his numerous expletives. Billy Graham, Nixon's spiritual mentor, reportedly vomited after reading some of the published verbiage, alarmed to discover a devil Nixon in contrast to the angel he had loved and nurtured through the years.

When J. Edgar Hoover passed away in May of 1972, Nixon eulogized him to bolster a loopy country's need for order, now that "one of the Giants" was finally gone. In the article "President Lauds Hoover," the *New York Times* shared Nixon's parting tribute to his foul-weather friend: "The trend of permissiveness in this country, a trend that Edgar Hoover fought against all his life, a trend that has dangerously eroded our national heritage as a law-abiding people, is being reversed. The American people today are tired of disorder, disruption, and disrespect for the law. America wants to come back to the law as a way of life." In private, Nixon reacted to news of Hoover's death with less finesse: "Jesus Christ! That old cocksucker!"

On the same month of Hoover's passing, Nixon had another schizoid reaction when George Wallace, running for the 1972 presidential race on the Democrat ticket and threatening to siphon conservative votes

away from the Republicans, got shot and became permanently crippled. Nixon put on a gallant show by visiting his opponent in the hospital but also initially feared the assassination attempt would be pinned on him and CREEP (the acronym his adversaries enjoyed applying to the Committee to Re-Elect the President). Word, however, circulated about Arthur Bremer, Wallace's assailant, having leftist literature in his apartment and being sympathetic to George McGovern: convenient information helping to guarantee Nixon's landslide victory.

The international accord Nixon tried to project, as proof of his diplomatic finesse, got shattered a couple of months before his re-election when, in September of 1972, television viewers became transfixed by the image of a masked Palestinian terrorist lurking on a concrete building's balcony as he and several other members of the Black September group held eleven Israeli athletes hostage during the Olympic Games in Munich. The kidnappers demanded 234 Palestinians be freed, as well as the release of Andreas Baader and Ulrike Meinhof, leaders of Germany's Red Army Faction and the notorious Baader-Meinhof Gang.

Wary that the authorities would not meet these demands, the terrorists killed all eleven hostages during a shootout with German police. ABC's sportscaster Jim McKay, reporting from outside the Olympic Village, was concise in summarizing what media would call the "Munich Massacre": "When I was a kid, my father used to say our greatest hopes and our worst fears are seldom realized. Our worst fears have been realized tonight."

Nixon, in spite of his ambitions, could not control the international bughouse. And as he publicly extolled the domestic laws, his cronies conspired to break a few. E. Howard Hunt—the second in command at the Watergate break-in, was among them. Even with the death of his wife from a plane crash still haunting him, and being sentenced to prison for 35 years in March of 1973 (though released by the Court of

Appeals in December), Hunt also managed in 1973 to publish a novel (under the pen name David St. John). It was called *The Coven*, and it told of a chanteuse performing at Georgetown's Blues Alley, who after mysteriously disappearing, later turns out to be an African voodoo priestess.

Hooper, Henkel, and Hunt seem to be channeling each other when Hunt's protagonist, Jonathan Gault, describes his encounter with a voodoo medium who carries a ceremonial "tray with what looked like the bleached bones of small animals" and sprinkled with ashes from a graveyard. Alluding perhaps to the scary spell Hunt might have been under during a Nixon meeting, Gault grapples with a dichotomy: "There were two voices, it seemed, in angry conflict, and as I watched and heard, the sensation grew that I was listening to an *externalized* debate of Good and Evil."

Hunt's novel also calls to mind *Chain Saw*'s Slaughter family, with their wicked rites involving juju masks, dead animals, chicken feathers, putrescent odors, and human sacrifice. The other story in *The Coven* is the horror of Georgetown itself. Once a cobblestone refuge for the haughty and the wealthy, it had mutated by the early '70s into a haven for Hare Krishna chanters, porno peddlers, and often-hostile stoners. Superstitious Judeo-Christians recoiled at the blitz of astrology manuals, Tarot decks, and Egyptian Ankh amulets multiplying in the area's head shops.

William Peter Blatty also cursed the area with satanic possession in *The Exorcist*, but Hunt, a white-collar rapscallion, also had his moral limits. He expressed them (via his Mr. Gault) with sardonic revulsion when appraising Georgetown's makeover: "Peeling pink paint, sagging steps that suggested active termites, and window-glass obscured with fingerpaintings, Day-Glo posters and scrawls instructing passersby to undertake unnatural connection with the president, and murder a pig

a day. About average for the humanistic life within." Though corrupt enough to accept blackmail money from Nixon's secret fund, Hunt still recognized a decadent society, even if he contributed to it.

A taped conversation between Nixon and John Ehrlichman, from the 2013 documentary *Our Nixon*, offers an eerie peek at the ethical blob absorbing Nixon's personality. His inner struggle with what John Dean had diagnosed as the "cancer" growing on the presidency" is evident when Nixon and Ehrlichman confer about the California break-in to Daniel Ellsberg's psychiatrist's office. Nixon claims, "I didn't know about that, did I?" Ehrlichman bravely reminds him that he *did* know about it, and Nixon replies with a bewildered "Yeah."

"Now, I didn't know there was a taping system in the room, at the time," Ehrlichman reflected. "Since then, it's occurred to me that he was talking for the record, among other things. But at the same time, I'm convinced that he really didn't know the difference between what was true and what wasn't true at any given moment, for a long time. And he could persuade himself of almost anything, which is kind of too bad."

By April of 1973, authorities traced the raids on Daniel Ellsberg's psychiatrist's office and the DNC headquarters at the Watergate Hotel to John Ehrlichman and H.R. Haldeman. Both agreed to fall on the sword. On April 30, when he made his televised address announcing that he had accepted their resignations, as well as his firing of John Dean (who was already colluding with Watergate sleuths), the Commander-in-Chief seated in front of the golden curtain now seemed to be immersed in a wicked wonderland between the ethical world he consciously believed and the underworld of wheels, deals, and deception he needed to maintain both his public image and what remained of the nation's equilibrium. But the face of Nixon fragmented more than ever. Historian Anthony Summers writes that Ehrlichman described

Nixon at this stage as a "sea anemone which recoils and closes when it is threatened. I began to feel that he didn't know what the truth was." The once, tough, anti-communist crusader succumbed to booze, Dilantin, and fits of sobbing. Both Ehrlichman and Haldeman claimed that Nixon confided about praying at night that he would die before he woke.

In a 1982 interview, Ehrlichman admits to, at one point, looking for a way out: "We're on Air Force One. We were going off to dedicate a John Stennis memorial rocket launcher, or something, in Mississippi, and I'm standing on the flight deck, and it occurred to me for about 30 seconds that I could crash this airplane, and that would put an end to everybody's problems. Mine and Nixon's and Haldeman's and everybody who was aboard."

The era's leading journalist Harry Reasoner, among those damned with the task of reporting GI body counts on the nightly news, was diplomatic when calling Nixon "a complicated man," but Nixon was himself sometimes candid, admitting he had a temper yet was always careful to keep it controlled. As Rick Perlstein reflects in his book *Nixonland*, "The strategy hewed to a Nixon maxim: *the only time to lose your temper in politics is when it is deliberate*." But the president could not live by his words, and Reasoner probed deeper as Nixon's temper got more irrepressible, seeing the president struggling to uphold "the image of a strong man beleaguered by fools."

E. Howard Hunt, G. Gordon Liddy, and a bevy of other suspect characters had poked holes into Nixon's aura, forcing him more into the role of animal trainer than statesman. The so-called "plumbers" were akin to the idiots the Cook feels compelled to beat and threaten: they had violated Nixon's protective code. And the five men who got caught installing bugging devices into the DNC headquarters were, in Nixon's eyes, bungling spooks. The Cook clubbing the Hitchhiker in

that memorable scene full of backlights, silhouettes, and dust could very well be a metaphor for Nixon's giving hell to the hooligans who helped to ruin him.

In June of 1973, when *The Texas Chain Saw Massacre* was about to roll camera, Nixon had already begun to show the face of moral schizophrenia to the world. Around this time the Carpenters released "Yesterday Once More," a tearjerker of a tune about listening to old songs on the radio and yearning for a past that "makes today seem rather sad." The month before, a good-natured Nixon invited the Carpenters to perform at the White House, and though he likely shared the song's nostalgia for a more-defined past, he again displayed his inner skirmish by introducing the group with a snarky anecdote: "an old story about a man who used to sing the same song, hum it over and over and over again. And his friend once asked him . . . , 'Why do you hum that same tune?' And he said, 'Because it haunts me.' And his friend said, 'It ought to haunt you: it died fifty years ago.'" But Nixon proceeded to acknowledge that "the Carpenters are very much alive," calling them "young America at its very best."

Nixon's mood got darker in the ensuing months. During the Senate Watergate Hearings in July of 1973, for instance, Haldeman's former aid Alexander Butterfield revealed that Nixon indeed kept secret recording devices in the Oval Office. From there, the President got more pressure to release the contents of those tapes, but he refused: "Let others wallow in Watergate," he told a gaggle outside of the White House. "We're gonna do our job."

Among the most sensational, caught-on-camera moments happened on August 20, 1973, when Nixon tried entering a convention hall in New Orleans to address the Veterans of Foreign Wars. He got so angry at his press secretary Ron Ziegler for failing to keep the reporters at bay that he grabbed Ziegler, turned him around, and pushed him into the

Fourth Estate's lair. Nixon then proceeded to give a speech that morphed into a macabre performance as he paced, stammered, and looked to one audience member like "Ed Sullivan on speed." Any achievements the president tried to make got upstaged by what he called the "goddamn cannibals" in the press who would not stop messing around that goddamned graveyard of Watergate.

"Shades of meaning flicker over the Watergate scene and defy precise judgment," John Osborne wrote in *The New Republic* on September 15, 1973. The scandal nurtured a political climate that shape-shifted with its leading villain. As David Greenberg writes in *Nixon's Shadow: The History of an Image*, "Enemies and allies alike observed that he presented different faces to different audiences. Haldeman called his boss 'a multifaceted quartz crystal. Some facets bright and shining, others dark and mysterious. And all of them constantly changing as the external light rays strike the crystal.'"

On November 17, 1973, Nixon gave a press conference at Disney World in Orlando, Florida, where he uttered his infamous "I'm not a crook" speech. A year after this proclamation, theater goers across America heard the Hitchhiker taunt his elder by declaring, "You're just a cook!" "I'm not a crook" and "You're just a Cook!" form a perverse couplet—a phonetic mind-tickler that further merges the fraying identities of two men humiliated by subordinates who turn houses of pride into houses of shame.

America was undergoing its own reassessments of what was normal and conventional, re-evaluating the post-World War II notions of the American Dream that appeared to be evaporating. Nixon became a projection: a human Rorschach blot whose guilt reflected the growing collective guilt. And it was all because of *the face*. Bob Woodward and Carl Bernstein, who were the darlings of the *Washington Post* following their Watergate expose that became *All the President's Men*, went on to write another book in 1976 entitled *The Final Days*. There, they

dramatize an incident in May of 1974 when Nixon returned from a trip along the Potomac on his yacht, the *Sequoia*. Photographers waited at the pier, and Nixon snapped:

> *"Nixon left his chair abruptly and started pacing. They were trying to get a picture of his face, goddammit. They were attempting to discover how he was handling the pressure. . . . Goddammit, Nixon shouted into the phone, why was the press always hounding him? Why couldn't he get a few private moments? How had it leaked out that he was aboard the Sequoia? Goddammit, he hadn't wanted it discovered. Why couldn't Ziegler control the press? Goddammit, goddammit, oh, goddammit."*

Woodward and Bernstein go on to quote Arthur F. Burns, Nixon's chief counselor in the administration's early years, whose thoughts upon reading transcripts of the tapes return to a recurring literary theme: "Here is a Dr. Jekyll. A split personality. What does it all mean? Does Nixon live a double life? Is he a great actor?"

"One year of Watergate is enough," Nixon declared in his 1974 State of the Union address, but the scandal continued to nullify his bromides about health care and world peace. Then summer arrived, and Nixon's carapace of control soon dissolved before the world. He got beaten up again on July 24, 1974, when the U.S. Supreme Court ruled unanimously against him, demanding that the president no longer hide behind any executive-privilege secrets. Nixon resisted and scoffed, but he had to surrender to the federal district court all of his tape recordings and subpoenaed documents. The *United States v. Nixon* case prompted the impeachment ritual. His most-prized confidantes warned him of the imminent bad news.

One of his subpoenaed tapes, a conversation he had recorded in June of 1972 with H.R. Haldeman, got released to the public on August 5, 1974. It revealed his direct role in covering up the Watergate break-in, quashing his previous denial. On the tape, he suggests to Haldeman that they use the CIA to put the clamp on the FBI's investigation. This "Smoking-Gun Tape" satisfied the special prosecutor Judge John Sirica and the House Judiciary Committee, who finally had a solid case against the president.

"I have never been a quitter," Nixon declared with a torn voice. "To leave office before my term is completed is abhorrent to every instinct in my body. But as president, I must put the interest of America first." As Nixon resigned on August 8, the same day that the *Chain Saw* crew was wrapping up its official photography, his trusted and abused press secretary Ron Ziegler was still there to give him moral support. On the following day, Nixon went into the East Room to address an audience that was alternately stoic and weeping. As he spoke, his mind wandered like that of an older man who has lived long enough to meld past, present, and future into one melancholy daydream. He was consistently complex in these final moments: humble, sad, yet gently defiant. Then, the now ex-president gave the two-hand victory sign, entered the presidential helicopter, and flew into temporary exile.

In the *New Yorker*, Jonathan Schell wrote in August of 1974 his first-hand account of Nixon's manner as he gave his final goodbyes to his cabinet: "Human feeling played across his face: grief, regret, humor, anger, affection. He spoke of his parents. His father, he said, had failed at many things he had undertaken, but he 'did his job' and had been 'a great man.' His mother 'was a saint,' he said simply. However, no books would be written about her, he said, weeping now."

Al Pacino's character Michael Corleone, whose true mendacity was clearer in the 1974 film *The Godfather: Part II*, was the opposite of Nixon.

The all-American son of European immigrants, yet burdened with mob roots, exchanges his honorable military service to become a player in an alternate world ruled by thugs, all the while showing how the gangsters were not so much different from many "legitimate" corporations and government honchos. But Corleone had a cold, invulnerable exterior that hardly ever varied. Most viewers quickly understood the connection with the "play close to your vest rules" required of hoods, CEOs, and politicians. By the end of Coppola's film, Michael, the new Godfather, is a murkier incarnation of his dad Vito. Nixon also worked to keep his enemies closer than his friends, but like the Cook, he was too goddamn human to conceal his devils as adroitly as the reptilian Corleone.

The Human Potential Movement held more sway as the '70s progressed, and confessional therapy got more press. Nixon (without consciously realizing) entered this forum his own way. Unlike John Lennon, who sought the primal assistance of Arthur Janov but remained on Nixon's enemies list nonetheless, Nixon needed neither primal screams nor gestalt sessions. He had his tapes into which he could vent his spleen and essentially bitch about almost everybody and everything. He stammered into his recorder when his strict mother was not there to scold. Now, Mr. Quaker was imitating other '70s crybabies, thinking only he would hear his recorded outbursts. But his darker moods gave the psychobabblers more chances to make patronizing insinuations about his being "unhinged." He once summed the problem up to Henry Kissinger point-blank: "The press is the enemy . . . write that on a blackboard a hundred times."

Nixon revealed his pangs of insecurity when speaking about outsiders conspiring against him, particularly when they ridiculed his humble beginnings. As a defense, he referred to his dirt-poor father and his California lemon grove. The Cook, likewise, in a desperate attempt to

control his ornery subordinates at the dinner party, conjures memories of Grandpa's talent for bludgeoning "the beeves."

Gunnar Hansen (in an audio commentary for the film's 40th Anniversary Blu-ray release) marveled at how Jim Siedow "was probably the only actor in the movie who could look benign and then become extremely evil without any makeup." The Cook's face, like Nixon's but worse, exposes a rictus of ethical clashes. Siedow's character, like Nixon in his final presidential days, represents a paragon of what R.D. Laing called "the divided self."

Hooper veered toward portraying a rural variation on Nixon, with lunatic eyes and body spasms ready to lash out. In real life, Jim Siedow was a kind, mild-mannered guy with some background in Shakespearean acting, so when the time came for him to come charging at Sally with his broom, Tobe needed to do lots of coaxing.

Siedow recalls some of that exchange in *The Texas Chain Saw Massacre: A Family Portrait*:

> "When we first started that scene in the barbecue shack where I'm beating Marilyn up—that was hard—we started out and I couldn't do it. They'd keep telling me to make it look real—'Hit her!'—They couldn't use anything that looked fake, so I'd start and—'No, you got to hit her harder, hit her some more!' Marilyn said, 'Hit me, don't worry about it.' And every time we'd try it she'd come up with a few more bruises. Finally I got with it and starting having fun doing it and started really slugging her, and we kept that up—we did eight shots—and then they finally said, 'That's a take.' She just fainted dead away—the poor girl was beaten up pretty bad."

Upon hearing Nixon's liberal use of words like "bitch," many Americans likely reacted as alarmed as *Chain Saw* audiences did when the Cook, yells "Kill the bitch!" (a command that the Hitchhiker echoes) as Grandpa whacks at Sally. Even during the scenes when he beats Sally with the broom, ties her up, stuffs a filthy rag in her mouth to stop her from screaming, covers her in a burlap bag, and tortures her all the way to his Slaughter house, the Cook still hiccups with flashes of semi-sanity. "No need to torture the poor girl," he yells at his two moron accomplices during the harrowing dinner scene. Squeamish viewers beg and bellow at the screen, hoping he makes a turnaround and heeds Sally's plea to "make them stop." He instead resorts to halfhearted triangular diplomacy: "Just some things you gotta do. Don't mean you have to like it." Yet, "Kill the bitch!" is the movie's final line, and it leaves an indelible impression.

The Cook, by releasing Mr. Hyde at the end, takes the film to another level of horror almost as excruciating as seeing Sally struggle to keep her skull from getting crushed by Grandpa's slipping hammer. Nixon, with recorded invectives rumbling beneath the tailored suit, became a horror ogre as well. Stress lined his face through the makeup, and he started to look meaner. Many expected the big scandal to push him out into the television airwaves screaming more profanities, as the nation in many ways grew mad along with him.

In 1974, several Watergate pundits opined that Nixon's downfall brought the country's spirit down as well: when Americans incorporated cynicism into their daily perceptions, when they lost what little faith they already had in their institutions, when they considered corruption as just an integral part of the working order, and when what they previously thought criminal they came to rationalize with the *Godfather* alibi that *corruption* and *power* go hand in hand.

Many considered this era a shock to America's conscience. To push another horror-movie analogy, Nixon became Washington's answer to *The Abominable Dr. Phibes*—the vengeful horror icon that Vincent Price portrayed in several films starting in 1971. Even the round, yellow smiley-face icon that appeared on buttons and charmed so many '70s adolescents could not withstand cynical scrutiny. The Nixon grimace became a lingering shadow.

America might have endured worse problems, but Nixon's hubris became a twentieth century parable. And it happened at a juncture when international forces tried to make the U.S. reconsider its eminent position on the planet, when the fall of South Vietnam lurked in the bleak horizon, and when *The Texas Chain Saw Massacre* arrived just in time to offer terror, therapy, and an unofficial appearance from the thirty-seventh president, who shifts in and out of the Cook's face like a holographic Halloween mask.

The fumes worsen and the flies buzz by the time Sally Hardesty wakens to find herself pinioned to an armchair with real arms, staring at a chicken's head and feet nailed to a board, a dead armadillo, more animal bones, a human skull, and the semi-corpse of Grandpa sitting opposite her at a table spread that includes sausage (likely her ground-up friends) and an overhead lantern made from the skin of a human face.

On the set, *Chain Saw* became a movie within a movie because the conditions, especially on that long night that bled into the following day, were so putrid and the indoor temperatures so high that cast and crew had to take periodic vomit breaks.

CHAPTER NINE

"YOU THINK THIS IS A PARTY??"

"I think we are all dead, and sitting in hell."

—DOROTHY PEARL,

WIFE OF CINEMATOGRAPHER DANIEL PEARL

We certainly would slide into some kind of irrational passion as the filming wore on," Gunnar Hansen would say, remembering what it was like to smell so bad that no one on the movie set would go near him. He was not the only poisonous player in the dinner party climax—*The Texas Chain Saw Massacre*'s ninth circle of hell—but Hansen knew deep down that making good art requires suffering.

Chain Saw became a movie within a movie: the conditions on that long night that bled into the following day were intolerably putrid. Some cast and crew members referred to it as "the last supper." The heat and humidity outside and inside were so high that tempers ignited and stomachs turned. Some were sickened, but the windows were covered with dark blankets to give the day-for-night illusion, and they had to run outside for oxygen and periodic vomit breaks. The Quick Hill Road house, where the "party" takes place, also had one bathroom for a cast and crew of about forty. Who could think about eating?

The fumes worsen and the flies buzz by the time Sally Hardesty

wakens to find herself pinioned to an armchair with real arms, staring at a chicken's head and feet nailed to a board, a dead armadillo, more animal bones, a human skull, and the semi-corpse of Grandpa sitting opposite her at a table spread that includes sausage (likely her ground-up friends) and an overhead lantern made from the skin of a human face.

Robert Burns had put together the menagerie of rotting carcasses, creating most of the pestilence as the indoor temperature got up to 115 degrees. One of the most revolting accounts of the dinner-party ordeal involves the actors being forced to wear the same clothes for the five weeks during principal production in order to maintain continuity.

Among the casualties was Gunnar Hansen's shirt, collecting mega-sweat from the jogging exercises he did regularly to keep his body in decent enough shape for the final chase sequence. Hansen claimed that languishing in a room full of putrefying headcheese and other moldy meat impelled him (along with some the other players) to lose touch with reality. In August of 2017, Hooper got quoted in the *Daily Telegraph* regarding the aftermath of those desperate hours: "At the end of filming, everyone hated me. It took years to re-establish those friendships but I knew what I needed to get."

Hansen, Marilyn Burns, Edwin Neal, Jim Siedow, and the eighteen-year-old John Dugan (who had to sit for hours under layers of makeup and prosthetics to look like a 100+ year-old man) endured work conditions that would no doubt be illegal in today's pampered and heavily unionized film industry. It turned out to be a twenty-six-hour ordeal, aggravated by the stress, the heat, the odor, and the dead dogs (as extra scenery) that got too rank, despite Dorothy Pearl's attempts to inject them with formaldehyde.

In the final production phase, Hooper, Henkel, and the rest of the crew edited the twenty-six hours down to an effective *Chain Saw* Götterdämmerung. "Looking at my shooting script," Gunnar Hansen

notes in *Chain Saw Confidential*, "38 percent of the pages are revisions, 62 percent are not. So of every five pages of script, two were revised." Robert Burns, in *The Texas Chain Saw Massacre Companion*, also recalls major changes: "The script was shortened considerably. The original had many pages of the kids driving around, with much late-hippie banter. Much of it was written day-by-day during shooting. The abandoned house sequence was added in, as the found location was across the street from the main house."

Robert Burns also describes how shooting those scenes had traumatized the house's original stewards: "So there were people living in the house—it was a nice, old Victorian, they were hippiesque people, at one with nature and at one with the house, and they were very concerned we not mess it up. And we said, 'We're not going to mess up your house!'—and of course we just came in and stomped all over it. We tried to be very careful in making it look run-down so as not to damage it too much—a fanciful pipe dream in the world of filmmaking. We were there longer than we were supposed to be . . . It didn't add to the camaraderie of filmmaking."

Cinematographer Daniel Pearl shared the cast and crew's worry over Hooper's free-form work habits that contributed to the dinner-party disorder. According to Hansen, Pearl recoiled when he initially read the script: "I had chills up my spine. I locked the door when I was reading it." Still, he appreciated the challenge, knowing that the limited budget allowed for only 16mm that he planned to expand to 35mm. To minimize the grainy look that would result from the blowing-up process, he used the slowest stock he could find. Regardless, he and Hooper argued continually over the lighting, while the rest went on perspiring, pouting, and waiting for filming to resume. As Ted Nicolaou, the sound recordist, recalls in *Chain Saw Confidential*, "We would spend hours each day waiting for Tobe and Kim to make up

their minds on what they were going to shoot. It was unusual for a low-budget film."

During the dinner scene, and the household argy-bargy leading up to it, Leatherface wears three masks, or three selves. As the Cook scolds him for ruining the door and for being slipshod in general, Leatherface appears as a matronly figure in an apron, armed with a wooden spoon, and even signs of a dowager's hump. His voice is high, though incoherent, as he tries to convince the Cook that everything is okay. Hansen claims his character mutters only gibberish, but he sounds as if he is saying, "I'm not kidding," when trying to convince the Cook that he properly disposed of the intruders. Sally, still bound and gagged, soon panics as she recognizes him and the Hitchhiker the moment her head emerges from the gunny sack.

Leatherface and the Hitchhiker lug Grandpa down the stairs in his rocking chair. Grandpa then assumes the role of an infant in one of the more unwatchable scenes. As Dugan remembers in Hansen's book, Hooper advised him that Grandpa "was an embryonic old man" to the point of regressing full circle to an infant phase. This explains Grandpa's baby-like motions when Leatherface cuts Sally's index finger so that the near-corpse could suckle and flex his body like an imp at his mother's teat.

The finger-sucking scene also has a backstory. The prop knife they used, which contained a tube of fake blood that Hansen was to squeeze onto Burns's finger, had malfunctioned. They tried many takes, and finally Hansen grew so impatient that he surreptitiously sliced her finger for real before exposing her to Dugan's saliva. Neither Burns nor most anyone else on the set even realized what had happened. Years later, during one of many after-screening Q&As, she learned about this for the first time. Dugan was also surprised but not as furious as Burns:

"I didn't find out until years later I was actually sucking on her blood, which is kind of erotic really."

Dugan apparently had libido fever during the shoot and was eager to include a scene when he was to tear off Sally's blouse. Hooper, however, still hoping for a PG-rating, did not abide. The film was, in fact, so chaste sexually that it did not even allow for any romance, an omission that McMinn regretted regarding her supposed relationship with Kirk, being that they do not even share a kiss. But romance, no matter how sweet, would have ruined the film's asexual allure. As Marilyn Burns observes in Hansen's book, "Their sexuality is so repressed that it manifests itself only as sadistic cruelty."

Hansen's book also has William Vail, as first-victim Kirk, interpreting the film differently. Vail alludes to what would later be called "torture porn": "I started thinking about just the simple fact of the abuse of the main character, and the torture she was put though, and the abuse she was put through. Because in a way you could look at it as porno, and that people who get off on the pain and torture could see that this movie is like a movie to get off on, something you'd watch in your bedroom without anybody else around."

Edwin Neal, the sassiest of the *Chain Saw* alumni, and who once vowed to clobber Hooper upon ever encountering him again, calmed down a decade later to share his sense memory in *The Texas Chain Saw Massacre: A Family Portrait*: "It was like its own major amphetamine. It just got crazier, and crazier, and crazier. You're sitting here at four o'clock in the morning, talking about hitting people in the head with hammers. What's the best way we can depict the hammer coming down the back of the head? These are grown men, sitting in the room discussing this like it was some kind of scientific tenet that they are working on here."

Marilyn Burns later recounted to Hansen in his book exactly how she felt during the feast of fiends: "You scared me to death. I didn't know you really at all, and by this time you're not sure if it's real or a movie. And snuff films were just coming in at this time, and I'm thinking—I'm not in a snuff movie, but I'm thinking *this is too real*. The leering, leering when you started coming at me, that was really scary."

For several years, snuff films (and the gruesome notion that people could be sacrificial figures on film against their will) were mere speculation. The snuff notion goes back to 1971, when ex-Fug Ed Sanders came out with a book entitled *The Family: The Story of Charles Manson's Dune Buggy Attack Battalion*. In it, he had spun a sensational tale about how Manson and his disciples filmed an actual murder. Sanders is also alleged to be the first to use the term "snuff" in connection with such an iniquitous medium.

As quickly as snuffing out a candle, "snuff film" became a trigger word that ultimately morphed into an urban legend. Yet shortly after Sanders's book, and the wild speculations about Manson swept a novelty-starved media circus, new rumors about films of actual murders started popping up. That same year, grindhouse pioneer Michael Findlay formed a production company in Argentina, where they made a film in 1971 called *The Slaughter*, inspired by the Manson Family murders.

The events in *The Slaughter* were, nonetheless, staged but later hyped as real, an illusion that grew when another producer purchased the film and got an additional director to add extra footage at the end when a supposed "real-life" actress gets disemboweled. They released the refurbished product in 1975 and called it *Snuff*, sporting the tagline, "The film that could only be made in South America . . . Where Life is Cheap."

Before most people had even heard of a "snuff film," *The Texas Chain Saw Massacre* offered a *sniff film*. Noses were burning, but no one really got killed on the set. But sort of like a snuff film, its performers endured

inhuman conditions and were not even sure how far the on-camera antics would take them. Production manager Ron Bozman summed up for Ron Bloom, in the November 2004 *Texas Monthly* article, the gulf between the director and everyone else: "Tobe really did have a vision. He knew exactly where we were at all times. But the rest of us were flying blind." Marilyn Burns blames it on naïve serendipity: "We were so young, so stupid, and so poor that we had to do everything in almost as realistic a way as possible."

Sally's incessant screams and the close-ups on her wavering green eyes, as the Slaughters torment her, are all the more grueling as Wayne Bell and Hooper's found sounds grate louder. Those close-ups were tailored best for crowded theaters full of viewers who also screamed, hollered, and sometimes hooted to the annoyance of those who like to take their horror more seriously.

After Leatherface changes from Grandma to a second, sterner mask to match his formal dinner attire, he mysteriously switches into the "Pretty Woman" face that Kim Henkel referred to as the "Clarabell Clown" mask (which the deleted scene of his dollying up in the nearby room would have better explained). This drag face is the most terrifying as he creeps closer to Sally before preparing for the ritual slaughter. Miffed that the "pack of hounds" takes too much delight in plaguing the hostage guest, the Cook explodes: "YOU THINK THIS IS A PARTY?" He gets more hysterical, and his facial tics increase, as he tries to placate both Sally and the two hooligans with such pointless drivel as, "It can't be helped, young lady." But the longer the pandemonium transpires, the more psyched he gets to join in on the fun, as his rotting smile betrays in a clammy close-up.

Hansen's book, which is the most comprehensive account from those involved in the production, recollects choice observations from his workmates. Ron Bozman recalled that he and his crew were "just out

of our minds at that point," due to the "smoking dead dog aroma" that permeated just outside the house when they tried soaking the carcasses with gasoline and the flames did not catch properly. Dugan, who nearly got asphyxiated in his Grandpa getup, confessed, "I was just trying to keep alive, to get through this day. I no longer even knew where the camera was." Marilyn Burns was a good sport despite leaking more real blood when the steel shaft of the foam-rubber on Grandpa's sledgehammer accidentally hit her head as she kneeled over the bucket. "It was a pretty tough shoot, though," she admitted, "but do you know what made it good? It made it to the camera. All our misery comes out on the film." In *The Shocking Truth*, Robert Burns, despite his fetish for collecting dead things, admitted it was "a very abusive production."

John Bloom summarizes, in his 2004 *Texas Monthly* article, the herculean effort involved in post-production: "In a film less than ninety minutes long, there are a total of 868 edits, some of them as short as four frames, or one sixth of a second." This foray into guerilla filmmaking turned out to be orderly, disciplined, and well crafted. In this methodical endeavor, Hooper managed to convey a near-documentary; the low budget helped. Plus, being an independent film, it was not bogged down with tried-and-true Hollywood camera angles.

In his interview for the *Family Portrait* documentary, an unflinching Edwin Neal offers wisdom that some cinephiles might consider sacrilegious: "There was some very ingenious working out of shot angles. It was a very learn-by-doing kind of thing. So, you get this documentary-type-style filmmaking because that's the only way they could figure out how to do it . . . Its popularity is based a great deal on seeing things that you've never seen before. These characters are much more interesting, I find, much more real than the characters in *Psycho*. I mean, three-fourths of the characters in *Psycho*, the original *Psycho*, are cardboard-ish . . . just your regular stock people. We don't care what

happens to these people. These people aren't interesting. Anthony Perkins's character was kind of interesting because he's not doing the same old stuff."

After a year of showering and attempting to cleanse the trauma from their minds, the cast and crew were finally enthused as the *Chain Saw* was about to buzz into its hometown. But the Lone Star death specter loomed once again, this time in Travis County. *The Texas Chain Saw Massacre* had its Austin premiere in October—just in time for National Sausage Month. But a stymied public soon had to make sense of two chopped-up Mormon missionaries: fatalities that some would call the "Texas *Band Saw* Massacre."

The killer was Robert Elmer Kleason, who (in another scenario to rival Robert Bloch's character of Norman Bates) ran a taxidermy shop. The young Mormons would often visit Kleason during their conversion rounds, while Kleason demonstrated his Southern hospitality by indulging them with delicious venison entrees. The local Mormon mission, aware of Kleason's reputation for illicit poaching, had warned the men to stop visiting. Yet Kleason just bided his time before the Texas authorities got wise two years later. He would be convicted and sentenced to death in Texas, but a technicality stayed his execution. His story continued to mutate . . .

After *Chain Saw*'s premiere, Gunnar Hansen shocked the world once more by exposing himself as a clean, kind, mild-mannered, intelligent, literate, poet. But even he looked back on the experience, particularly the protracted dinner scene, and understood how the mass hysteria on the set made him shapeshift into a different creature. He recalls in the *Family Portrait* documentary how he had drifted into a parallel world: "An hour into shooting, and it was smelling so bad we had to switch it out. And so, I think it was very easy for the scene to be very intense because we were all overheated, and we all smelled bad, and the food

smelled awful, and probably nobody liked each other at that point any-
more, and so it was easy to squabble and fight. And as I said, that was
the scene where I finally sort of forgot myself and got very involved
with killing Sally."

Going back to *The Greening of America*, Charles A. Reich had an
apparent obsession with bell-bottoms, for they represented what he
saw as the Woodstock generation's freedom of movement. In one of his
final chapters, he suggests a solution for wiping out war and reforming
market-driven values: ". . . the willing buyer of whatever the machine
produces is replaced by a buyer who buys only what he chooses. The
machine is forced to obey, and the market power of buyers is restored.
The machine has to turn out Beatles records, bell-bottom pants, or
better hospitals."

Reich, in his enthusiasm for entering "Consciousness III," saw such
clothes as a sign that America's youth was developing "a significant new
relationship between man and technology." He envisioned this as a
spontaneous mutation "sprouted up, astonishingly and miraculously,
out of the stony soil of the American Corporate State." He also wrote
that, during what was then Nixon's domination, governments would
have to undergo a sea change to adjust to this collective shift to (what
he fancied as) pure individualism. "At that point," he writes, "the
President would have to don bell-bottoms and a dirty T-shirt and go
looking for his constituents."

Sally's bell-bottoms, which Reich would have hailed as giving "the
ankles a special freedom as if to invite dancing right on the street," get
more soiled and tattered the longer she survives the Slaughter family's
attacks. Reich's utopian symbol gets slimed with layers of red-dyed
Karo syrup that make the cloth turn solid. By the time Burns makes
her second plunge through a window, the once purely white bell-
bottoms become toxic.

Deceived into thinking the filming ordeal was over, Burns got a grim surprise. As she states in *The Texas Chain Saw Massacre: The Shocking Truth*:

> *"The final day of shooting, I took off those white pants that just stood up to greet me every morning, threw them down, and I thought I'm finished, that's the end, that's over. Never again will I have to come and put on those horrible clothes; I can get my hair back into condition, I could get my skin back. I mean, I was going to have to rebuild everything. I was a mess. And they called me that night, and they said, 'Marilyn, something happened: we didn't get it.' I said, 'You didn't get what?' 'We didn't get it; we gotta reshoot this.' So, when I was crazy at the end of the movie, laughing hysterically, that wasn't acting. That was me, having to go back and do it one more time."*

With Reich's sartorial dogma in mind, viewers can regard Sally's marred bell-bottoms, once-liberated linens now tainted beyond repair, as one of the film's subtle digs at the counterculture's fashions and, by default, many of its ideals that, by 1973, were showing wear and tear. The party was over, and the fat killer danced against the sunset, waving his weapon in fury before the screen went black.

Despite their obvious differences, *The Texas Chain Saw Massacre* and *Deep Throat* explore two movie taboos that intensified as the '70s unraveled: dangling flesh and flesh eaters.

CHAPTER TEN

LEATHERFACE AND LOVELACE

[The Texas Chain Saw Massacre is] "*despicable . . . ugly and obscene . . . a degrading, senseless misuse of film and time.*"

—LINDA GROSS, LOS ANGELES TIMES

Leatherface and Lovelace—two early 1970s icons of guerilla film-making tangled in a sociological courtship. Respectively, they explored the horrific and horny extremes, became movie mutations, and helped to instigate challenges about which films are "acceptable" to show, which age group could see them, and which communities—as well as other countries—would ban them.

As two marauders off to invade cinema's visceral frontier, Leatherface and Lovelace stretched the boundaries of "good taste" and engendered future grindhouse offspring that combined brutality with doses of sex (although usually not hardcore pornography). Leatherface and Lovelace raided the body (or, for academics, "the body politic") and broke tradition's backbone during a unique and hot-blooded period in contemporary American history.

In *Chain Saw Confidential*, Gunnar Hansen mentions that Robert Burns, *Chain Saw's* art director and production designer, once fashioned

a "Linda Lovelace *Deep Throat* pinball machine . . . something Bob had designed and built from a previously defunct, more innocent machine. He was proud of his invention and quick to point it out." Perhaps Burns also had an unconscious premonition that Leatherface and Lovelace might somehow cross cultural paths. Teri McMinn, in one of several squeamish reflections about her *Chain Saw* days in the role of Pam, reflected how, "at the time that was all happening, doing horror, hard-core horror, was like doing hard-core porn."

When finishing the film, Hooper and Henkel were not exactly chirpy about its commercial promises. "There were quite a few days," Henkel recalls in Hansen's book, "where I thought, *There's no way in hell we're going to get through this with anything that's worth doing anything [with], except sticking it in a shoe box and throwing it in the back of the closet.*" Edwin Neal was just as doubtful: "I didn't know that it would all fit together. That was my biggest fear, was that the parts—some of which were quite good—how were they going to get them in a cohesive whole? This worried me a great deal."

Along with Hooper, Henkel, chief editor Larry Carroll, Sallye Richardson also worked assiduously on a Steenbeck for over a year to stitch the right parts together. "*Chain Saw* was made in editing," Richardson recalls in the *Texas Chain Saw Companion*. "But basically, once post-production started, nobody touched that film apart from Tobe and me . . . I'm the one who cut the tracks. And if you think Marilyn Burns screamed for one day—it took me maybe two weeks to cut that track . . ."

It was late in the summer of 1974 when they finished editing and made something greater than they had anticipated. *Chain Saw* was all trimmed to camouflage the clutter they had assembled the year before. Now, they had to convince players in the movie business to concur. The business side of *Chain Saw*'s history offers another kind of

pornography involving the passions, degradations, and sometimes sadism of accountants, lawyers, plaintiffs, alleged mobsters, and fiscal busybodies obsessed with facts, figures, and fluid dollar amounts.

Apart from how the cast and crew withstood the heat, the stench, and Hooper's incessant retakes, the distribution phase of *The Texas Chain Saw Massacre* provided extra layers of horror that reflected the changing power dynamics of movies, particularly the diminished role of the old studio system. Bigwigs like Paramount, Warner Bros., Universal, and even American International Pictures (Roger Corman's old haunt) turned down offers to distribute *Chain Saw*. Columbia had initially agreed until its board of directors met in New York City, caught a screening, and refused to dine on Hooper's cannibal holocaust.

Warren Skaaren, the film's prime benefactor who contributed its jaw-dropping title, came to Hooper's aid once again. A dream offer arrived after Skaaren touched base with Bryanston Films, which formed in the early '70s, partly as a result of the vast sums of money its members were making from distributing *Deep Throat*. Bryanston proved adept at dispensing naughty, violent, low-budget fare that established studios would not touch.

Bryanston was manned by Joseph "The Whale" Peraino and his brothers Anthony "Big Tony" and Louis "Butchie." They doled out hefty sums of cash for what they saw as promising projects. By the time Bryanston lured Hooper and company into a deal, the advance for the film went up to approximately $225,000. It was as if Daddy Warbucks were reborn from a comic strip figure into a real-life mogul hurling directives from a smoke-filled boardroom. Even Jay Parsley found new hope that his precious $40,000 investment was not doomed to swirl down a commode.

Just as the promises of money and exposure helped Hooper feel restored, another American, much more prominent and supposedly

the most powerful, was falling from grace. As he prepared to leave his Oval Office after clinging so long to stay, President Nixon resigned. Mystically speaking, Nixon became the ritual sacrifice in an atmosphere that was tough on government corruption but prosperous for transgressive movies that allowed Leatherface to become a new species of monster and for Lovelace to introduce a large swath of America to body parts and activities they otherwise dared not talk about in public or to themselves.

When Hooper and company signed the deal in August of 1974, and Bryanston released the film, Hooper had no pretenses about "socially redeeming value." The press notes quote him with a detached and somewhat nihilistic attitude: "It's a film about meat, about people who have gone beyond animal meat and rats and dogs and cats. Crazy retarded people going beyond the line between animal and human."

With *Deep Throat* and other feature-length "skin flicks" going more mainstream, a few who had tinkered in what some in those days referred to as "poontang" became horror-bound. Wes Craven admitted to making porn films in the weaning stages of his career. So, when he spiked *The Last House on the Left* with rape and the close-up of a woman forced to urinate in her jeans, he was already inured in the art of mixing horror with kink. Instead of making dirty pictures, however, Hooper and Henkel started with sex-free horror but fell into a web of financial mischief usually associated with an underworld that bank-rolled "smut."

Despite its shady side, Bryanston was shrewd about marketing independent movies that reflected the shifting tastes. Among them was *Return of the Dragon* (1972), which Bruce Lee both starred in and directed. In bringing out this second-to-last Lee entry, Bryanston contributed to the massive idolatry surrounding him after his death in July of 1973. In 1974, Bryanston was responsible for letting the public see

John Carpenter's first feature *Dark Star,* as well as the 3-D nudity, sex, violence, and even bowel rape in *Andy Warhol's Frankenstein.* Amid the horror, lechery, and violence, the Perainos also hoped to put out a movie about a pope. For *Chain Saw,* they also produced a killer poster: Leatherface flaunts his weapon, Pam hangs by the meathook in the background, and the caption asks, "Who will survive and what will be left of them?"

Who could fault Hooper and company for flirting with the purported underworld, when the respectable overworld proved so dismissive and prissy? Bryanston had an instant appetite for *Chain Saw,* but its initial largesse proved to be an illicit fix when actors and others involved with making the film later discovered that, despite the millions of dollars it was raking in, tiny fractions of those earnings showed up on their royalty checks.

There was all that talk about how *Chain Saw* required merely several thousand dollars to make and was grossing millions, but most of that cash got funneled into a mystery wallet. Years afterward, actors complained about getting little or no pay. The attempt to settle this matter with Bryanston head-on proved as treacherous as those dramatized accounts in Hollywood blockbusters of the time like *The Godfather: Part II. Chain Saw* got mired in what appeared to be a mob-style scandal.

With a reputation for usually being easy going, the Bryanston bosses were known to display a different temper when clients complained about not getting their expected share. The Perainos attempted to distract the dissenters with tales about accountants being out of town. And when the disgruntled crossed the Rubicon by asking to examine the Bryanston books, the Perainos gave their pre-break-your-legs notice: "You ain't got the balls to sue me."

To comprehend the quicksand Hooper and Henkel had entered is to understand *Deep Throat'*s cultural impact and commercial success.

When *Deep Throat* premiered at Time Square's New Mature World Theater on June of 1972, curious crowds stood in lines spanning blocks to witness the incursion into what many called "porn chic." Prominent feminist authors like Erica Jong and sexologists like Dr. Ruth Westheimer lauded how the movie would inspire everyday folk to bring up otherwise icky sexual matters at watercooler conversations in the workplace.

Martin Scorsese, Brian De Palma, Mike Nichols, and Jack Nicholson caught a screening. The ever-puckish Truman Capote liked the film and thought Lovelace charming but admitted, "I know a lot of people who don't want to see that sort of thing and so they don't. They probably couldn't stand it. You see it at your own peril." Others with more middle-of-the-road reputations such as Frank Sinatra, Barbara Walters, and even Nixon's vice president and public moral scold Spiro Agnew had a peek at this kryptonite to the mores of the Silent Majority.

Like lemmings, audiences were willing to pay the then-extortionate $5.00 admission to witness the sixty-five-minute sex tale that became the event of the season. Unlike the usual porn, with its spiritless and mechanical loops, *Deep Throat* had a story plot, a catchy soundtrack and theme song, and lots of self-deprecating humor that allowed the explicit scenes to fall back on parody. And many, likely embarrassed or nervous, laughed along.

Johnny Carson, a barometer for relevant topics via his *Tonight Show* monologues, joked about judges being able to watch *Deep Throat* but not being able to listen to Nixon's tapes. One night, Carson's alter-ego, the turbaned seer Carnac the Magnificent, who routinely guessed questions to answers, responded to "The Mississippi River" with "What's the only thing that has a bigger mouth than Linda Lovelace?" Bob Hope said that, being "fond of animal pictures," he went to see it and "thought it was about giraffes," while Nipsy Russell perhaps

accidentally called the film "Sore Throat." Al Goldstein, the jovial publisher of *Screw* magazine, found religion: "I was never so moved by any theatrical performance since stuttering through my own bar mitzvah."

Deep Throat became such a common coffee-klatch topic that Bob Woodward and Carl Bernstein used the movie title to denote a mystery Watergate leaker in their tome *All the President's Men*. However, for all of its widespread outrage, *Deep Throat* sounded an alarm to the staid movie industry: independent movies, even without customary cinematic merits, could gross hundreds of millions of dollars and leave an indelible impact.

Into 1972, the West Coast contributed to these cultural shifts. San Francisco porn kings the Mitchell Brothers, who ran their own theater on O'Farrell Street, were bemused by a hilarious moral contradiction. A young model named Marilyn Briggs moved to San Francisco in 1970, where she took several jobs including topless and bottomless dancing. She answered a casting-call advertisement in the *San Francisco Chronicle* for what seemed like a major Hollywood production. Instead, she became the Mitchells' superstar Marilyn Chambers. But while she portrayed the nymphomaniac lead in *Behind the Green Door*, another Marilyn confronted casual shoppers in supermarket aisles across America, this time holding an infant as her wholesome mug appeared on boxes of Ivory Snow for a photoshoot she did before her *Green Door* breakout.

Unfortunately, as many well-meaning media voices tried convincing the public that sex is not a vice, the sexual entertainment industry was often vice-ridden. In the early '70s, the Colombo crime family was grabbing a fair share of attention. For those immersed in numbers, *Deep Throat* supposedly cost only $25,000 to make, was shot cheaply on 16mm, and took away over $600 million. But the cash was attached to the Perainos, who were in turn, reportedly attached to the Fort

Lauderdale-based Colombo gang. In order to assure that they got their investment back, which ended up letting them accumulate hundreds of millions of dollars, the Perainos used the rough tactics displayed in such Hollywood productions of the time as *The Don is Dead* and other variations on *The Godfather.*

For decades, the film world and its public ambled in a haze about what is "dirty" or worse "not socially redeeming." In 1957, the Supreme Court's "Roth Decision" defined "obscene" to be any work whose "dominant theme taken as a whole appeals to the prurient interest." Then in 1966, the Court attempted to clarify its definition, with a ruling that included the familiar phrase "utterly without redeeming social value"—a judgment so subjective that practically any book, including that high school favorite *The Catcher in the Rye* (with its sexually addled protagonist Holden Caulfield) could be labeled as obscene. Two years before, when the Court attempted to rule whether or not to apply the Scarlet "O" to Louis Malle's *The Lovers*, Justice Potter Stewart was so perplexed at what constitutes "obscene" that he uttered the now-legendary line, "I know it when I see it."

While still commanding his executive power before facing his own scandal, Nixon joined Congress in rejecting the results of the LBJ-sponsored Commission on Pornography and Obscenity. When released in 1970, *Report of the Commission on Obscenity and Pornography* found no evidence of a direct link between pornography and bad behavior. Worse for Nixon, the study results also recommended sex education in schools to help combat venereal disease and unwanted pregnancies. The only Commission member to dissent from its findings was the future bankruptcy fraudster Charles Keating, Jr., who in the late '50s headed a Roman Catholic anti-pornography group called Citizens for Decent Literature.

Nixon responded by going into overdrive:

> *"If the level of filth rises in the adult community, the young people in our society cannot help but also be inundated by the flood . . . The pollution of our culture, the pollution of our civilization with smut and filth is as serious a situation for the American people as the pollution of our once-pure air and water. Smut should not be simply contained at its present level; it should be outlawed in every State in the Union. And the legislatures and courts at every level of American government should act in unison to achieve that goal."*

Along with Nixon's scolding, Keating tried to stop newsstands close to his office from selling magazines like *Oui* and *Playboy* and lambasted the Ramada Inn for offering adult entertainment on its cable television system. The Burger-led Supreme Court also threw its monkey wrench into the age of free expression. In June of 1973, the Court ruled in *Miller v. California* that "obscenity" could be defined by community standards, nullifying previous notions that the definition of "obscene" could apply nationally. What was acceptable for New York could now be deemed obscene in less lenient states like Texas or even small towns in California.

The 1973 decision had a three-pronged attack. In order for a work to be "obscene" it had to 1) offend people according to the "community standards" where they lived, 2) describe or show sex or excretion in an offensive manner, and 3) be devoid of "serious literary, artistic, political, or scientific values." In short, the Court decision left the country more confused. The first two stipulations at least confined the decision to communities, but the third depended too much on the personal

quirks of "reasonable persons." With this third specification, even *The Texas Chain Saw Massacre*, as sexually chaste as it is, could be ruled as lacking in all of the esteemed values that city fathers in locales across the nation could arbitrate willy-nilly.

Deep Throat was the litmus test. The FBI started small by intimidating Lovelace, its director Gerard Damiano, and its co-star Harry Reems, who played the endowed Dr. Young. When *Deep Throat* started getting into trouble, and the New York Court of Appeals seized it while subjecting its makers, distributors, and exhibitors to another obscenity court case, some prominent writers and academics came to its defense. Film historian Arthur Knight, whose book *The Liveliest Art* is often required reading in college cinema courses, defended the film, insisting it indeed had all of that "socially redeeming value." Sexologist John W. Money, from Johns Hopkins University, attempted to be complimentary when declaring, "It puts an eggbeater in people's brains."

Subsequent scandals involving its stars, including a court case that Reems later faced when Jerry Falwell charged him with obscenity, spiced up talk shows. In the 2005 HBO documentary *Inside Deep Throat*, Larry Parrish, a prominent prosecutor who worked against the movie, claims, "*Deep Throat* attacks the very core of our being." But in a recursive chain of absurdity, the more the government and various moral crusaders tried to gag *Deep Throat*, the bigger and more rousing its legend got.

Poor little *Chain Saw*, with nary a smooch and only a few cuss words, *putt-putt-putted* to fame yet still got snagged into the institutional and financial mire usually consigned to "dirty" movies. The *Chain Saw* squad called the Perainos' bluff and did sue. Unfortunately for them, Bryanston faced peril when they transgressed the Burger Court obscenity standards by marketing *Deep Throat* from state to state, inevitably reaching states that took umbrage—and action. The company got caught

up in litigation and no longer had enough money to pay back their debts even if they so desired. A baffling web of lawsuits and counter-lawsuits followed, with members of the *Chain Saw* crew even suing each other. The film's original producers fought to get their creation back, but creditors and other distributors would not let go of the rights.

In the meantime, *Chain Saw* still managed to cling to sprockets around the country. In New York City, in the midst of budget crises and rising crime, it offered some catharsis for horror enthusiasts fixing for another jolt to their jaded systems. The movie also found two unexpected enthusiasts. Judith Crist appreciated it as a new chapter in horror history. But Rex Reed was the most zealous. Reed, noted for rolling his eyes when showing disapproval, issued biting and verbose movie pans when appearing on television venues like *The Mike Douglas Show*. He tended to lambaste films he thought were in "bad taste" and even panned *Myra Breckinridge*, the only movie he starred in.

Reed, who saw *Chain Saw* at Cannes, appreciated the genuine subversion and cinematic novelty. For him, the film had the power to make "*Psycho* look like a nursery rhyme and *The Exorcist* look like a comedy." He hailed it as "the most horrifying picture I have ever seen." To pique interests all the more, Reed proclaimed, "The film is positively ruthless in its attempt to drive you right out of your mind." After such a build-up, who could resist?

Critical reaction elsewhere was, in some cases, similar to the negative reception of *Deep Throat* two years before, particularly on the West Coast, when Ms. Gross from the *Los Angeles Times* called it "ugly and obscene." "Be prepared for a totally disgusting and, for many, literally nauseating experience," the *Catholic Film Newsletter* wrote in October of 1974. "The film is sick, and so is any audience that enjoys it." What better way to inspire errant Catholics to run and see it as soon as possible?

Johnny Carson continued to be a bellwether for the "norm" in his nightly monologues. Just a couple of years before, he was relatively generous, though facetious, toward Linda Lovelace and *Deep Throat*, but when he caught a *Chain Saw* screening, he was livid and flabbergasted over the existence of such "trash." "Johnny Carson, on the *Tonight Show*, hated it," Hansen recalls in *Chain Saw Confidential*. "I watched him one night as he ranted about the movie, getting angrier as he went. Though I do not remember his exact words, essentially he said that *Chain Saw* was junk and should have received an X rating, not an R."

Overseas, the reactions varied. British critic Derek Malcolm saw and admired the film in 1975, but he sensed there might be some kind of ban. "Morally retrograde it may be," he wrote, "but then so are nightmares." The BFI London Film Festival did host a BFI-members-only screening, but British authorities, who continue to display a habit of banning things as well as people, spoiled the fun. England still had actual blasphemy laws that remained on the books as common law offenses until 2008. Though blasphemy was not the issue with *Chain Saw*, the British Board of Film Classification found other excuses to block distribution.

Stephen Murphy, then acting as the BBFC's Secretary, saw the film, liked it, placed it in the rather flattering category of "fictionalized documentary," but thought it too disturbing even for an "X" certificate. The distributor made some cuts, but the Board still said no. Oddly, even its members admitted that, while it lacked much explicit violence, its atmosphere of madness and terror was so constant that no truncated version would have altered the menacing tone. James Ferman, who replaced Murphy in 1975, was more adamant about repressing what he described as "the pornography of terror." *Chain Saw* did not get a formal nod from the BBFC until 1999, around the time Ferman left his position, when even its members credited the film's relative subtlety, at least compared to subsequent horror offerings.

In France, it got selected for the Director's Fortnight at the 1975 Cannes Film Festival. In Italy, whose earlier *Mondo* shockumentaries jostled the world and whose directors like Dario Argento would follow up with layer after layer of *giallo* excess, took a natural shining. They released it, dubbed it, and even renamed it *Non Aprite Quella Porta* (or *Don't Open That Door*).

Wes Craven, credited with bringing out the first chain saw in a modern horror film with *The Last House on the Left*, appreciated Hooper's foray, fixating on the adjective "Mansonite" to describe the film's impact. John Kenneth Muir, in his book *Eaten Alive at a Chainsaw Massacre: The Films of Tobe Hooper*, elaborates when quoting Craven who, upon watching the film for the first time claimed, "I remember thinking, whoever made this must have been a Mansonite crazoid. A filmmaker like Tobe Hooper can convince you you're really at risk in a theater—that's quite an attainment."

Author Wilson Bryan Key, who in *Subliminal Seduction*, claimed to see a man's "partially erect genitals" in a 1971 Gilbey's London Dry Gin ad, also wrote in *The Age of Manipulation*, the following accusation: "Hysterical fear reactions were initiated by movies such as *The Exorcist* and *The Texas Chain Saw Massacre*. Their producers publicly admitted both films contained violent and frightening subliminal stimuli."

In the meantime, life proved more complicated for Gunnar Hansen, who had difficulty hiding in a crowd. A year or two after the film's release, some pearl-clutching culture vulture confronted him at an "art" event. He tells of the incident in *Texas Chain Saw Massacre: A Family Portrait*:

> *"When you're involved with a project like that, particularly if you're visible like being the killer, you get blamed for a lot of society's problems. I was at a chamber concert, and*

during the intermission, this Philadelphia dowager comes up to me and is talking and says, 'You know, Gunnar, there were 12 people murdered today in New York City, and it's your fault.' I'm usually made speechless by comments like that. But I think that a lot of people think that movies like that are the cause of a lot of problems, when I think they're symptomatic of some societal issues. And to my mind, though I'm not a psychologist, [the movies] probably are harmless or at least let people work through some misery. . . . My answer is that the misery is there, and the film simply uses that misery."

Judging from how reactions to *Chain Saw* resembled some of *Deep Throat*'s negative feedback, the movies with explicit sex somehow gave hostile critics a perspective for judging movies with unprecedented violence. Two strident examples occurred in 1976. One was in Ottawa, Canada, when "morality detectives," as an article in Ottawa's *Citizen* newspaper described them, descended on a theater and a drive-in to warn proprietors that they would face charges if they did not withdraw the film. To underscore the comparison with pornography and sex-ploitation films that included gang rape, the article states, "*The Texas Chain Saw Massacre*, a low-budget screamer, which shows every intention of becoming an underground classic of the macabre, has gone to join *Ilsa, She Wolf of the SS*."

In America that same year, *Harper's* ran a feature called "Fashions in Pornography." In it, Stephen Koch, a friend of Warhol and author of a book on the Warhol films, suddenly channeled his inner prude, calling *Chain Saw* "a vile little piece of sick crap with literally nothing to recommend it: nothing but a hysterically paced, slapdash, imbecile concoction of cannibalism, voodoo, astrology, sundry hippie-esque cults,

and unrelenting sadistic violence as extreme and hideous as a complete lack of imagination can possibly make it."

Koch went on to write that *Chain Saw* is "a particularly foul item in the currently developing hard-core pornography of murder." He wrote off the entire work as a "scab picking of the human spirit." An apparent fan of "classic" Silver Screen musicals, Koch lamented the "impossible trip from the rosettes of Busby Berkeley to *The Texas Chain Saw Massacre* . . . that sickening ride from an impotent but refreshing sentimentalism to an impotent but monstrous viciousness." Not content with just trashing the film, he also took aim at its star, referring to Hansen in the plural as "Obese gibbering castrati snarling chain saws as they chase and kill screaming women."

In the early 1980s, the *Chain Saw* producers prevailed when the courts at last let the film rights revert back to them—just in time for a second life through New Line Cinema. From there, a franchise was born: what Hansen describes as "*Chain Saw* tchotchkes (including *Chain Saw* lunchboxes, t-shirts, clocks, facsimile posters, aprons, masks, and toy chain saws, as well as countless different Leatherface action figures)."

The Texas Chain Saw Massacre was also being hailed as "art." Writing for the *New York Times* in 1981, after the film got re-released and around the time that it got added to the Museum of Modern Art's permanent collection, Vincent Canby acknowledged that *Chain Saw* "represents the changes that have taken place in the last eight years between what was then and what is now acceptable (read expected, perhaps) in terms of horror-film horrors." Canby was being more or less complimentary: "Mr. Hooper's camera (the photography is unusually good, even in the seemingly blood-scratched print I saw) never dwells on the carnage as it happens, preferring, instead, to suggest the carnage by interior decoration."

According to Edwin Neal, Oliver Stone was so impressed by the dolly shot of Pam walking from the swing to the Slaughter house that he gave Neal a bit part in *JFK*, hoping to get some inside information on Hooper's technique. As *Chain Saw* got more acclaim, *Deep Throat* ended up with more notoriety than popularity.

Adding to the off-screen melodrama, Bill Kelly, a police chief with a reputation for enforcing tough laws and recruitment tactics, was among the sanctimonious crusaders against the *Deep Throat* revolution. As quoted in *The Other Hollywood: The Uncensored Oral History of the Porn Film Industry*, Kelly boasted about using a particular object lesson: "*The Texas Chain Saw Massacre* has been seen by innumerably more people than *Deep Throat*. About twenty million people saw *Deep Throat*, roughly, if there's a hundred million-dollar take. Probably fifty million people saw *Texas Chain Saw Massacre*. I mean, I was teaching police recruits, and I'd ask, 'How many of you saw *Texas Chain Saw Massacre*?' About 75 percent of them raised their hands. I said, 'Congratulations. You sent two and a half dollars of your money to the Colombo family in Fort Lauderdale . . .'"

Leatherface and Lovelace inevitably diverged into separate paths. Linda Susan Boreman (Lovelace was a fake name, after all) seemed to enjoy her work until a few years afterward, when she joined other groups such as Women Against Pornography, testifying that she had been hypnotized, exploited, and essentially raped. She would chronicle it all in her 1980 autobiography, *Ordeal*.

Gunnar Hansen as Leatherface, on the other hand, hated his ordeal during the filming, feeling the equivalent of being hypnotized, exploited, and emotionally raped as he reeked his way through the final throes of production. When the nightmare was over, and the plaudits poured in regarding his performance and the movie in general, he crowed about his contribution to horror history.

Hansen continued to show pride in the film, though he felt understandably bitter about not getting his fair share of the loot, a similar gripe that both *Deep Throat*'s director Gerard Damiano and its co-star Harry Reems expressed when they too received crumbs from the vast sums. Hansen and the rest of the *Chain Saw* cast and crew were deluded into thinking that the remuneration would equal the adulation.

Despite fond memories of fiendish times, Hansen continued to share a caveat, claiming that nine months after the film's original 1974 release, his first royalties came to a monstrous $47.07. "I guess I was just naïve," Hansen wrote in his 1985 article for *Texas Monthly* called "A Date with Leatherface." "The truth is that I made very little money, most people don't even recognize me, and those who do certainly don't think about sex."

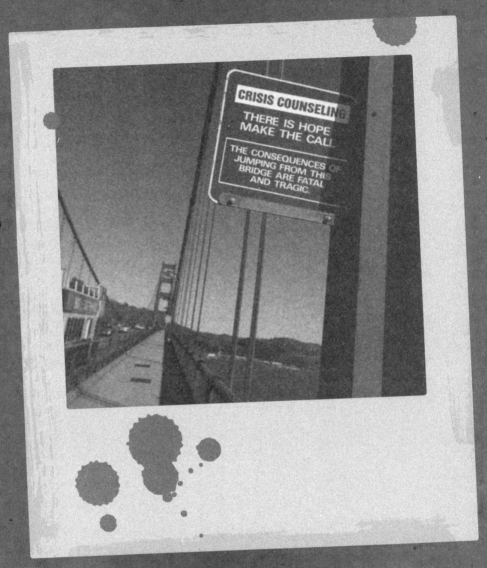

By the autumn of 1973, so many desperate divers had committed suicide at the site that a Golden Gate Bridge Board of Directors convened with a plan to erect a $1 million barrier to deter future death dives. On the night of November 16, 1974, unsuspecting audiences were enticed to see an unidentified sneak preview at San Francisco's Empire Theater . . . Mass commotion ensued . . . From the moment when John Larroquette's voice claimed *Chain Saw* was based on "a true story," the result came close to what a psychedelic garage band from the mid-'60s once called a "psychotic reaction."

CHAPTER ELEVEN

YOU'RE GONNA MEET SOME MENTAL PEOPLE

"San Francisco stands on modern hills, Broadway lights flash the center gay honky-tonk Elysium, Ferry building's sweet green clock lamps black Embarcadero waters, negroes screaming over radio, / Bank of America burns red lights beneath the neon pyramids, here is the city, here is the face of war . . ."

—ALLEN GINSBERG,
"BEGINNING OF A POEM OF THESE STATES,"
FROM *THE FALL OF AMERICA*

For those adventurous or sensitive enough to experience or at least be aware of its spells, the San Francisco Bay Area is the mind-fuck mecca. With its countless astrologers, Tarot readers, psychometric specialists, psychedelic gurus, Satanists, witches, fanatics representing the "official" organized religions, as well as sundry acupuncturists and chiropractors, this is a place brimming with cures and philosophies on how to live a better life, expand consciousness, and commingle with the "spirit world." But into the early and mid-1970s, darker forces got the best of a city otherwise known for its liberal and

experimental temper. One November night, some San Franciscans reached their breaking point when the *Chain Saw* buzzed into town.

Stephen Harrigan, in his July 2014 *Texas Monthly* article, "A Double Date with Leatherface," recalls attending the film's October 1974 Austin premiere with Gunnar Hansen: "The movie is iconic and ironic now, so clearly a forebear of latter-day sadistic horror movies, from *A Nightmare on Elm Street* to *Saw VI*, that it takes an effort to recall how raw and sick and effective it seemed to us at the time. We were an audience encountering it out of nowhere, with no familiar tropes to grab on to."

However, the solar flares that influenced the raging moods of Central Texas also affected Northern California, drawing San Francisco into Leatherface's synchronistic web. The city was being plagued with real-life instances of "raw and sick." Tobe Hooper mentions another connection in his essay, "American Freak Illumination: The Unofficial Autobiography of Tobe Hooper": "San Francisco and Austin were considered sister cities. There was a lot of traveling between them. Some of that could be explained by [the fact that] most of the mescaline production took place out in the Hill Country near Austin. Lots of Texans in San Francisco." This is also where the 13th Floor Elevator's Roky Erikson went to cool off his breakdown but instead got hooked on heroin and contracted hepatitis.

When *Chain Saw* had its San Francisco sneak preview, the town had been experiencing an epidemic of tragic gross-outs that ultimately affected the film's local reception. The malevolent voodoo spells and sculptures of bones, feathers, and chicken claws that bedeviled the Hardestys and their friends when they entered the Slaughter madhouse seemed to be hanging over the Bay Area as well.

One example is how the Haight-Ashbury district had deteriorated. Omens permeated the neighborhood when Charles Manson rented a house on Cole Street for several months in 1967 shortly after leaving

prison. There, he met Susan Atkins and others. But even Manson got spooked by the Haight's bloodcurdling vibes and, by the year's end, transplanted his "family" to Southern California. Roger Smith, Manson's parole officer from 1967–68, offered his assessment in a 1995 *A&E Biography* entitled *Charles Manson: Journey into Evil*: "You may recall a song, the lyrics which were 'if you come to San Francisco, you'd better wear a flower in your hair.' By 1967, if you came to San Francisco, you needed to wear a .45 in your belt; it had changed that fast."

In a three-day gala that culminated in October 6, 1967, several mourners saw the pall at the end of the tunnel when they carried a coffin down Haight Street to Buena Vista Park, filled with such trinkets as long-hair locks, beads, candles, issues of the *Oracle* and *Berkeley Barb*, and other period bric-a-brac. These craftier flower children realized they had become mass media stooges and picked an aptly somber Sunday to acknowledge the "Death of Hippie." An epitaph summarized the era's end: "Once upon a time a man put on beads and became a hippie. Today, the hippie takes off the beads and becomes a man, a free man." How "free" is still debatable.

Entering the '70s, the Bay Area and its environs faced an aftermath of drug abuse and burnt-out idealists struggling to keep a myth alive. And murderers lurked. One of the first mishaps occurred in October of 1970: a Manson-style massacre about one hundred miles south of the city. Police found a Santa Cruz optometrist, his wife, two sons, and his secretary tied up with silk scarves, riddled with gunfire, and left for dead at the bottom of the family swimming pool. The *Rockford Star*, an Illinois newspaper, picked up on the story, pointing out that this occurred "in a scenic area dotted with homes of the rich and middle class, but also with hippie communes and wandering young people, whom the victims had reportedly 'chased off' from their property more than once."

The family's killer appeared to be a psychopathic environmentalist, leaving behind a note attached to the windshield wiper of the doctor's Rolls Royce, warning of many such fatalities to "anyone or company of persons who misuses the natural environment or destroys same . . ." The signature consisted of the names of the four Knights of the Tarot. Four days later, the authorities found the killer, an eco-zealot with holy convictions named John Linley Frazier, who, like others, had resorted to the Book of Revelation, claiming that his god told him to commit the murders to hasten the "end times." Like Manson and Sirhan Sirhan, he would benefit from a life sentence after California abolished the death penalty in 1972.

The Bay Area faced a spate of other bizarre murders within a four-to-five-year span. Forensic experts had sought to link the Santa Rosa Hitchhiker Murders to maniacs like Ted Bundy, but another suspect was saturating the press and tormenting the region: a hooded atrocity known as the Zodiac.

The Zodiac found his victims starting (officially) on December 20, 1968, when he fired a .22 caliber semiautomatic at two teenagers in a secluded lovers' lane area in Benicia, California. From there, he traveled through San Francisco and Lake Berryessa. He liked varying his murder weapons, handling many types of guns, including one that projected a guiding light beam. In his basement, he crafted a homemade knife and electronic bombs; he also devised a method of covering his fingertips with glue to avoid leaving traces.

These precautions proved resourceful for him in the following year on July 4, when he entered another lovers' lane nook in Vallejo and shot another young couple multiple times. The local police got a taunting call that night from someone claiming to be the killer, letting them know he was also responsible for the previous December murders. After a curt "Goodbye," he hung up, and police traced it to a

fingerprint-free pay phone that was not far from the police depart-
ment. The man survived the attack and described the killer as a stocky
white male of average height, but this time the killer had hair that was
brown and curly—different from the thinning, lighter hair of other
descriptions.

A writer manqué, he was fond of sending letters beginning with "This
is the Zodiac speaking" (replete with disquieting typos) to various news-
papers, along with several cryptograms that baffled CIA, FBI, and NSA
experts. They included his trademark Celtic wheel cross and incessant
boasts about his past crimes and crimes to come. A definitive example is
a July 31, 1969 letter he had sent to the *San Francisco Chronicle*, the *San
Francisco Examiner*, and the *Vallejo Times*. It was full of ciphers that a
Salinas schoolteacher had cracked the following month: "I like killing
people because it is so much fun it is more fun than killing wild game in
the forrest because man is the most dangeroue anamal of all . . ."

On September 27, a couple at Lake Berryessa in Napa County, try-
ing to enjoy the pleasant weather with a picnic, became the next Zodiac
casualties as he bound and repeatedly stabbed them. Area police also
received a call, informing them he was the perpetrator of the double
murder. As before, the suspected pay phone the killer used was just
blocks away from the police headquarters, this time with a palm print.
And again, the woman died but the man survived, describing the killer
as wearing gloves, a black hood, and the infamous crossed circle on his
chest. He also toted a gun in one hand and a knife resembling a bayonet
in the other. For some reason, the Zodiac left clues on the side of the
victims' car, listing the dates and the places of the murders he had
already committed, along with his Celtic-cross symbol.

On October 11, the Zodiac committed his first San Francisco assault
when he entered a cab near Union Square. By the time he got to his
Presidio Heights destination, he took out a .9mm and fired it into the

back of the driver's head. This time, someone watching from a nearby window described the killer as sporting a crew cut. But police did find blood-soaked fingerprints on the cab—either the killer's error or a devious message that he wanted to get caught. The *Chronicle* reported the incident on October 12, describing the suspect as "white, about 40, 170 pounds, a blond crewcut, wearing glasses." On the following day, the *Chronicle* got another of his missives, this time with a bloody piece of the cabbie's shirt, along with a threat to immolate the occupants of a school bus, boasting that he would "just shoot out the front tire + then pick off the kiddies as they come bouncing out."

San Francisco's star attorney Melvin Belli would soon have his hands full when representing the Rolling Stones in their plans for the accursed Altamont Speedway concert, several miles east of the city. But on October 22, Belli had to appear on a live telecast, at the Zodiac's request, on the local KGO talk show to speak with the supposed killer (who called himself "Sam"). Sitting beside host Jim Dunbar, Belli had to contend with Sam's whining about headaches and not wanting to "be hurt."

Nearing Christmas, Belli got his own Zodiac missive that included another bloody swatch of the cabbie's shirt:

> "Dear Melvin, This is the Zodiac speaking I wish you a happy Christmass. The one thing I ask of you is this, please help me. I cannot reach out for help because of this thing in me won't let me. I am finding it extreamly dificult to hold it in check I am afraid I will loose control again and take my nineth & posibly tenth victom. Please help me I am drowning. At the moment the children are safe from the bomb because it is so massive to dig in & the triger mech requires much work to get it adjusted just right. But if I hold back too long from no nine I will loose completall controol of my

self & set the bomb up. Please help me I can not remain in
control for much longer."

Playing mind games with the police for so many months, the Zodiac struck again on March 22, 1970. A mother and her baby daughter were driving in the evening, southeast of the city. When a car sidled over to them, and its driver told them there was something wrong with their tire and volunteered to help them fix it, they were obliging. But he had instead loosened the tire bolts and got a charge out of seeing the woman drive off as the tire dislodged. He then pretended to be sorry and offered to drive them, taking them along until swerving down a lonely country road, and telling the woman in his monotone voice that he was going to murder her and then toss the baby out the window.

He was somewhat absentminded when he drove to the wrong end of a freeway. The woman took advantage of the momentary distraction and escaped with her child, running away in the dark. Fortunately, a driver came to her rescue after the Zodiac gave up looking for her, taking her to the nearby police station. There, she was stunned to see the likeness of her assailant in the composite Zodiac sketches posted on the wall: a white, balding and burly man, with a round face and wearing glasses.

On July 24, the Zodiac again goaded the *Chronicle*, gloating about "the woeman + her baby that I gave a rather intersting ride for a couple howers one evening a few months back that ended in my burning her car where I found them." The *Chronicle* got another letter postmarked July 26, 1970, with more graphic and, once again, badly written descriptions of dream tortures that he would commit if the newspaper failed to reproduce his prized Celtic "buttons":

> *". . . I shall (on top of everything else) torture all 13 of my*
> *slaves that I have wateing for me in Paradice. Some I shall*

tie over ant hills and watch them scream and twich and squirm. Others shall have pine splinters driven under their nails + then burned. Others shall be placed in cages and fed salt beef untill they are gorged then I shall listen to their pleass for water and shall laugh at them."

On March 13, 1971, the Zodiac (sometimes referred to as the "Cypher Slayer") sent a message to the *Los Angeles Times*, invoking the villains of the Beatles' 1968 animated feature, *Yellow Submarine*: "If the Blue Meannies are evere going to catch me, they had best get off their fat asses & do something. Because the longer they fiddle & fart around, the more slaves I will collect for my afterlife."

Paul Avery, a *Chronicle* reporter, also feared that he was in the Zodiac's crosshairs when receiving a threatening Halloween card. Avery did not take this lightly, and neither did his colleagues. They distributed hundreds of buttons that read "I Am Not Paul Avery," which the *Chronicle* staff and Avery himself wore in solidarity. Avery also started toting a .38 caliber revolver for extra confidence.

Avery did not stop there. He helped to devise a caper that would combine low-budget cinema with a plan to catch the killer. Tom Hanson, an aspiring filmmaker, realized the Zodiac story would make good copy and agreed to contribute. With hope, the movie, if promoted properly, would lure the real Zodiac into the theater. Avery contributed an opening disclaimer for viewers terrified of being the next victim, stating that the film's "goal is not to win commercial awards, but to create an 'awareness of a present danger.'"

Director Hanson was so zealous about helping to solve the crimes that he collaborated on the trap that would involve the Zodiac's handwriting. He got Kawasaki to agree to hold a motorcycle giveaway at the RKO Golden Gate Theater. Contestants had to submit cards with the

phrase, "This is the Zodiac speaking" in long hand. The theater staff collecting the cards aided Hanson in trying to trace signs of the killer's scrawl on one of them, but to no avail.

The Zodiac Killer was released in April of 1971: a rare species of true-crime movies about crimes that were still occurring. A curious script addition portrays the star killer as a frustrated mailman, decades before the phrase "going postal" characterized those driven to murder due to their stressful jobs. The lead actor Hal Reed gives a spirited performance as Jerry the killer. While some had described the actual Zodiac as a tall, paunchy, lumbering white man, Reed's portrayal seems at first to be a rather handsome and genial guy with a decent build who simply loves rabbits and hates people.

Jerry does get scarier as the plot progresses, particularly in scenes when he dons his executioner's robe while worshipping at some make-shift altar. In what was by then an Alfred Hitchcock tradition (*Strangers on a Train, Psycho*), the killer has issues with a parent, this time a dad who is confined to an asylum. The script is often faithful to the actual Zodiac police record and dips into some bizarre moments with a low-budget look that adds to its awkward moments of dark humor. A cast of eccentric characters fills out the story, including a cameo from Doodles Weaver. After Jerry rants in a fascinating monologue about who is really insane and who is not, the closing credits read, "This is not The End."

Bombarded by continual reports of random and sordid massacres, San Francisco citizens lost whatever grasp they had on the '60s love myth. Still, many wandered the streets looking for answers, seeking to retain the thrill of nonconformity, the spirit of Zen, and the cosmic joke that now provoked wails instead of titters. Veterans returning from Vietnam likely took Scott McKenzie's Top 40 song from 1967 about going to San Francisco where "you're gonna meet some gentle people"

seriously enough to adopt the town as their emotional port. Many of them stayed simply to let loose, while others joined the array of meth-zombies. In October of 1971, Werner Erhard, influenced by such hippie treasures as Zen Buddhism and Alan Watts, helped to plug this spiritual void by conducting his first EST course at the Jack Tar Hotel on Geary Boulevard and Van Ness Avenue.

Something else occurred by June of 1971—this time on the East Coast and not far from the nation's capital, altering much of America's perception regarding gun rights. This happened after a teenage thief from Prince George's County in Maryland, with a penchant for robbing houses, finally got caught. He begged the police for a more lenient sentence by providing information about a man he knew who allegedly kept "live grenades." Following the teenager's lead, the Bureau of Alcohol, Tobacco and Firearms raided the Montgomery County home of Kenyon Ballew, a National Rifle Association member whom the government suspected of stockpiling weapons illegally, some of which were war relics. They invaded his sanctuary while he was taking a bath, shot him in the head when he tried defending himself with his Colt .44 revolver, and left him paralyzed. His grenades turned out to be deactivated, and the government could find no reason to press any charges against him.

The NRA did not take well to this Keystone Cop fiasco. They had previously helped the government establish rules and regulations that conformed more to "gun control," but after Ballew's tragedy, the NRA members started to perceive federal agents as adversaries and set their priorities on Second Amendment rights. Despite the more stringent Gun Control Act of 1968 (in response to the shooting deaths of several political figures), killers across the country still obtained their arms regardless of the rules, and the argument that ordinary citizens were the ultimate victims of excessive gun control got more compelling.

In a paradox befitting such crazy times, the NRA and the Black Panthers adopted a similar attitude: a gun is the only protection against tyranny. As people from otherwise opposing sides of cultural divides clung harder to their ammo, the overly armed Zodiac continued with more murders, letters, cryptograms, and forensic dead ends until March of 1971.

Strange paradoxes occurred around the same time, when the former Albert Pike Memorial Scottish Rite Temple on 1859 Geary Boulevard (a site also struck by the 1906 earthquake) became the new home for the Peoples Temple, commandeered by Jim Jones. Before moving his flock to Guyana and directing one of the world's biggest mass suicides (partly homicides), Jones was already acquiring a reputation for abusing his desperate and largely black congregation. He also had a knack for political maneuvering that would include aiding George Moscone in his future mayoral bid to replace Joseph Alioto. This new Peoples Temple happened to be next door to what would become another trouble spot: 1805 Geary, the location of Muhammad's Temple No. 26.

By 1973, Allen Ginsberg was a poet laureate for what became the cultural messes. He published a collection entitled *The Fall of America,* and his message seemed to marinate in the phantasm that the U.S.A. is uniquely violent. Though he considered himself more spiritual than political, Ginsberg was among those needling America's self-image during the early '70s, throwing a shroud of guilt over susceptible minds. His book, which won the National Book Award for Poetry, included a frontispiece with the line "Apocalypse prophesied—the fall of America signaled from Heaven." But while Ginsberg rhapsodized over America's purported demise and thrilled devotees at such places as City Lights Books in North Beach, who fell for his charms, others in San Francisco continued to fall *literally*—from a beloved tourist site that was also a suicide lure.

Perhaps some of those who jumped off the Golden Gate Bridge read the *The Savage God: A Study of Suicide*, a popular book when published in 1971. A. Alvarez, the author, tried to take his own life with 45 sleeping pills and failed, but he was friends with the poet Sylvia Plath, who was successful back in 1963 when she decided that enough was enough and inserted her head into a gas oven. "Suicide may be a declaration of bankruptcy which passes judgment on a life as one long history of failures," Alvarez writes. "But it is a history which also amounts at least to this one decision which, by its very finality, is not wholly a failure. Some kind of minimal freedom—the freedom to die in one's own way and in one's own time—has been salvaged from the wreck of all those unwanted necessities. Perhaps this is why totalitarian states feel cheated when their victims take their own lives."

By the autumn of 1973, so many desperate divers had exercised their "minimal freedom" that a Golden Gate Bridge Board of Directors convened with a plan to erect a $1 million barrier to deter future plunges. Some members of the psychiatric community and some clerical figures favored the proposal, but some civil libertarians objected, viewing suicide as an individual right. We were not living in a totalitarian state, after all, despite what anti-American militants thought.

The Zodiac, in the meantime, kept an eerie silence, but police questioned several suspects. As early as October of 1969, they interviewed a chubby white man in his thirties, an intelligent loner who resided in a trailer and surrounded himself with dead animals. His name was Arthur Leigh Allen, and he had been scuba diving in Lake Berryessa on the day of the September 1969 murders. That evening, he came back home with blood on his clothes and a knife resting on the front seat of his car. An anonymous tip to the Vallejo police sent them to question Allen. He admitted to authorities that he was in the area, but that he had used his knife to cut up a chicken for a barbecue.

Two years later, however, a "friend" of Allen contacted the police, informing them that Allen indeed referred to himself as the Zodiac, even before the moniker became public knowledge. He also claimed that Allen boasted about using a gun with a flashlight attachment to hunt people down. When questioning Allen more, police learned about some of his macabre literary interests, particularly Richard Connell's "The Most Dangerous Game," a story he had read in high school about a big-game hunter of humans, which became the basis for the famous 1932 RKO-Radio Picture. Leigh also liked the 1945 film adaptation of the same story, also from RKO, entitled *A Game of Death*.

Allen was also impressed by the 1939 20th Century Fox movie *Charlie Chan at Treasure Island*, starring Sidney Toler as the famed detective. The movie arrived at theaters just when the man-made Treasure Island became the site of the Bay Area's Golden Gate International Exposition of 1939–40, and the film's most fascinating scenes take place in the exotic trappings of Treasure Island's "Temple of Magic."

As if sending messages intended for decoding thirty years into the future, the film includes a villain named Dr. Zodiac, a charlatan of the supernatural whom one character describes as "a big shot in the spook racket around here." But when Chan arrives at the charlatan's home and asks if Dr. Zodiac is a San Francisco native, a sullen Turkish servant, sporting a fez, glorifies his boss: "Dr. Zodiac is a native of the universe. He knows all things about all people." The turban-clad Dr. Zodiac appears larger than life, in a black robe adorned with astrological signs, as he darkens the room and treats his guests to a phony séance: the razzle-dazzle of incense, crystal gazing, a floating hand, an invisible voice, and a disembodied head fading in from out of the gloom, calling out "Zodiac, I am here."

"Ectoplasm most interesting: ghost filled with hot air," Chan concludes, immune from being hoodwinked. Seeking to unmask the

impostor, Chan eventually uncovers an elaborate blackmail scheme: files loaded with dirt on many citizens hidden away in Dr. Zodiac's vault. Perusing a "History of Psychiatry," Chan diagnoses Dr. Zodiac as a "man of great ego, with disease known to science as *pseudo-logia-fantastica*." In short, the criminal's superiority complex should ironically entrap him. Chan then employs a Dr. Rhadini (Cesar Romero), who performs at the "Temple of Magic," to challenge Dr. Zodiac's powers, but the plot wanders eventually into a predictable surprise ending. Some of *Charlie Chan at Treasure Island*'s references must have influenced the real Zodiac, but Arthur Leigh Allen was not the only suspect, so at least one other culprit had seen the movie.

Allen displayed another clue: a wristwatch his mother had given him that had the Zodiac's circled cross on its dial. The source for the Zodiac's sobriquet got more zanier when the *Chronicle* received an anonymous letter back in November of 1970. This time it was from what appeared to be a concerned citizen alerting the paper to a *Playboy* issue with an ad for Zodiac watches, a Swiss brand from Zodiac Astrographic. "The trademark on the face of the watch," the letter advised, "is identical to that used by the notorious killer."

Once police got a search warrant to comb through Allen's trailer home, they discovered more psychological links that had all the script details of another Ed Gein-ish Hollywood thriller: small, dissected creatures kept in the freezer, as well as sex toys. Now, the police and other inquiring minds faced a dilemma that made finding a real killer more difficult. Allen, if innocent, demonstrated how people with or without psychopathic leanings, and influenced by various books and movies about similar types of murders, were often alike. Scattered pieces of the population, not secret societies but atomized outsiders, were adopting similar fetishes. They sought refuge from the norm by living out variations of Ed Gein-Norman Bates-Leatherface existences:

amassing firearms, knives, and other weapons, collecting animal car-
casses, possessing bomb diagrams, immersing themselves in pornogra-
phy or sexual voyeurism, or simply hoarding armaments as survivalists
in the event of an invasion. Authorities faced another hair-raising pos-
sibility: there might be several Zodiacs.

Though Allen fit the "type," and his background had extraordi-
nary matches to the Zodiac information, the police could not link him
directly to the killings. Even Allen's fingerprints did not match the
bloody ones left on the San Francisco cab. They attempted to match
Allen's handwriting, going so far as to have him use a similar felt-tip
pen that the Zodiac employed in his letters. They even had him write
with both hands: no match. Allen aroused new suspicions, however, in
September of 1974 when he got charged with molesting children and
spent three years at Atascadero State Hospital. Still, the case against
Allen eventually went cold (even with subsequent DNA testing).

It was inevitable that at least one Bay Area serial killer would use the
occult to exploit earthquake fears. Some Fundamentalist Christians,
with ultra-conservative axes to grind, have also used the San Andreas
Fault line as a godly warning about the wages of a liberal city's "sins."
Though born and raised in Santa Cruz, Herbert Mullin made a mark
on San Francisco when he justified his numerous murders by merging
spiritualism with seismography.

This once clean-cut Catholic lad, a star of the varsity football team
and popular among his peers, was devastated at sixteen when, in the
summer of 1965, a close high school friend got killed in a car accident.
Mullin set up a shrine in his bedroom to commemorate his dead pal,
including a large photo of the boy illuminated by votive candles. Mullin
was never the same afterward. Warnings of a madman in the making
surfaced a year later when he claimed to hear disembodied voices and
started believing in the hereafter. Being a dedicated follower of mystical

fashion, he also embraced the Eastern belief in reincarnation, finding a way to make those beliefs congeal with his Catholic upbringing.

Mullin's ensuing years teemed with contradictions. He got into a couple of colleges and proved resourceful in mechanical drawing, but his disposition got so morose that he ended up in and out of various mental institutions. Each time, he managed to prove himself harmless enough to voluntarily leave the hospitals, even though his behaviors got more frightening and his prognosis more hopeless. With the label "paranoid schizophrenic" practically stamped across his forehead, he would wander through streets and talk to himself, sliding deeper into his spiritual pit after ingesting pot and LSD.

During this stay in San Francisco from May 1971 to September 1972, where he dwelled in such shadier parts as the Tenderloin district, Mullin acted out more and more, scaring his friends and neighbors by pounding on apartment floors with his fists, screaming at imaginary people, and placing lit cigarettes on his penis. He tried blending in with an art collective but ended up creeping out so many of its inhabitants that they voted to kick him out. "He left the human race that day," one of the more sympathetic collective members declared. "It was the final rejection."

Another warning sign appeared when Mullin aspired to become a priest—a total surrender to the supernatural that led to his obsession with earthquakes and his mission to prevent the next "Big One." He calculated dates to suit his methodology, marveling at how his birthday of April 18 was also the date of the 1906 San Francisco earthquake and the death of Albert Einstein. The coincidences galvanized his messianic impulse as he pored over articles about global death rates and seismographic patterns. To him, the Bible said that killing was okay. He also got obsessed with the number 13.

On Friday, October 13, 1972, Mullin found his first sacrificial victim when he eyed a homeless man on a secluded road in the Santa Cruz mountain region and bludgeoned his head with a baseball bat. Around this time, Mullin was impressed by a section in *The Agony and the Ecstasy*, Irving Stone's novel about the life of Michelangelo, which goes into detail about the art of dissection. On October 24, he decided to try it on a college hitchhiker, slicing her open, examining her entrails in a secluded wooded area, and hanging some of the intestines on trees. He also spoke of "The Die Song," some kind of melody or spell he would cast to eradicate those around him. When describing it, he let guilty feelings about his dead best friend slip out: "I can sing that song to them and they'll have to kill themselves or be killed—an automobile accident, a knifing, a gunshot wound. You ask me why this is? And I say, well they have to do that in order to protect the ground from an earthquake . . ."

Believing that his father was sending him telepathic messages to kill also made Mullin feel guilty. On All Saint's Day, he sought refuge in a Catholic church in the Santa Cruz suburb of Los Gatos. But the father confessor could not save him: the biological father's voice proved stronger, telling him that the priest wanted to die. After kicking and stabbing the priest six times in the chest and back, Mullin left him bleeding on the church floor.

By December, Mullin purchased his first firearm. With signs (or promises) that the Vietnam conflict was coming to a close, he worried that the resulting lack of overseas murders—and therefore fewer sacrifices—would anger the lords of the Richter scale. He tried to join the Marines by mid-January of 1973, hoping to make as many Vietnamese blood sacrifices as possible. He got as far as a pre-enlistment physical, and the induction process somehow went smoothly, but when he refused

to sign a document acknowledging past criminal arrests, including narcotics charges, the Marines finally sent him a notice: "Enlistment is not authorized." From there, his only choice was to remain a civilian avenger.

That same month, Mullin's thoughts drifted back to high school, but this time he sought a classmate who turned him on to being a conscientious objector, sold him his first pot, and (in his mind) set him on the wrong path. To correct this blunder in his personal history, he tracked down the guy and his wife, shooting them both in the head and stabbing them repeatedly. A month later, he went to Henry Cowell Redwoods State Park, where he encountered four teenage campers whom he perceived as polluting the environment and shot them in the head. He also made off with their .22 rifle.

The final Mullin murder was on February 13, 1973. An elderly man caring for his lawn was at the wrong end of the stolen .22, but this time witnesses saw it all, including Mullin's license plate number. When authorities finally caught up with him, and the Santa Cruz County District Attorney's office put him on trial, Mullin got sentenced on September 18 to life in prison for 10 homicides—and there were no reports of earthquake tremors resulting from that decision.

In their book *The Die Song*, authors Donald T. Lunde and Jefferson Morgan use the words of one of Mullin's former roommates to reveal that some of San Francisco's nonconformists back in the day also had alarming insight: "I did tell him that he was going off the deep end, and that he was getting to the point where he was not only daydreaming, but he was living out his daydreams, which of course the whole world is right now."

As if Mullin's earthquake dementia and the Zodiac were not frightening enough, another terror wave hit San Francisco. This one had more direct ties to Tobe Hooper's world: one of its perpetrators (among the more vicious) had moved beforehand from Texas to Northern

California. The fictional radio announcer at the beginning of *Chain Saw* referring to a "cholera epidemic" hitting San Francisco was on the mark—that is if "cholera" were a metaphor for a city-wide holocaust.

Author Clark Howard narrates the nightmare that germinated back in the summer of 1970, when a group of men from the Nation of Islam converged at a Houston mosque. A charismatic man, in tatty business attire, spoke to the group in a soft but persuasive voice: "You know, San Francisco is going to be the very first Muslim-run city in the country. We already have a master plan for the gradual acquisition of various business enterprises. And I don't mean to imply any *illegal* takeover; I mean a strictly legitimate attrition wherein white business owners will sell out to Muslim buyers . . . Of course, we may have to—well *encourage* some of the white folks to move on, but there are plenty of ways to do that."

Assuring his congregation that Chicago was still the Nation of Islam's "New Mecca," the speaker continued to harp on this second California plan. Five of his followers were so inspired that they hopped into a car and left Houston for a pilgrimage to the place where many others— from the pioneers of the Gold Rush, to the 1960s flower children, and to the movers and shakers who transformed the Castro District into a gay Mayberry—had traveled for hope and broken dreams. And one of the five who traveled from Houston would be among those who would terrorize San Francisco starting in the fall of 1973.

A year before *The Texas Chain Saw Massacre*'s San Francisco premiere, another speaker, in Clark Howard's account, addressed a congregation in a San Francisco warehouse loft, telling of an evil scientist named Yakub, who lived thousands of years ago, on the island of Patmos, also the place where "John the Divine," banished by the Romans, was supposed to have encountered signs of a pending apocalypse that inspired his Book of Revelation.

In a pre-*Frankenstein* experiment, Yakub created what human history would call Caucasians by sifting out "black germs" and repeatedly breeding women to conceive "brown germ" babies until the brown got lighter, and eventually the "weaker," melanin-deficient offspring became a new race. This germ grafting continued for six hundred years, but in pre-*Blade Runner* fashion, the intended slaves got too smart and ended up threatening their makers, becoming "white devils" and "grafted snakes" who populated the Earth to spread such infidel dogmas as Judaism, Christianity, and ultimately atheism.

It was a fanciful tinkering with evolution and history similar to a 1931 futuristic novel called *Black No More: Being an Account of the Strange and Wonderful Workings of Science in the Land of the Free A.D. 1933–1940*. It is set in America with a "Dr. Junius Crookman" operating a color-transformation sanitarium. Its author, George S. Schuyler, was an H.G. Wells fan and a black iconoclast who collided with the orthodoxy of many black activists and preachers. He rebuked organized religion and believed that regional factors were more important than racial ones in determining a person's character and destiny.

Schuyler had intended his novel as a satire on race relations and racial strife. Others, however, were less satirical, attributing the story's origins to an enigmatic figure named Wallace Fard (alternately Wallace D. Ford, Wallace Don Ford, W.D. Farad, W. F. Muck Muck, Wallace or Fred Dodd, Wallie Ford, Wallace Fard Muhammad, Master Farad Muhammad, Prophet W.D. Fard, and even Allah). Fard had been accused of inciting at least a portion of America's black population, particularly in the Detroit area.

Existing pictures of Fard show what looks like (and what some FBI documents describe as) a swarthy white guy, but his ideas became the foundation for a rabid Nation of Islam sect that preached against "the white devil." Through the decades, the FBI assembled a file on him

reflecting a life of shifting identities and several arrests for crimes rang-
ing from Prohibition-era bootlegging to deadly weapon assault. Elijah
Muhammad, however, was so enamored with Fard that he considered
him "the all-knowing supreme being" and carried out the man's legacy
once Fard disappeared mysteriously by the mid-1930s.

Flipping a middle finger to the love-drunk Age of Aquarius, racial
battles (that Manson allegedly dreamt about inciting) were already
marring San Francisco's headlines in August of 1971, when members of
the Black Liberation Army, on a "terror and chaos" mission, gunned
down a cop at the city's Ingleside Station and were finally convicted
decades later. The Yakub chronicles account likewise triggered ghoul-
ish consequences when a small, criminal cadre took what could have
simply been an allegory as the literal truth and set out to wreak revenge
on the "grafted devils." They conspired on the second floor loft of the
Black Self-Help Moving and Storage Company, which the Nation of
Islam operated. Their goal was to ascend to the level of "Death Angels,"
but to get their "wings," they had to kill lots of white people, and their
favorite method was decapitation.

In a pre-*Hostel* variation (a film in which the price of killing Asians
and Europeans was lower than that of the more hated and, therefore,
more valuable Americans), the aspiring Death Angels also had a quarry
hierarchy. Grown white men were the easiest to kill because they were
the easiest to hate; therefore, a follower had to kill nine of them. White
women (perhaps due to vestiges of chivalry) were more difficult to kill,
so only five of them had to die, but white children, the most difficult of
all (due to other ethical vestiges), required but four murders. The Death
Angel prize for such tasks was a special lapel pin and a ticket to Mecca.

(A fifty-one-page FBI memo dated August 8, 1957 includes files
about the Nation of Islam that provide somewhat similar accounts: "All
Moslems will murder the devil because they know he is a snake and

also if he is allowed to live, he would sting someone else. Each Moslem is required to bring four devils, and by bringing and presenting four at one time, his reward is a button to wear on the lapel of his coat, also a free transportation to the Holy City Mecca to see Brother Mohammed.")

Clark Howard in *Zebra*, his definitive book on the homicides, retraces the bloodshed that happened from October of 1973 to April of 1974. They became known as the Zebra Murders, named by the police task force unit whose mission was so vital that it got its own police-band wavelength: "Z" for "Zebra." (The animal's contrasting-color stripes were an afterthought, conjured by journalists, not crime fighters.)

The Zebra killings started at a volatile time when America faced another constitutional crisis. Vice President Spiro Agnew left office, pleading "No Contest" after a Federal Courthouse in Baltimore convicted him of income tax evasion. Once Nixon's pit bull, who acquired a reputation for verbose putdowns of protestors with such terms as "pusillanimous pussyfooters," Agnew put his tail between his legs and left Nixon with one less ally to help fend off the Watergate wolves.

More international strife spread by September. A bloody CIA-hastened coup in Chile replaced Salvador Allende with dictator Augusto Pinochet. London got struck by more IRA bombs, this time maiming at least thirteen people at the city's train stations at King's Cross and Euston. Guerillas in Buenos Aires went on an ammunition grab by attacking a military post, leaving one soldier dead. In October, the OPEC crisis began. And by late 1973, Pol Pot and his Khmer Rouge got closer to the Phnom Penh border, preparing to slaughter close to two million people and build mountains of skulls in the future "Year Zero."

At around the same time, CIA director Richard Helms was allegedly shredding documents related to the mind-control experiments, known as MK-ULTRA, that the agency conducted from the early 1950s on through most of the 1960s. These "behavior modification" efforts

involved hypnosis, sensory deprivation, trauma-induced mind control, and lots of drugs, particularly LSD, administered to unwitting subjects in both the U.S. and Canada. Helms must have suspected that in a couple of years, Senate committees would investigate and attempt to uncover the mostly illegal government shenanigans.

When Charles Fort once claimed that life transpired in "one inter-continuous nexus," he was obliquely predicting the uncanny coinci-dence that occurred on October 20, 1973. This is the day that Nixon enacted his "Saturday Night Massacre," when two of his previous sup-porters, Attorney General Elliott Richardson and Deputy Attorney General William Ruckelshaus, refused to fire Archibald Cox (whom Nixon perceived as an enemy) and tendered their resignations. Future failed aspirant to the Supreme Court Robert Bork, acting as solicitor general, heeded Nixon's command to stop Cox's inquiries into White House mischief. Much of the press corps looked upon this as the true symptoms of a despot.

Also on the evening of October 20, the Zebra killers claimed their first bounty. After a failed attempt to snatch and kill three children hours before, the aspiring Death Angels found a couple taking an evening stroll along Telegraph Hill. They were abducted, dragged into a van, tied down, and beaten. The man escaped but survived with a butchered face, but the woman, after being molested, finally lost most of her head to a machete. Evoking both *Chain Saw*'s ballet finale (when Leatherface waves his weapon toward the sky in ceremonious rage) and the flashbulb corpse shots at the film's beginning, Clark Howard describes how the killer waved his blood-spattered machete in the air, performing a demonic rit-ual dance as he prepared to photograph his kill: "From under the driver's seat, he removed a Polaroid camera with flash attached."

Shortly after his release from jail, a young man tried to buy some drugs. The logical place for him to go was the Haight, where he tried

scoring with someone he knew in one of the nearby projects. He left money with the proviso that he would get his fix upon returning later that night. But when he came back, someone handed him just a slip of paper with a scribbled telephone number. Heading to a nearby pay phone, the beleaguered junkie looked like another "grafted devil" to his attacker, and before he could even pick up the receiver, the man got shot three times in the chest. Resisting death, he wobbled for about twenty feet from the phone before falling onto the pavement.

The Death Angels did not always deploy a consistent M.O. On one occasion during a rainy Sunday morning in November, one of them (the one of the five who rode up from Houston) shot a Jordanian-Muslim grocery store owner on Larkin Street. But they were back on script by December 13, when the liberal reformer (and future San Francisco mayor) Art Agnos was leaving a meeting about plans to create a health center for the Potrero Hill district. The killer thought he could fire his way to a triple-play as he watched Agnos speak with two white women. Agnos got two Zebra bullets, but the assailant failed to kill the two women who ran away shrieking. By standing still and staring back at him, Agnos had stunned and scared his fleeing attacker. Agnos then delayed his fall once he took refuge in the home of a nearby black family, who helped him until an ambulance arrived to take him to Mission Hospital, where doctors found injured kidneys, lungs, and spleen.

Agnos was relatively lucky, but not so a woman that same night when she crossed paths with another Death Angel contender who threw her in a doorway at Haight and Divisadero and shot her twice in the chest and once in the back. Into the Yuletide, a slim, nineteen-year-old man, clad in denim and strutting with a happy gait in his motorcycle boots, got gunned down on Market and 12th Streets, leaving behind a Teddy bear he had purchased as a Christmas gift for his kid sister.

Meanwhile, America dodged a nuclear catastrophe in late October, near the end of the Yom Kippur War, when the U.S.S.R., sensing a weakened president, threatened to propel Soviet troops into the Middle East to battle Israel. Nixon was sleeping during those hours, but Henry Kissinger and Secretary of Defense James Schlesinger teamed up with the Joint Chiefs of Staff chairman Admiral Ernest Mourer to send a warning message to Moscow. The Kremlin nerve center got the jitters, and the Politburo held an emergency meeting. KGB head Yuri Andropov was belligerent, but Leonid Brezhnev followed the tempered advice of Prime Minister Alexei Kosygin and finally backed off, afraid to make Nixon (the "mad man") nervous, even though the president was still in his slumbers. The U.S. canceled its Defcon 3 alert and postponed the world's extinction.

By the holiday season, San Franciscans joined the rest of the thwarted world as the Kohoutek Comet, hyped up in the press to outshine Halley's legendary fireball, turned out to be a dud. Those seeking some kind of celestial wonder to distract them from trying times had to look elsewhere. Faithful Christians saw no new Bethlehem star to lead them out of darkness, but the doomsayers thinking that Kohoutek would signal an apocalypse found hope in the ongoing blitz of murder and mayhem.

Another apocalypse came along days later. It would prove to be the most horrendous Zebra assault, involving a man abducted near Ghirardelli Square at Fisherman's Wharf. Dragged to a warehouse, he was blindfolded, bound, stripped naked, tied to a board, and left to the mercy of several men who lined up to stab and slice him with knives and meat cleavers. His body parts—minus the head, hands, and feet— were trussed up like a holiday turkey and hurled into the ocean. On Christmas Eve morning, another shattered citizen called the police after discovering the remains washed up on Ocean Beach's rocky

shore, with visible pieces of hairy flesh and matted blood sticking out from the canvas and twine. The coroner's office unwrapped the fetid package to find arms wired to the torso, knees wired to the chest, and intestines trickling out from the slit abdomen. Authorities could only call him "John Doe No. 169": he was too mutilated to identify.

Slouching into 1974, with Nixon still reeling from the Watergate Hearings, Hooper and Henkel continued to stitch together the post-production pieces of their magnum opus. San Franciscans, braving a cold front that made the city more unbearable, also heard about murders committed by neither Zodiac nor Zebra. During the early hours on January 24, 1974, the body of a forty-nine-year-old Canadian-American immigrant surfaced faceup on Ocean Beach. In July, another body was found with its throat slashed and multiple front-and-back stab wounds. Several other such incidents tallied up to at least fourteen San Francisco men, all gay and all apparently engaging in some kind of intimacy with the killer, who became known as the "Doodler."

The Doodler would meet his conquests in bars or restaurants in the Castro district, draw flattering pictures of them on cocktail napkins or sketch pads, and then walk out with them to discreet locations before slashing and stabbing. Sometimes he drew them while they were naked and engaged them in erotic tumbles before brandishing his weapon. Though authorities released a composite sketch of the man, none of the three Doodler survivors came forward for fear of "coming out" when testifying in court. Harvey Milk, already active in local politics, expressed empathy for them, but their silence allowed the Doodler to vanish.

The American public got snookered into another kind of ritual violence, this time media-generated, when on January 28, 1974, Muhammad Ali beat Joe Frazier in a boxing match at New York's Madison Square Garden. Several Death Angel contestants watched it

via closed-circuit television at the Winterland Ballroom. Ali's victory gave the Zebra killers such twinges of ecstasy that they hopped into their black Cadillac to go on another killing cruise that would claim four more fatalities.

Among the marks was a woman with a penchant for sewing who, while on her way to purchase some fabrics, got shot at Geary and Divisadero: twice in the back. Another victim, this time a man, whistled down Scott Street, privately celebrating his sixty-ninth birthday when someone snuck up from behind and shot him twice. Another man, eighty-four, lonely, poor, and living at (what were then) the slums of Folsom Street, rummaged through trash for old clothes and other items to supplement his fixed income. He too got shot twice in the back, but he had enough adrenaline to grab his assailant. The struggle finally broke him, and he expired on the concrete at Ninth and Howard Streets. A woman, immersed in the humdrum of washing and drying her clothes in a laundromat on Silver Avenue, was spotted by another Zebra assassin, who stormed in and gunned her down, hitting her once in the upper back and once in the abdomen, under bright lights, and in front of several witnesses. The killer sped away in the black Cadillac that waited for him.

Following the January 28 killing spree, San Francisco came to a shivering standstill. People of all races were afraid to step out at night. The evening tourist trade suffered, and Carol Doda had to limit her famous nude dancing at the Condor Club in North Beach to the earlier hours. "I walked out into the foggy street and looked both ways," Herb Caen wrote in the *Chronicle* on January 30. "Nobody was in sight. Was I the only person left alive in the city? 'The Last Time I Saw Paranoia' is not my favorite song, but I felt a chill." After a three-year hiatus, the Zodiac also returned, sending the *Chronicle* a new communication, postmarked January 29, 1974. Here, he tallied his body count to

thirty-seven but also anointed himself a killer film critic as well, using his trademark spelling gaffes by calling *The Exorcist* "the best saterical comidy that I have ever seen."

On the evening of January 30, President Nixon gave his State of the Union address, ignoring the Watergate peril hulking over him and instead boasting of sundry administrative accomplishments. He dismissed talk of a coming recession but did acknowledge the menace of inflation and the OPEC-induced energy crunch. The San Francisco authorities, mired in local chaos, were not so preoccupied with the oil drought. Earlier that day, the *Examiner* issued a plea to the public, posting on its front page, above the masthead, a telephone number for people to call with any clue about the "wanton murders." "For the first time in San Francisco's history," Howard writes, "the [police] department officially warned citizens not to venture outdoors after dark."

With wicked timing, the Symbionese Liberation Army entered the fray. The SLA was a group of extreme Marxists, headed by a black Soledad prison escapee. He held sway over his foot soldiers, most of whom (if not all) were affluent young whites (mostly women) squirming in the post-'60s season of white guilt. They often channeled their self-loathing into self-righteous shrieks, but they also succumbed to a self-induced hypnotic trance that enabled them to bow and scrape before their self-appointed chieftain, who called himself Field Marshal Cinque.

The SLA had already murdered Marcus Foster, a progressive, black school superintendent in Oakland, because he was "establishment." They resented his attempts to prevent school truancy and vandalism and even bragged about prepping for the kill by dipping the bullets in cyanide. "The so-called army seemingly came out of nowhere," Earl Caldwell of the *New York Times* observed in 1974. "Its first communiqués, those that said the organization had murdered Dr. Foster, were so

startling that for a while even the police felt that they were part of a hoax." The SLA amplified tensions in February of 1974 by kidnapping the nineteen-year-old newspaper heiress Patricia Hearst.

Hearst's rebellious attitude toward her forebears got to a point when she accused their newspaper, the *Examiner*, of being "irrelevant," and this petulance might have made her an easy mark. By Hearst's own accounts, the SLA dragged her from her Berkeley paradise, slammed a rifle butt into her face, drove her to a secret hideout, and shut her away into a smelly closet, where they blindfolded her, pelted her with such epithets as "bourgeois bitch," and to prevent her from overhearing them, left her alone with a radio blaring out soul music at ear-splitting decibels.

Soon, Hearst exhibited symptoms of "Stockholm Syndrome": a condition when desperate captives adopt their captors' logic. She shocked the public by posing in a photograph next to the SLA banner with its seven-headed cobra. She also adopted the Symbionese ideology, going by the name "Tania" (after a former Che Guevara comrade) and becoming an iconic dupe as a security monitor captured her wearing a wig and toting a rifle as she participated in an SLA heist at a Hibernia Bank in the Sunset district. Many started to suspect that "Tania" was a willing accomplice. Nixon's last attorney general William Saxbe declared that she was in league with the rest of the "common criminals."

The *Chronicle* suspected that the Zodiac might have been trying to confuse the authorities by meddling in the Hearst affair, when the paper received another of his letters on February 14, claiming an Old Norse term for "kill" lay in the Symbionese Liberation Army's initials.

The Zebra murders also acquired a larger statewide backdrop by February, when some authorities suspected the killings were linked to several other execution-style murders of whites across the state. Despite initial resistance from law officials compelled to protect "houses of

worship," state investigators reached their limits and sidestepped the rules by aiding Gus Coreris and John Fotinos—the prime Zebra investigators—in surveilling Muhammad's Temple No. 26 (formerly the Fillmore Auditorium). Watching from atop a building in Japan Center, they collected photos of several men going in and out of the mosque. The increased diligence led to a Zebra lull, for a short while.

Then, on April Fool's Day, two clean-cut and optimistic Salvation Army cadets—a nineteen-year-old man and a twenty-one-year-old woman—were strolling down Geary Boulevard in the cool, early evening to buy some snacks. About two months had transpired since the last Zebra attack, so they were more preoccupied with the fresh-air aroma after a day of rain. Just as they got to Webster Street they were both shot in what had proven to be the Death Angels' favorite spot: the back. The man died, but the woman wriggled on.

A city usually proud of its "diverse," "liberal," and "all-accepting" attitude—which Scott McKenzie called a place to "wear some flowers" with "gentle people," and where Tony Bennett claimed to have left his heart—had to fess up to a tarnished image. Behind the fog lurked multiple murders driven solely by race: this time, black on white. When police produced composite sketches of suspects, authorities began to stop and question young, black, male residents resembling the pictures. Those whom the police recognized as innocent received Zebra check cards for insurance against future profiling.

Cries of discrimination followed the "Zebra sweeps." Black Panther Bobby Seale called the stop-and-search measures "vicious and racist." The American Civil Liberties Union vowed "appropriate legal action," and the NAACP also filed with the U.S. District Court against the dragnet. Mayor Alioto flatly stated that the police were merely acting on a description of the suspect, who was not only black but male, young, and thin faced. "With Zodiac," Alioto told *People* magazine, "we

stopped about 1,000 white men. I wish somebody would look into how many whites we stopped for Zodiac."

This was not enough for virulent protestors who stooped to spitting on Alioto and hitting him with a picket sign. Alioto, a complicated and old-fashioned Democrat with Catholic pieties, was sometimes kind and sometimes gruff. But this time, the besieged Mayor, still dealing with continuing crime problems in the drug-addled Haight district, a strike by sanitation and transport workers, and several bombings that included his house, had to contend with demonstrators from the Progressive Labor party, swarming outside of his home to yell, "Alioto is a Nazi!" over and over again.

As the grafted-devil corpses abounded, and San Francisco's paradox of love and hate got more unruly, the *Examiner*, as well as members of the Arab community, offered reward money for Zebra leads. Some reporters and journalists about town were quick to spin stories and theories. Clark Howard relates how the *Examiner* invited ordinary black citizens to impromptu interviews. One young man working for the Postal Service expressed his distaste for seeing so many cops around. An attorney was thankful that the police were on the lookout but expressed concern that blacks were being harassed. The general response was less against the killers and more against what they saw as larger societal ills, including the canard that violence is somehow worse in America than in other, more troubled, spots on the globe. One woman who operated a bookstore proclaimed, "These incidents are the consequence of violent propaganda thrown at us daily by the news and entertainment media." *Examiner* reporter Bob Hayes concluded that the massacre "involves a sickness that is as American as apple pie."

Madness in America—and the world—raged on, and signs of a new world crept in, as other seemingly disparate events converged into a hazardous tapestry. In April of 1974, Stephen King published his first

horror novel, *Carrie*, which put an American teenager through peer persecution and pubescent hell. On April 3, 148 tornadoes blasted thirteen states, particularly parts of the Midwest and South, the death toll reaching to 315 with over five thousand injured. In June, a Marsh Supermarket in Troy, Ohio installed the first UPC barcode, christening this soon-to-be-pervasive device by scanning a pack of Wrigley's gum.

In May, the *Chronicle* received one more cryptic movie review, signed by "A citizen" but suspected to be the Zodiac (or a Zodiac permutation). This time, the focus was on Terrence Malick's 1973 film *Badlands*, about a young couple that goes on a murder rampage in South Dakota. Here, the slayer who bragged about the prospect of shooting up schoolchildren expressed his moral outrage over the film's "murder-glorification." On May 18, India detonated its first nuclear weapon, code-named "Smiling Buddha," the day after the SLA had its standoff in South Central Los Angeles, as the LAPD and SWAT teams shot at the burning compound and obliterated several members, while Cinque shot himself in the head. "Tania" remained missing—for the time being.

More Zebra outbreaks erupted on the evening of Easter Sunday when a fifteen-year-old boy and an eighteen-year-old merchant seaman were gunned down while waiting for a bus at Fillmore and Hayes. The seaman asked an approaching man for a cigarette and got a grunt for an answer. The grunter then pulled out a gun and shot the seaman two times, hitting the lower back and slicing the kidney and liver. He fired at the fifteen-year-old two more times, hitting beneath his rib cage, splitting his liver and piercing his lungs, with the other bullet penetrating his left arm. The killer managed to flee toward Grove Street.

Oddly, an undercover Zebra unit had driven past the exact area about a minute beforehand, but they were too early to detect anything suspicious. The bullets this time were the same .32 caliber type that

accompanied the other Zebra shootings. The two young men survived but lay in serious condition at San Francisco General Hospital. Police chief Charles Barca was, like Mayor Alioto, so much in the dark at this point that he confessed the next day to Roger Mudd on the *CBS Evening News* that he felt helpless.

Once the NAACP won its court case to end the "stop and search," Operation Zebra seemed to be at a standstill. Fate then took a perverse twist. One of the suspects, a Zebra crony who was assigned to dispose of the chopped-up remains belonging to "John Doe No. 169," was so panicky at seeing how accurately one of the newspaper sketches captured his likeness that he arranged a meeting place to tell the police all he knew. He also figured that he could pass the $30,000 reward on to his wife and child. He even got to meet with Mayor Alioto. Most important, he detailed the entire story of the "Death Angels," their points system regarding white men, women, and children, and the set of wings that would take them to Mecca. Though an unstable fellow who was more involved in the homicides than he admitted, this informer had enough juice in his story to lead police to the suspects.

By May, in what would become one of California history's longest criminal trials, four Death Angels got indicted. They would later be convicted of first-degree murder (along with several other counts) and sentenced to life imprisonment. The death toll tied *directly* to the Zebra Murders reached fifteen, with eight wounded survivors. Still, others suspected there were many more. Mayor Alioto gave a press conference on April 29, addressing accounts of over eighty similar murders, including slaughtered hitchhikers, taking place throughout California with possible Zebra links.

In the meantime, a group of concerned San Franciscan women, miffed that their city was getting such a bad reputation, started a campaign. They sent a letter to the Motion Picture Association of America's

president Jack Valenti, decrying movies like *Dirty Harry* as well as television shows like *The Streets of San Francisco* for using their precious town as a crime-story backdrop. "Although entertainment producers always claim only to be giving the public what it wants," they wrote, "there is a limit to the degree to which they should be allowed to appeal to the public's baser instincts." They got no response.

The grisly San Francisco events, rattling at gut-grinding speed, were a prelude to an outrage that involved merely make-believe murder. And the holiday season helped orchestrate the disorder, just as it had in 1972, when Tobe Hooper stood in the crowded Montgomery Ward, saw the chain saws, and felt a brain buzz. A. Alvarez, who attempted suicide on Christmas of 1960, was also suspicious about the holiday season in general: "All my life I have hated Christmas: the unnecessary presents and obligatory cheerfulness, the grinding expense, the anticlimax. It is a day to be negotiated with infinite care, like a minefield."

On the night of November 16, 1974, as Nixon already signed a contract to write the first of his memoirs, and the plutonium-tainted Karen Silkwood, a chemical technician turned labor activist regarding nuclear fallout at the Kerr-McGee plant where she worked, was on her way to speak to a New York Times journalist before dying in a mysterious car crash near Crescent, Oklahoma three days earlier, unsuspecting audiences who anticipated a wholesome Thanksgiving dinner in the coming days were enticed to see an unidentified sneak preview at San Francisco's Empire Theater. It was to accompany a screening of Joseph Sargent's *The Taking of Pelham One Two Three*. Mass commotion ensued.

San Francisco Supervisor Peter Tamaras, who was part of the team looking for ways to make the Golden Gate Bridge suicide averse, hired a young administrative assistant named Peter Bagatelos. Bagatelos, now a practicing San Francisco attorney, was among those who had

attended the screening that evening and, for this book, was kind enough to recall the event:

> *"The advertised movie was* Pelham, *and the theater was pretty crowded. The sneak preview came on first. I remember seeing the opening with the graveyard and the body rotting. It was pretty violent and not the kind of stuff we were used to back then. My wife, friends, and I were among the first people who left and went into the lobby to leave the theater. However, we decided to stay and protest the movie. There were about eighty people who then filled up the lobby. I thought at the time someone might have a good lawsuit for intentional infliction of emotional distress. But it turned out that, by protesting and speaking to the* Chronicle, *we secured the success of the movie and the genre, which was aimed at shock value and inflicting emotional trauma. It was not much different than if someone came on the stage and vomited on us."*

Considering the period and the context, Bagatelos's response was probably widespread for a local audience still devastated by so much nonfiction. From the moment when John Larroquette's voice claimed *Chain Saw* was supposedly based on a "true" story, the result came close to what a psychedelic garage band from the mid-'60s once called a "psychotic reaction." But by 1974, moviegoers were not exactly babes in the woods regarding violence and fear signals. This was the year that gave the world films making disaster and chaos either a comedy (*Law and Disorder*) or an inescapable force (*Death Wish, Earthquake, The Towering Inferno*).

The Empire audience that night was not expecting family fare, either. They were psyched up to watch this new Walter Matthau thriller, an R-rated nail-biter about thugs hijacking a New York City subway train, holding the passengers for a million-dollar ransom, and threatening to obliterate one hostage for each minute the money is delayed after a one-hour deadline. But for many of the viewers, *Chain Saw* might just as well have been a true-to-life documentary, which they were in no mood to experience.

Critic John L. Wasserman, who got his reputation writing funny pans of (often good) movies for the *Chronicle*, continued to joke. While impressed by Marilyn Burns's screaming "without surcease for the last 45 minutes of the picture, thereby setting a modern record," he spent much of his literary energy satirizing the Empire fiasco and satisfying his stomach:

> *"The flap, of course, occurred a week or so ago when* The Texas Chain Saw Massacre *had a sneak preview at the Empire. The preview audience, apparently expecting a Walt Disney movie, was outraged, and demanded their money back. 'Ugh, what a disgusting movie,' they said, having no clue whatsoever from the title. To be sure, it's not a fun movie. As a matter of fact, it's pretty gruesome and sadistic and ugly. But I survived and, to show my contempt, ate two hot dogs and some popcorn, to boot."*

Sensational accounts of its Empire reception became part of *Chain Saw*'s legend. Danny Peary, in *Cult Movies*, claims that the Empire viewers "had no knowledge of the film's violent, stomach-turning content or even its forbidding title . . . Soon unsuspecting viewers were seeing a huge man with a chain saw in a mask made out of what once

was a human face, making mincemeat out of . . . college-age kids. Some viewers threw up; others stormed the lobby to protest." As Hooper recalls in his 2014 chat with *Interview* magazine, "People were running out of the theater throwing up, and several fights broke out."

The spectacle at the Empire Theater was a moment when *Chain Saw* held up a disconcerting mirror to a city that could still smell blood from the preceding months. Its citizens still felt the spell of invisible bones, feathers, gourds, and juju masks hanging over their skyline. The imbroglio also became another selling point to get more audiences across the country to see the movie that was pissing off so many. For the gore fans and those who appreciate film as a transgressive art, a cinema original was born. But for the protesters and the pukers, *The Texas Chain Saw Massacre* should have been called *The Purge*.

Chain Saw was entirely new, with a narrative that strayed from conventions by providing a farthing of a backstory with no expected resolution—factors that charmed so many and alienated others. *No Country* is relatively conventional: the dope smugglers, the crooks looking to retrieve their loot, the cops on the killer's trail. But the inanimate object—the killer's airgun—functions as an extra villain and teases out *Chain Saw* conjecture. Many viewers, trained from an early age to fear death, are the ones stuck with the corpses: embalming, cremation, open-coffin funerals, dried remains assembled into voodoo hexes, and sanctified or vandalized gravesites.

CHAPTER TWELVE

NO COUNTRY
FOR "JUST AN OLD MAN"

"Things happen here about they don't tell about. I see things. You see, they say that it's just an old man talking. You laugh at an old man. It's them that laughs and knows better."

Yes, he was "just an old man" and a drunk to boot, fondling his beer bottle, squirming in the grass, and spewing what would sound like nonsense to most. Yet anyone listening closely, in this case Franklin Hardesty, might suspect dark prophecies encoded in the slobber. In *The Texas Chain Saw Massacre*'s narrative, the soused storyteller (Joe Bill Hogan) holds a fugitive viewpoint. He sees "things," but they translate into slippery hints: gestures, omens, signs, and symbols that together might provide an answer, a pattern—or nothing at all.

The Texas Chain Saw Massacre includes another bit of paradox: while the old man rants, another man in a straw hat and overalls, holding a pipe, and sitting in the back of a truck telling stories, directs Sally to a rather dodgy guy in sunglasses and cowboy hat (Jerry Green) who escorts her to her grandfather's grave. This storyteller is played by

Austin native John Henry Faulk, a one-time radio announcer from the 1950s whose knack for homespun anecdotes got sidetracked when he faced charges of being a communist and appeared on the McCarthy-era blacklist. Faulk fought back with a lawsuit against AWARE, Inc., a consulting firm that screened actors for networks that were leery about hiring "reds." Such media potentates as Walter Cronkite and Edward R. Murrow were among his supporters. By the summer of 1962, Faulk was successful in his libel suit, and he wrote a book about the hassle, which became the basis for a 1975 made-for-television movie called *Fear on Trial*. But perhaps due to last-minute edits, or simply to provide an inside joke, this real-life raconteur functions in *Chain Saw* as merely a backdrop to the blubbering reprobate in the foreground.

Tobe Hooper and Kim Henkel apparently liked this idea of an incoherent old coot as potential seer. They returned to it in Hooper's 1977 film *Eaten Alive*, fashioning a story based on a true-crime maniac, a bar owner from the late 1930s named Joe Ball, who earned the nickname Bluebeard of the South Texas, due to the many victims he jettisoned to the alligator pit surrounding his establishment. Ball's misdeeds became public knowledge when he killed himself in September of 1938. The police arrived to take his body, but they also traced him to the multiple murders.

Being the Hooper feature that followed *Chain Saw*, *Eaten Alive* has some of the previous film's haunting touches: the sleazy atmosphere, the eerie regional country songs, and the dissonant sound collaborations with Wayne Bell.

Eaten Alive's best scenes are the muddled soliloquies of the lead character Judd, who runs the grimy Starlight Hotel. Gushing over memories of Frank Buck (the legendary animal collector, hunter, author, actor, and movie director), Judd also relishes his own bond with an old crocodile that once chewed off his right leg but now does his bidding. He

also collects animals for his zoo, and the sight of his poor little caged monkey starving to death while looking out at the huge, hungry reptile is among the film's most chilling moments. Judd is also a veteran, who longs for the order of army regulations, taking his sexual anxieties out on women he perceives as whores.

Thanks go to the character actor Neville Brand for his flawless Judd portrayal. He is unkempt, unhinged, and wanders about his territory with the same paranoia that Leatherface shows when reacting to his home's invaders. Brand earned kudos in the 1950 crime drama *D.O.A.* as Chester, the sadistic lackey and likely boyfriend of the dapper mobster played by Luther Adler. He is still arguably the best Al Capone, whom he portrayed in the television series *The Untouchables*. Behind his ratty hair, damaged eyeglasses, and horrid disposition, Brand's Judd retains a touch of pathos in the close-ups on his contorted face as he cringes at the catastrophe all around him that he helped to create.

"It's all according to the instincts," he rationalizes to one of his guests, a troubled mother played by Marilyn Burns, when his "croc" gobbles up her family dog. Though he knows he has slaughtered people with his scythe and thrown them to his beast, Judd mutters what sound at times like moral condemnations and regrets: "I tell it, and I tell it, and I tell it! It don't set right with me." He occasionally attempts to sort it all out by imagining he is back in the army, shouting "Give me the uniform!" and commanding to himself and to the world: "Tell 'em to get and get! Give 'em the signal!"

During the immediate years before and after the arrival of *Chain Saw*, America and the world faced events that seemed so absurd that they might have cohered better in such a crazy codger's mind. There were more serial killers like New York's Son of Sam (who claimed to speak to a god and might have had fanatical accomplices) and such other religiously motivated mass homicide-suicides as the tragedy of

Jim Jones and his Peoples Temple. And like the opening of *Chain Saw*, cosmic events like solar flares, asteroid scares, and approaching comets also flashed into the news—mere planetary flukes to most but dark foretokens to those seeking them.

By 1980, when New Line Cinema re-released *Chain Saw*, the times were again rife with, what Charles Fort would call, "strangely associated things." In February, Santa Fe's New Mexico State Penitentiary endured a thirty-six-hour riot. Official tallies recorded thirty-three inmates killed and over one hundred injured. The prisoners-at-war demonstrated gore and sadism unparalleled in the eyes of the authorities and journalists: mutilation, rape, torture, axes and shivs slicing into flesh, pipes crushing skulls, acetylene torches burning extremities, and the hacking of bones.

In May, Mount St. Helens erupted after an earthquake, killing over fifty people. By summer, the Dallas/Fort Worth area got hit with record-breaking temperatures of up to 113 degrees Fahrenheit. The Midwest and South also endured a devastating heat wave and drought that cost billions of dollars in agricultural losses and thousands of lives. By July, President Carter was so intent on aiding Afghanistan's "holy" war against the Soviet Union, which also involved protecting oil assets in the Persian Gulf, that he signed a bill requiring most young adult males, born after January 1960, to sign up for a peacetime draft. "God is on your side," Carter's national security adviser Zbignew Brzezinski assured the Mujahideen a year before, speaking to an Afghan fighting force whose members would include Osama bin Laden.

Ronald Reagan basked in victory as he prepared to enter the White House, selling himself as the new economic hopeful, even though he would soon oversee a worse recession. Not long before Christmas, John Lennon got shot outside of the same apartment complex where Roman Polanski had filmed *Rosemary's Baby* twelve years beforehand; his

killer Mark David Chapman toted a copy of *The Catcher in the Rye*, which authorities would also find in the possession of Reagan's attempted assassin John Hinckley Jr. a year later.

As inflation continued to run amok, reports started spreading about a killer virus transmitted primarily through sexual intercourse, blood transfusions, and—from what some back then imagined—possibly saliva and even the air. What started as a sexually active Missouri teenager's puzzling death in May of 1969 metastasized into biological malware out of control: an international epidemic. Also, the threat of incurable genital herpes turned the mere intimate contact of two naked bodies into a fearsome prospect. Though not fatal, it vied with AIDS as the '80s scourge.

By August of 1982, *Time* magazine had a herpes cover story entitled, "The New Scarlet Letter." "Now, suddenly, the old fears and doubts are edging back," the article stated with biblical bumptiousness. "So is the fire and brimstone rhetoric of the Age of Guilt." As if gloating over thoughts of a fulfilled prophecy, Hal Lindsey, in his book *The 1980s: Countdown to Armageddon*, would write that "the decade of the 1980s could very well be the last decade in history as we know it."

Considering these examples alone, it is not surprising that author Cormac McCarthy chose 1980 as the setting for his 2005 novel *No Country for Old Men*. Perhaps *Chain Saw*'s "old man" was also among McCarthy's sources for the title. Though much more lucid than the "old man" or Judd, the novel's protagonist Sheriff Bell narrates fragments of "things." Bell occupies much of the storyline with his troubled reflections, reminiscences, and uncertainties about the future. Unlike the *Chain Saw* drunk, *No Country*'s Bell does not laugh and has nowhere near the old man's smug self-assurance. He is, in fact, a man of fine manners and deep doubt. Apart from the dialect (which McCarthy reproduces in its ungrammatical realism), his words often make sense

and are likely to strike a chord with readers of varying regions and even varying ages.

A World War II veteran with traditional Southern views on many issues, Bell tries to keep his balance while tottering over shifting moral templates. In contrast, Llewelyn Moss, a Vietnam veteran who likes to hunt antelope, also tries to forge some meaning, but his perspective is more limited and mercenary. He has no qualms about keeping for himself the cache of money he finds in the desert at the scene of a gory crime gone wrong. But both Bell and Moss must contend with a wildcard third party: Anton Chigurh—a serial killer who stalks Terrell County, Texas, a dusty place near the Mexican border. Chigurh is not only a killer but one with an esoteric belief system that makes his attacks all the scarier.

When the Coen Brothers turned *No Country for Old Men* into a movie two years after the novel got published, many viewers, like the readers, might not have immediately perceived any thematic parallels with *The Texas Chain Saw Massacre*. Yet what melds the two movies most is the specter of the airgun—an object the Slaughters in *Chain Saw* hate and that Sheriff Bell (Tommy Lee Jones) in *No Country* fears. The fiendish Slaughters view the airgun as the enemy—the technological menace that put people like themselves out of work. In a moral reversal, Bell (the good guy) echoes the Slaughters' sentiments, seeing the airgun as just one more example of a new world edging him out.

On the one hand, the differences between the two films are obvious. *Chain Saw* was entirely new, with a narrative that strayed from conventions by providing a farthing of a backstory with no expected resolution—factors that charmed so many and alienated others. *No Country* is relatively conventional. Moviegoers had been led down its path before: the victims of circumstance, the dope smugglers, the crooks looking to retrieve their loot, the cops on the killer's trail, and

even Anton Chigurh (Javier Bardem), who does not deviate much from other psychos of past crime capers. But it is the inanimate object—the killer's unconventional weapon—that functions as an extra villain and teases out *Chain Saw* conjecture.

The Coen Brothers capture this message visually in the film's beginning. One of the deputies (Zach Hopkins) forces Chigurh into the back of a police car, placing the airgun in the front seat: the close-up on the alien weapon sets the ominous tone, even before the killer's face appears. What the film lacks, and what makes McCarthy's novel more engrossing, are Bell's numerous italicized introspections: thoughts of a weary man accustomed to life as it used to be and the baleful direction he sees it heading.

Bell, in the novel, has thoughts that a sober-minded "old man"—or a less deranged Cook from the Slaughter household—might have shared. He attempts to graft some kind of perspective as he tries to abide new days that put "his soul at hazard." To get a grip while his foundation shifts, Bell sides with "the old timers." "I just have this feelin we're looking at something we really aint never even seen before," he tells a fellow sheriff after encountering carrion corpses in the middle of the desert.

Elsewhere in the novel, Bell is perplexed while recalling a questionnaire handed out in the 1930s about problems in American schools, with results that listed such examples as chewing gum in class and running around the halls. Decades passed, and someone got hold of those same blank forms and handed them out again. The problems listed this time included arson, drugs, rape, and suicide.

In the film, Llewelyn Moss (Josh Brolin), who functions to some degree as Bell's doppelgänger, does not obsess over ghosts of ethics past. He is instead intent on keeping his illicit money while trying to evade Chigurh and the gangster cohorts. In one scene, Bell meets

Moss's wife Carla Jean (Kelly Macdonald) at a restaurant for help in tracing her husband's whereabouts. He lapses into reverie, revealing his fixation on the airgun by telling her about an abattoir east of Sanderson named Charlie who used to slaughter "beeves" with a mallet, truss them up, and then slit their throats. One day, Charlie slipped up and encountered "600 pounds of very pissed-off livestock." Charlie tried shooting the cattle, but the bovine thrashing made him miss, and the shot bounced off the wall, hit Charlie in the shoulder, and paralyzed his arm. "Even in the contest between man and steer, the issue is not certain," he tells Carla Jean in an attempt to provide an object lesson. But Carla Jean, looking more confused and suspicious, asks why she has to hear all of this. "I don't know," Bell responds. "My mind wanders."

Had Sheriff Bell really existed in 1980, he would have been doubly dumbfounded when over in Elbert County, Georgia, architects erected a nineteen-foot-high monument that became known as the Georgia Guidestones. Dubbed by some as America's answer to Stonehenge, they are meant as instructions for surviving the apocalypse that Sheriff Bell dreads. They are also alleged to correspond with several celestial patterns, with a slot that aligns the sun during equinoxes and solstices. In place of Moses's Ten Commandments, the Guidestones provide ten dictates, inscribed in granite columns that together form both a star and a cross.

The Guidestones' messages stress sentiments similar to those of the Club of Rome and other environmentalists and globalists of the early '70s. The first big rule is to keep the world population under five hundred million—a sign that lots of people must die. They also call for such familiar bromides as more "diversity" and a new "living language" that would unite the planet. "Be not a cancer on the earth; leave room for Nature," the stones advise. Several of its strictures about "fair laws"

and "improving fitness" are pleasant enough for a universal Hallmark card, but the jumble of dates, numbers, letters, and (at times) misspelled words also recall the Zodiac killer.

The inscribed "author" of the Guidestones (who commissioned the work) is an "R.C. Christian" (possibly referring to the Rosicrucians or the Rosy Cross Christians). "A Pseudonyn" appears in parentheses under the name—a typo that seems too planned. Some have read the letters, taken together, as an anagram for "Untarnished Conspiracy." The Rosicrucians have supposedly bequeathed knowledge from generation to generation about a solar cycle, the climax (occurring every thirteen thousand years) involving what some accounts describe as "coronal mass ejections" intent on destroying the Earth. The Guidestones' true believers anticipate more financial falls, drops in oil and food production, ethnic and racial conflicts, mass riots, and an apparently postponed "end of days" that was supposed to fall in line with the Mayan calendar on December 21, 2012.

The Guidestones are another Rubik's Cube–style puzzle that might simply be an elaborate trick with no real answers and enough Masonic mind games, ciphers, sigils, and symbols to confound people and divert them from real dangers. But Yoko Ono has heaped praise and chanted about them, while covens of witches have visited them as altars for their pagan rites, along with stories, once again, of mutilated chickens. Others have expressed disdain for this monument and its preachy rhetoric by leaving such graffiti messages as "Death to the New World Order."

Complementing the Guidestones, a book called *The Aquarian Conspiracy* appeared in the spring of 1980. It sold millions of copies and essentially carried on much of the early '70s agenda of groups like the Trilateral Commission. Author Marilyn Ferguson, who started with brain research and branched out into studying the genetic code,

psychotherapy, and other areas of "human potential," writes with the boundless optimism similar to that of Charles A. Reich in the previous decade.

While many saw the early '80s as another period of doubt and despair, Ferguson felt a positive "social transformation resulting from personal transformation." Her book celebrates a new dawn of "paradigm shifts," a new "consciousness experience," and "a new human agenda" emerging to transform a troubled world. She focuses on "health, psychiatry, psychology, states of consciousness, dreams, meditation" to demonstrate "the dawning of the Age of Aquarius," which the casts of *Hair* had hailed in song and that Carl Jung referred to decades before.

Ferguson's influences came from those who forged academic careers out of merging Western with Eastern philosophy, aspirations that the Stanford Research Institute shared when it corralled such intellectuals as mythologist Joseph Campbell, anthropologist Margaret Mead, psychotherapist Carl Rogers, and once again, behaviorist B.F. Skinner, along with other "transpersonal" educators and captains of industry, to produce a study called *The Changing Images of Man* that explored "alternate future histories." The introduction mentions "how past images have led to our present industrialized society with its crisis-level problems; and what types of images appear to be needed as we move into a post-industrial future." It sounds scientific and bland enough, yet wastes no time in scaring the daylights out of its readers with a 1969 observation by former United Nations Secretary-General U Thant: "If such a global partnership is not forged within the next decade, then I very much fear that the problems I have mentioned will have reached such staggering proportions that they will be beyond our capacity to control."

While the 1980s ushered in a renewed élan for post-'60s, post-nationalist "paradigm shifts," there was a corresponding rise of

hard-nosed, old-fashioned Christians, primarily Baptists and Pente-costals, retrofitting old thought patterns for a "new age." This "reli-gious right" and "Moral Majority" tugged at Reagan's coattails, while contrasting cadres of astrologers, cosmic prognosticators, Satanists, Rolfing enthusiasts, and others, representing both organized and dis-organized religion, vied for alternative media space. They all appeared to be pulling the nation into warring directions and slicing American minds into smaller pieces with prophecies of either impending har-mony or impending doom. Believers and mystics talked a good game about people cohering through "transformative experiences" or "repenting" the old-fashioned way. All the same, more and more Amer-icans reacted to these mystifying bombshells by doing the opposite: they got increasingly atomized.

In 1981, along with Ronald Reagan's near-assassination, another oddity occurred, this time on America's prime-time tube. In the popu-lar sitcom *Barney Miller*, a distraught citizen, played by Jeffrey Tambor, rushes into Capt. Miller's police headquarters, railing about a nefarious organization called the Trilateral Commission. He even names some names—David Rockefeller, Henry Kissinger, Walter Mondale—while blurting out "New World Order" (already by then a meme), insisting that the Commission arranged for George H.W. Bush to be vice presi-dent to Reagan instead of Gerald Ford. Miller and his cohorts are baf-fled, as were probably most of the viewers in 1981, but the canned laughter provided ample distraction from what someone might have slipped into the script as a warning, or a joke.

Once *The Texas Chain Saw Massacre* enjoyed its comeback in the early '80s, the movie started to accumulate the cultish devotion and moneyed interests that would turn it into a franchise. Sequels, prequels, remakes, and remakes of prequels followed. But in 1993, Kim Henkel directed and wrote his own version of what he thought a *Chain Saw*

sequel should look like. Encouraged by producer Robert Kuhn, Henkel made this at an auspicious time. As people headed into the mid-to-late '90s, more social tumults occurred, and more got entranced by their home computers, the rise of the internet, as well as a resurging interest in flying saucers and other unexplained "phenomena."

Not until the 1990s did conspiracy theories and cosmic prophecies go so mainstream. "The truth is out there" was a renowned line from a television series that specialized in the uncanny. President Clinton gave his blessing shortly after taking office in 1992, assigning his associate attorney general Webster Hubbell the task of investigating any of the government's previous UFO cover-ups. Henkel's film arrived when UFO sightings increased while the mysterious activities inside of places like Area 51 spiced up the public discourse. Thoughts of approaching asteroids lived rent-free inside the heads of wary citizens as hearsay about such stellar death stones appeared in news accounts and several films. Among the first was the CBS television movie *Without Warning* from 1994. In 1997, NBC aired *Asteroid* and the Family Channel offered *Doomsday Rock*, while TriStar Pictures hurled ghastly "bug meteors" through the big screen in *Starship Troopers*.

As a new world opened up, vestiges from an older one expired. Richard Nixon passed away in 1994 but lived to see the Berlin Wall and the Soviet Union crumble. Though he died regretting his failure to defend South Vietnam, he also left behind a legacy more glamorized than people thought he would achieve back in 1974. Even the fall of Saigon, a festering boil on America's conscience, turned out in the ensuing years to be a Pyrrhic victory for the North Vietnamese and the Viet Cong. A decimated economy and rekindled animosities between the northern and southern parts of the country turned any so-called "liberation" and "unification" into tribal turf wars. According to historian Stanley Karnow, the communist victors put over three hundred

thousand "South Vietnamese civil servants and army officials as well as doctors, lawyers, teachers, writers, and other intellectuals, into concentration camps euphemistically called 'reeducation' centers." The Chinese, Cambodians, and Vietnamese subsequently fought among one another.

In August of 1995, Madalyn Murray O'Hair, along with her son Jon Garth and granddaughter Robin disappeared from her Austin, Texas home.

Back in 1965, she had fled the death threats from Baltimore locals and scuffles with cops to set up a new life and headquarters in Tobe Hooper's hometown, but as she continued to provoke the faithful, the city of Austin proved equally unhospitable. Local police, upon learning of her disappearance, conducted a less-than-wholehearted search. Local and federal authorities, journalists, and even members of her American Atheists organization were atwitter, not sure if this was a case of genuine foul play, one of O'Hair's publicity maneuvers, if the CIA or the Vatican had abducted her, or if she and her family had absconded with loads of the American Atheists' loot and were sipping daiquiris in New Zealand or at some remote nook in the South Seas. All they knew was that the muckraker who exposed the follies of the supernatural suddenly became a ghost.

Henkel also delved into the era's vogue for mystic conspiracies in his *Chain Saw* follow-up: symbolized here by a greasy white pickup truck with "Illuminati Wrecking" scrawled on its side. Its driver is a loon named Vilmer who also sports an electronic leg propelled by remote control; Matthew McConaughey plays him like a provincial college jock pretending to go wild.

The movie also includes a pretty but insane character named Darla (Tonie Perenski), based on the real-life Texas killer Karla Faye Tucker—a significant figure in the 1990s for being the first female

sentenced to death in the U.S. since the 1980s and in Texas since the nineteenth century during the Civil War. Despite her post-prison Christian conversion and an international fan club (that included Pope John Paul II) pleading that her sentence be commuted, Tucker finally got her lethal injection in 1998.

Henkel's protagonist—a feisty adolescent named Jenny (Renee Zellweger)—stands out as more of a "final girl" type: she gets angry, fights back, and at one point wields a shotgun. Darla, who has amorous designs on Jenny, starts spilling the beans when Jenny asks for the meaning behind all of the mayhem: "I really shouldn't be telling you this. But you know how you always hear these stories about people who run everything but nobody knows who they are? Well, it's true . . . I mean, who do you think killed Kennedy? . . . That government stuff is bull crap; it's these people. And they've been doing this kind of thing for like a thousand or 2,000 years, I forget which, and nobody, I mean nobody, knows their names, and *that's* who Vilmer works for."

The key Illuminati figure, an oleaginous European named Rothman (James Gale), appears to hold the inscrutable secrets to all of the disarray unraveling within and beyond this one little morsel of Texas melodrama. "I want these people to know the meaning of horror," he intones as his lackey Vilmer submits. Jenny eventually eludes her killers but still goes nuts, coming face-to-face in a hospital ward with her predecessor Sally Hardesty—Marilyn Burns with the eyes of a madwoman, being wheeled away on a gurney by a barely recognizable Paul Partain. To bolster the reunion, John Dugan also shows up as a policeman questioning Jenny after her ordeal.

Henkel's original title was *The Return of the Texas Chain Saw Massacre*, and he had completed production in 1994. While Tobe Hooper's 1986 sequel (with the weapon's name inexplicably elided into

one word) *The Texas Chainsaw Massacre 2* played it for laughs, Henkel mixed the titters with a more confounding and provoking storyline. He appeared to tailor his script for audiences savvy about the fashionable occult obsessions as well as the post-Watergate disclosures about MK-ULTRA and other CIA-based mind-control programs that would fertilize volumes of ongoing conspiracy lore. Besides alluding to the Leatherface family's original last name, including a maxim-spouting hellion named W.E. Slaughter (Joe Stevens), Henkel also loaded the movie with other anomalies, including a drag-queen Leatherface (Robert Jacks) who is much more funny than frightening.

Columbia TriStar, which ended up distributing the film, submitted the print to another kind of massacre by editing out several scenes, including a crucial one at the opening when Jenny applies ruby-red lipstick in giddy gusto for her high school prom before her stepfather (David Laurence) kills her buzz when trying to molest her. Even when its bowdlerized version got a limited release as *Texas Chainsaw Massacre: The Next Generation* and went to video by 1997, the film still showcased Henkel's talent for portraying chaos and madness within claustrophobic settings.

When the Hale-Bopp comet arrived in March of 1997, it outshone the duds of Kohoutek and the 1986 pseudo-appearance of Halley that complemented Hooper's pseudo-sequel. Hooper was among the soon-to-be-thwarted Halley enthusiasts. In his 1985 campy sci-fi spoof *Lifeforce*, he shared the widespread sky-gazer anticipation by replacing the asteroid belt from Colin Wilson's novel *The Space Vampires* (on which the movie is based) with visions of Halley's arrival.

Lifeforce follows an Anglo-American expeditionary crew as it nears Halley to discover a race of erotic parasites. Hooper chose a simpatico actor to play the hero. Steve Railsback, a Texas native, scared American viewers as Charles Manson in the 1976 TV-movie *Helter Skelter*, with

Marilyn Burns as Linda Kasabian. Years later, he would portray Ed Gein. Here, he is Vietnam veteran Colonel Tom Carlsen, who encounters the extraterrestrial parasites and tries to warn the world after his spacecraft lands in Texas.

Like *Chain Saw*, *Lifeforce* is a meditation on death, but the focus here is on the scary prospects of what George Romero called "the living dead." In his 1978 sequel *Dawn of the Dead*, Romero offered a hideous vision of life after death: zombies clawing at mall store windows in the vain attempt to return to a place they once called home. Hooper's *Lifeforce* creates what he nicknamed "the walking shriveled," whose after-death souls ride blue rays up into a bloodsucking eternity.

Hale-Bopp, however, became the comet that people could truly see. But some were not content simply to look. Marshall Applewhite's Heaven's Gate cult used Hale-Bopp as the pretext for collective suicide. His cohort Bonnie Nettles (who helped him start his UFO-worshipping cadre in the early '70s) died in the mid-'80s, but Applewhite continued with the cause, plugging into "transhuman" powers via the home computer, as part of his group's income came from web designing and keeping a website of its own. The new age of the internet, its psychedelic fervor from the shape-shifters of Silicon Valley, and the cosmic tales that accompanied its onslaught, were perfect Heaven's Gate auguries.

Applewhite also refined his criteria for attaining otherworldly clout, including a cleansing of the intestines, exorcising untidy sexual thoughts, and aspiring to shed the cumbersome earthly body. The men devised a duplicate shaving strategy to further merge their identities. For Applewhite, sexual abstinence was such a challenge that he had himself castrated in Mexico City. Six of his followers did the same. Applewhite and his gelded apostles hoped that the comet would bring

along a spacecraft, swinging low like a sweet chariot to whisk them to "The Evolutionary Level Above Human."

The Heaven's Gate suicides occurred on March 26 and hit the headlines, along with footage from one of their videos in which Applewhite's crazed face invaded television screens on the nightly news. Unlike Jim Jones and his Peoples Temple, who left a mess of poisoned cadavers rotting on Guyana's grounds, Applewhite and his adherents departed in an orderly manner at their Rancho Santa Fe, California barracks. All thirty-nine of them lay in identical bunks, arrayed in matching Nikes and black-and-white tracksuits. During a period when cocktails came back into vogue, they even showed panache with their choice of poison: vodka with a jigger or two of applesauce and ample barbiturates.

Four years after Hale-Bopp came and left without any reported out-of-body ascents, Madalyn Murray O'Hair finally resurfaced under hideous circumstances. She got yanked kicking and screaming from her one precious life at age 76. Despite a lackluster response from local Austin police, John MacCormack, a reporter for the *San Antonio Express-News*, a private investigator named Tim Young, and an IRS Special Agent named Ed Martin were key players in helping to solve the mystery.

O'Hair goofed when hiring David Waters, an ex-con, as a typesetter and promoted him to office manager. But when she discovered that he had stolen $54,000 from the American Atheists' treasury, she raised her own version of hell by pressing charges. When his sentence seemed too lenient, she wrote about Waters's shady past in her organization's newsletter, including his previous murder conviction and the time he beat his mother up with a broom and urinated on her. Vowing revenge, he got two accomplices to aid him in holding the three Murray-O'Hairs hostage.

Waters's initial plans involved getting at least half a million dollars in gold coins from them. They transferred their victims to another San Antonio motel with a room on the first floor, making it easier to transport the bodies when they finally killed them. The details of who killed whom remain murky, being that Waters and his accomplice Gary Karr delighted in blaming each other when the time came to fess up.

In a 2011 documentary with the queasy title *Good Riddance*, Ed Martin, who took an interest in the case beyond his official IRS duties of looking into accusations of O'Hair's purported embezzlement, got the details directly from Waters: "Gary was in the living room, he looked like he was mad at something. I asked, 'Where's Robin?' I headed for the bedroom, Gary got up and followed in behind me. She was dead. Apparently he had got her in the bedroom, I assume that he was making advances toward her, or what have you. One thing led to another, she pissed him off . . . he strangled her . . . With this event, Jon and Madalyn were gonna have to go. There was just no two ways about that."

They disposed of the Murray-O'Hairs by gagging, clubbing, smothering or strangling, and dismembering them, then stuffing the remains of all three into fifty-five-gallon drums, before driving them from San Antonio back to Austin. Finding an isolated ranch, they dug a pit, threw the bodies in, doused them with gasoline, and buried their charred remains in the shallow grave.

In the process, Waters and Karr also had to kill Danny Fry, the other, more sensitive cohort (a simple con-man with no previous violent past), who was becoming a Madalyn fan. Waters claimed he shot him and left the dismembering to Karr. When Dallas County authorities discovered Fry's naked headless and handless body along the banks of Trinity River in early October of 1995, just days after the Murray-O'Hair murders, the case stayed cold: police had neither fingerprints,

clothes, nor a face to identify him. For several years, Fry was another "John Doe" in the eyes of the law, consigned to a pauper's grave.

However, Waters's embittered ex-girlfriend helped to make the pieces cohere. By 1999, when the FBI got involved, she gave plenty of incriminating information (and got federal protection as a result). She claimed that, around the time he had disposed of the bodies, Waters reeked of bleach.

With no religious or political motives (Waters later claimed he was not an atheist), Madalyn's abductors acted out of greed and vengeance. Even this proved futile when, after keeping the loot in an Austin storage unit with a flimsy $5.00 lock, the killers found out that three young hooligans picked the lock, stole the stolen gold, and spent it like drunken sailors on visits to topless bars and to Vegas, as well as on cars and guns. (That is, at least, the official story.)

Once in custody, and desperate to toss the blame onto his partner in crime, Karr told the authorities that Waters subsequently had nightmarish visions of a hand reaching out—a la *Deliverance*—from the ground where they had left their victims. Karr placated the authorities by drawing a map to aid in the search, leading them to the remote town of Campwood to find the remains. But the journey turned out more like the closing scenes from *Night of the Living Dead*, replete with helicopters and cadaver dogs sniffing away. But they found nothing, and this was perhaps Karr's strategy: no bodies, no murder case

In May of 2000, the Federal Courthouse in Austin nevertheless put Karr on trial for extortion and kidnapping. One of his biggest adversaries in the courtroom was his ex-wife, who recorded Karr at a weak moment when he admitted that he knew of the homicides, though he still blamed Waters. She also mentioned how, soon after reports of the missing Murray-O'Hairs came to light, Karr started looking dapper, with Armani suits and other expensive attire. Then, Waters's

ex-girlfriend (still bolstered by the FBI) took the stand, keeping to her previously damning accounts of the boyfriend who once jabbed her in the chest with a kitchen knife, smashed a gun against her mouth and broke some teeth, and bragged to her about his fantasies of severing some of Madalyn's body parts.

The lawyer defending Karr brought out some witnesses who seemed to materialize from out of the *Weekly World News*, professing to have seen a living Madalyn still stalking the planet like an undead Elvis. One claimed to have witnessed her drinking a Coke at a San Antonio bar; another (a born-again Baptist) was certain that, in the fall of 1997, he had spotted her sitting all alone at a restaurant in Romania, scarfing down pasta.

One female juror even admitted to developing a crush on Karr, but it did not matter. Karr got convicted of extortion but not kidnapping, yet his prior rap sheet guaranteed life in the slammer without parole.

Waters did not fare much better. He was already indicted for extorting, kidnapping, and robbing the Murray-O'Hairs. The still-missing bodies allowed the specter of "reasonable doubt" to loom over the case. So, in January of 2001, after eking out a leniency plea, Waters led authorities to the covered pit in an isolated ranch in the Texas outback. Life once again imitated *Chain Saw* art, when the world discovered that the Murray-O'Hairs got a Texas-style sendoff.

First, they dug up Jon Garth's sawed-off femur and then his fractured skull still tightly wrapped in the plastic bag that suffocated him. They unearthed Madalyn on her back along with shards of her flowery dress and her stainless-steel hip replacement. And then they found Robin's skull. Subsequent dental records, DNA tests, and the serial number on Madalyn's prosthetic hip joint formally identified the family. Waters got his final sentence two months later in Austin, and when escorted out of the Federal Courthouse, an elderly atheist yelled at him:

"Ghoul. Filthy Ghoul." Waters would die in a prison hospital from lung cancer in 2003.

When the Murray-O'Hairs vanished, American Atheists, the group Madalyn had founded, were reluctant to give much information to the Feds due to a litigious IRS already on the organization's trail for back taxes. They could neither fully understand nor explain the thousands of dollars that they were forced to surrender to Jon Garth, who in turn, needed to meet his kidnappers' demands. Some Atheists members, however, made frantic phone calls to the Murray-O'Hairs during their captivity. Ellen Johnson, who manned the group's headquarters in Madalyn's absence, got so exasperated by Jon Garth's money requests that she intuited something was afoul: "I have no idea if there's a gun to your head or not," she bellowed to him over the phone. The group tried to get answers, until the day the cell phone replies from San Antonio stopped.

Years before, her son William, the initial reason Madalyn started her anti-school-prayer crusade, waited for Mother's Day of 1980 to publicly declare himself not only a Christian but a conservative Christian, getting plaudits from the likes of Jesse Helms and just in time for the advent of Reagan. This new William went on to write a *Mommie Dearest*-style book about his "evil" upbringing and renounced all of his previous atheist activities.

Back in November of 1986, Madalyn published a piece in her *American Atheist* magazine entitled "Plotting Atheist Funerals." She wrote, "I don't want a bunch of numbnuts listening to my favorite music when they don't even know why I loved it so. I would prefer that blathering idiots not attempt to encapsulate my life in eight sentences. I don't want anyone to endure a moment of silence on my behalf." She also specified that "William J. Murray III has been a traitor . . . Under no circumstances, for no reasons whatsoever, do I care to have him in

attendance for any activities related to my death, [or] to the disposal of my body."

William J. Murray did eventually make the effort to file a missing persons report with the Austin police when he realized something bad must have happened. He also got Senate connections to reach then-Attorney General Janet Reno and deem the disappearance an official federal case. However, after the gruesome excavation in 2001, he broke one of the Ten Commandments by not honoring his mother's wishes. American Atheists attempted to fight William with a restraining order, but the law allowed him to keep the remains and hold the burial ceremony in a secret place with no atheists invited.

Madalyn also specified that she wanted her expired body to go to "a little place . . . a small corner of the outdoors . . . where the sun will filter through the trees and lay its gentle, warm hand upon one's face." On other occasions, she also specified that "Woman, Atheist, Anarchist" appear on her headstone. The Murray-O'Hairs instead got an unmarked grave in the Austin suburbs. William might have seemed to at least heed his mother's request when he prevented the inexplicably present Baptist minister from praying over her cremated remnants, but the minister was there to pray for William.

Like everyone else, O'Hair was not infallible, but as one of America's most caustic but always engaging skeptics, she might have helped to lift the veil over the rash of occult obsessions and other spiritual follies that trended during the twentieth century's final years and into the twenty-first. Throughout her militant years, O'Hair was preoccupied with making sure that the crèches and menorahs stayed out of public buildings and off of public lawns. By the early '90s, she acknowledged that Judeo-Christianity was no longer her only affliction, as other world religions, as well as religions masquerading as ideologies, elevated despots into deities and threatened free speech.

In earlier times, she had toyed with communism and, in 1960, attempted to defect to the Soviet Union, but it was a desperate move. She was broke, saddled with two boys whose blood fathers did not want them, and was a misfit in a Baltimore neighborhood vigilant about "conforming." But she later boasted about being "the single person who disassociated atheism from communism," a stigma left over from the Red Scare days of the mid-'50s, when the Eisenhower Administration slipped "under God" into the Pledge of Allegiance and inscribed "In God We Trust" on paper currency to make America feel holier than "godless" Russia.

O'Hair eventually acquired her own horrific visions of the future, which she shared in May of 1995 during what would be her last public appearance. "I am dreadfully afraid of Islam," she told an audience of students in Houston at her alma mater: the South Texas College of Law. "I am so afraid that the last conflagration in the United States is going to be between Christianity and Islam, and that the human beings of the world may well be destroyed."

No Country's Sheriff Bell could not articulate O'Hair's anxiety, but he had his own darkly poetic spells. "Age will flatten a man, Wendell," Bell replies when his deputy assistant observes that Bell's conjecture about the life span of a 1977 Ford burning in the desert at a crime scene is "very linear." The murders, assassinations, mental breakdowns, and other problems have always been around, but for one person confined to one lifetime, life is indeed as *painfully* linear as the progression of events that preceded and followed *The Texas Chain Saw Massacre*.

Unlike Leatherface, Richard Nixon, or Marshall Applewhite, Bell adhered to the man he had always been, not inclined to adopt a new face or contrive a newfangled legacy. He wanted a humble life, but circumstances made the simple thought of a just god waiting at the other end more tenuous. In the film, as he peruses a newspaper, Bell laments

over a California couple who rented rooms to the elderly, tortured them, killed them, buried them in the yard, and then cashed their Social Security checks. It was the kind of murder that left him stunned, especially the fact that "a man ran from the premises wearing only a dog collar."

The film's Deputy Wendell (Garret Dillahunt) is a likeable and sometimes profound presence. When Wendell brings back the lab report that the murders involved no bullets, Bell reacts as if he were just informed of a Martian landing. The information defies his parameters. For Bell, the entry wound to the victim's forehead must have been from a knife gouging and not the dreaded slaughterhouse innovation: the airgun to oblivion.

"Once you quit hearing 'Sir' and 'Ma'am,'" Bell reflects, "the rest is soon to follow." He commiserates with a fellow old-timer who laments the "dismal tide" of change, new days when people walk the streets of Texas with "green hair and bones in their noses." Though he is himself considered by the prevailing consensus an "old man," Bell looks for paternal figures to guide him, realizing that getting older does not necessarily include getting smarter. He visits Uncle Ellis (Barry Corbin), a retired sheriff confined to a wheelchair after being shot on duty years back. In the film, he lives alone in an unsanitary house commandeered by roving kitties, with coffee fermenting on the stove for at least a week. Ellis's assailant had since died in prison, but Bell is flabbergasted when he asks Ellis what he would do had the guy been released. Ellis is indifferent, claiming there would be no point in the old "eye for an eye" adage.

"You can't stop what's coming," Ellis concludes, with the dumb dispassion that many sometimes exhibit when surrendering their territory and their identities to foreign invaders. Not satisfying Bell's need for nostalgic support, Ellis, a content masochist, accuses Bell of being vain

to think that the world hinges on his understanding of its quirks and injustices. While disappointed in Ellis, Bell also has doubts about his late father's approval and even his "heavenly father's" legitimacy. He spent his younger years assuming that his god would find him, but when he got older, this prospect too was a letdown.

Sheriff Bell finds himself in the same quandary that vexes a character from another Coen Brothers film. Larry Gopnick (Michael Stuhlbarg), the beleaguered physics professor in *A Serious Man*, finds his whole life upended: his wife wants a divorce, his children increasingly flout his authority, a disgruntled student tries to bribe him with money for a passing grade and threatens legal action, his hopes for tenure start to fray with talk of the college committee receiving anonymous letters questioning his moral character, his physically ailing brother (who lives at Gopnick's house) gets arrested on charges of "sodomy," and amid this clamor, Gopnick accrues extortionate legal fees he cannot pay.

With all of these problems, Gopnick's wishful narrative, about life cohering more with age, derails. Faced with such a crisis, Gopnick hears nothing but palaver about his ethnic traditions and how he must accept his god's will, even though he has no idea where this so-called divine plan is heading. So, like a good member of "the faith," he seeks counsel from three rabbis. Two of them offer riddles: one sees a kernel of hope in a desert of despair while looking out on a half-empty parking lot; the other tells of a Jewish dentist who almost loses his mind after finding Kabbalah codes embedded in a "goy's teeth." The third, and most revered, rabbi does not deign to see him at all, preferring instead to recite Jefferson Airplane lyrics to Gopnick's son, who stares back at the scraggly elder while blasted on the weed he inhaled before his Bar Mitzvah. Franklin Hardesty faces a similar crisis when confronted with mystical taunts, fretting. Pam's depressing astrology forecasts and the mysterious smear the Hitchhiker left on the van. Franklin is, after

all, the one most susceptible to numinous hoopla, the one who hears the old man's rantings: the first signs of a riddle that sets his mind in overdrive. And as the world assumes Franklin's vulnerable role in trying to decipher what could simply be absurd digressions, more skeptical viewers have to wonder if the enigma itself is the challenge and that any attempts to claim a "solution" are cruel hoaxes. An example would be the Zen-like koan that Chigurh poses to "Friendo," *No Country*'s gas station proprietor (Gene Jones), who is lucky enough to wager the right side of a coin toss and avoid being killed. The killer says it is more than a coin, yet it is just a coin. When drawing mental blanks, some people cop out and resort to the lackluster cliché, "It is what it is." But much of the time it isn't.

"Everything means something, I guess," Sally Hardesty tells Franklin with minimal conviction. And life's "weird" synchronicities can be as astounding as a fireworks display, best left without a patchwork theology to "explain" them. *Chain Saw* conversely entices viewers with pseudo-mystical red herrings, but the film's ultimate message (like Hitchcock's *Psycho* and Craven's *Last House*) is secular. Even when the coincidences multiply to look like messages from "beyond," viewers are left to conclude that, aside from weather or planetary patterns, people often get screwed not by "spirits in the sky" or demons in the depths but by the malevolent beliefs of other mortals.

Besides reflecting the horrid times, *The Texas Chain Saw Massacre* addresses another social ill that blossomed in the late '60s and early '70s: the cartoonish manner that contemporary mainstream movies used to depict "rednecks," with their "backward" and "intolerant" ways. In an era when the white-hat hero got "deconstructed," a new villain prevailed. The "redneck" became Hollywood's version of the "white devil"—propaganda that helped to widen the racial divide.

Easy Rider was among the most brutal, even though the ending indicates that the hippies "blew it" with or without "redneck" opposition. Gunnar Hansen once referred to *Chain Saw* as "Sort of *Deliverance* on steroids." But *Deliverance*, released in 1972, is not as anti-"redneck" as some might remember. The film initially depicts the people of Northern Georgia's Cahulawassee River Valley as "inbred" mental defectives and snaggle-toothed rapists. But the tone changes by the end, when the three city slickers who survive their macho misadventure get nurtured by a Southern town that is kind and civilized, even as developers force the residents to relocate and to wheel their little church along with them.

Sheriff Bell, in McCormac's novel, also feels resentful and confused about trends that mock "rednecks," reflecting on how the early years of fighting the "Indians" and the Civil War had a traumatizing effect on people of his region and ilk: "Two generations in this country is a long time. You're talkin about the early settlers. I used to tell them that havin your wife and children killed and scalped and gutted like fish has a tendency to make some people irritable but they didn't seem to know what I was talkin about."

Confined to his small Texas turf, and regretting that his jurisdiction has been marred by its first unsolved homicide in forty-one years, Bell fights a linear war in what has become a non-linear madhouse—a world morphing into a globalized blob with sharp teeth. No one, not even his chronically cheerful wife (Tess Harper), can console him. When *No Country* comes to an end, Bell is dazed, exhausted, and ready to retire. He tells of his dreams, one of them involving him and his father on horseback, riding through a cold, snowy mountain pass in the dead of night. As his father rides past him, Bell thinks dad is going on ahead to make a fire that will warm him when they reunite. "And then I woke up."

Bell's waking up is ambiguous. It could mean that he has finally come to terms with the sad news that a true fatherly hand was just an illusion. Or it could suggest that he escaped once more from the eternal nightmare that so terrified Hamlet as he contemplated what waits in the mind after the body, as the cliché goes, "passes on." Like *Chain Saw*, *No Country* ends with the screen going black, leaving viewers as alone and disoriented as the protagonists. Sheriff Bell ends the novel and the film with the paradoxical conclusion that waking up from a dream can be a symbolic demise. Sally Hardesty escapes Leatherface, but her hysterical laughter suggests that she is off to a padded cell, still breathing but metaphorically dead.

The story of the Slaughters, the Hardestys, the "chain saw," and the airgun flickers in darkness beyond any traditional closure. *Chain Saw* is instead a story about—and the product of—a disoriented and terrorized culture, a movie that reacts to and then goes on to propagate what conspiracy theorists call "trauma-induced psychological warfare." Viewers trained from an early age to fear death, the "gnashing of teeth," and "the wages of sin," face in *Chain Saw* a much more real nightmare: the ordeal of the survivors. They are the ones stuck with the corpses: embalming, cremation, open-coffin funerals, dried remains assembled into voodoo hexes, and sanctified or vandalized gravesites.

Speaking to *Vanity Fair* in the year his novel got published, Cormac McCarthy had a stoic attitude: "Most people don't see anyone die. It used to be if you grew up in a family, you saw everybody die. They died in their bed at home with everyone gathered around. Death is a major issue in the world. For you, for me, for all of us. It just is. To not be able to talk about it is very odd." In contrast, Tobe Hooper indicated in 2014 to *Interview* magazine that he felt darkly enthralled as he sliced through death's door while running from the inevitable: "You can't get away,

you can't escape. You'll jump through a plate-glass window several times and end up being right back in the spider's web."

The *Chain Saw* victims are both the characters and the audience. They range from the generations of the "old man," to the baby boomers in the Econoline van (the film's original audience), to the boomer babies, and to all their posterity, who will continue to endure assaults on their senses of logic and proportion. Yet despite the blood, the despair, and Sally Hardesty's piercing screams, the film offers its survivors some practical inspiration. After encountering *The Texas Chain Saw Massacre*, discerning viewers will travel with care, reject mind-mucking mystics, ignore those nasty actuarial tables with their projected "life expectancies," and instead aspire to a death that is gentle, painless, peaceful—and free at last from the threat of an afterlife.

NOTES

CHAPTER ONE: "THE ZEITGEIST BLEW THROUGH"

Baumgarten, Marjorie. "Tobe Hooper Remembers 'The Texas Chain Saw Massacre.'" *Austin Chronicle.com* 27 October 2000. https://www.austinchronicle.com/screens/2000-10-27/79177/.

Bloom, John. "They Came, They Sawed." *Texas Monthly*. November 2004. https://www.texasmonthly.com/articles/they-came-they-sawed/.

Ebert, Roger. "Just Another Horror Movie—Or Is It?" *Reader's Digest*. June 1969: 127-8.

Karnow, Stanley. *Vietnam: A History* (Revised and Updated). New York: Penguin Books, 1991: 668.

CHAPTER TWO: "CRYPTOEMBRYONIC" JOURNEY

Bloom, John. "They Came, They Sawed." *Texas Monthly*. November 2004. https://www.texasmonthly.com/articles/they-came-they-sawed/.

Brautigan, Richard. *All Watched Over by Machines of Loving Grace*. U.S.: The Communication Company, 1967.

Burks, John. "Rock & Roll's Worst Day: The Aftermath of Altamont." *Rolling Stone.com* 7 February 1970: 51. http://www.rollingstone.com/news/story/5934386/rock_rolls_worst_day.

Dror, Olga. "Learning from the Hue Massacre." *The New York Times* 20 February 2018. https://www.nytimes.com/2018/02/20/opinion /hue-massacre-vietnam-war.html.

Hansen, Gunnar. *Chain Saw Confidential: How We Made the World's Most Notorious Horror Movie.* San Francisco: Chronicle Books, 2013: 97.

Hooper, Tobe. "An American Freak Illumination: The Unofficial Autobiography of Tobe Hooper." Notes to *Eggshells: An American Illumination* (1971) DVD. Louis Black Productions and Watchmaker Films, 2017.

Jaworzyn, Stefan. *The Texas Chain Saw Massacre Companion.* London: Titan Books, 2003: 27, 55.

Kolata, Gina. "Boy's 1969 Death Suggests AIDS Invaded U.S. Several Times." *The New York Times* 28 October 1987: 15. https://www .nytimes.com/1987/10/28/us/boy-s-1969-death-suggests-aids -invaded-us-several-times.htmlLewis, Anne S. "No Ordinary Folk: The Texas Documentary Tour: Peter, Paul & Mary." *Austin Chronicle* 3 December 1999. *Austin Chronicle.com.* https://www .austinchronicle.com/-screens/-1999-12-03/74947/.

McGowan, David. *Weird Scenes Inside the Canyon.* London: Headpress, 2014: 47.

Nevin, David. "Texas Sniper's Murder Rampage." *Life* 12 August 1966: 24-31.

Stur, Heather. "The Viet Cong Committed Atrocities, Too." *The New York Times* 19 December 2017, https://www.nytimes.com/2017 /opinion/vietcong-generals-atrocities.html.

Varon, Jeremy. *Bringing the War Home: The Weather Underground, the Red Army Faction, and Revolutionary Violence in the Sixties and Seventies.* Berkeley: University of California Press, 2004: 154-160.

CHAPTER THREE: SCARY WEATHER

Fort, Charles. *The Book of the Damned*. New York: Tarcher/Penguin, 2016: 21, 37, 96, 102, 109, 268, 291.

Goldberg, Danny. "Alice Cooper—Love Them to Death." *Circus*, July 1971: 16.

Hansen, Gunnar. *Chain Saw Confidential: How We Made the World's Most Notorious Horror Movie*. San Francisco: Chronicle Books, 2013: 22, 108.

"How Solar Flares Affect Human Health—Our Mind and Body." *MessageToEagle.com*, 19 March 2015.

"Indian Terms Words Hers, Not Brando's." *The New York Times* 1 April 1973: 78.

Jacqueline, Marshall. "Solar Flare: The Sun Touched Our Psyche." *Washington Times.com* 31 December 2014. http://www.washingtontimes.com/news/2014/dec/31/solar-flare-sun-touches-our-psyche/.

Mann, Brian. "The Drug Laws that Changed How We Punished." *NPR: Morning Edition*. 14 February 2013. https://www.npr.org/2013/02/14/171822608/the-drug-laws-that-changed-how-we-punish.

"Sickening Solar Flares." *Nasa.gov*. 8 November 2005. https://www.nasa.gov/mission_pages/stereo/news/stereo_astronauts.html.

Srivastava, B.J. "The Geomagnetic Solar Flare Effect of 3 May 1973 at Indian Stations and Its Effect on the Counter-Electrojet." *Journal of Atmospheric and Terrestrial Physics*. Volume 36, Issue 9, September 1974: 1571–1575. http://dx.doi.org/10.1016/0021-9169(74)90236-0.

Reich, Charles A. *The Greening of America*. New York: Bantam Books, 1971: 252.

CHAPTER FOUR: "I WAS THE KILLER!"

Adams, Nathan M. "Hitchhiking—Too Often the Last Ride." *Reader's Digest*, Vol. 103 July 1973: 61.

Bloch, Robert. *Psycho*. New York: The Overlook Press, 2010: 10.

Bonn, Scott A. "Origin of the Term 'Serial Killer.'" *Psychology Today. com* 9 June 2014. https://www.psychologytoday.com/us/blog /wicked-deeds/201406/origin-the-term-serial-killer.

Bonn, Scott A. "The Real Life Horror Tale of the Twisted 'Co-ed Killer.'" *Psychology Today.com* 17 March 2014. https://www .psychologytoday.com/us/blog/wicked-deeds/201403/the-real-life -horror-tale-the-twisted-co-ed-killer.

Dalmas, Robin. "What Killed Hitchhiking?" *NBC News.com*. 2013. http://www.nbcnews.com/-id/-6576347/ns/travel-road_trips/t /what-killed-hitchhiking/.

Hansen, Gunnar. *Chain Saw Confidential: How We Made the World's Most Notorious Horror Movie*. San Francisco: Chronicle Books, 2013: 41.

McGee, Henry W. "The Hitchhike Murders." *The Harvard Crimson* 14 February 1973. http://www.thecrimson.com/article/1973/2/14 /the-hitchhike-murders-pbbebllen-reichb-was/.

"Officials Identify Body in Miami Case." *The New York Times* 23 July 1973: 37.

Reich, Charles A. *The Greening of America*. New York: Bantam Books, 1971: 429, 244, 395.

Slater, Philip. *The Pursuit of Loneliness: American Culture at the Breaking Point*. Boston: Beacon Press, 1970: 33.

Texas Chain Saw Massacre: A Family Portrait. Dir. Brad Shellady, 1988. MTI Home Video, 2000.

Wilson, Colin, and Donald Seaman. *The Serial Killers: A Study in the Psychology of Violence*. UK: Virgin Books, 2007: 192.

Wisniewski John. "Roger Bartlett ("Texas Chain Saw Massacre" musician) Interview." *Classic-Horror.com*. 22 October 2010. https://classic-horror.com/newsreel/-roger_bartlett_interview.

CHAPTER FIVE: "THE COST OF ELECTRICITY"

Bender, Marilyn. "Youth Buyers." *The New York Times* 22 November 1970: 139.

Ehrlich, Paul R. *The Population Bomb*. New York: Ballantine Books, 1968: xi, 130-31.

Goldman, Albert. "Rock in the Androgynous Zone." *Life* 30 July 1971: 16.

Hamill, Pete. "The Revolt of the White Lower Middle Class." *New York* 14 April 1969: 28-9.

Hansen, Gunnar. *Chain Saw Confidential: How We Made the World's Most Notorious Horror Movie*. San Francisco: Chronicle Books, 2013: 43.

Healey, Gene. "Remembering Nixon's Wage and Price Controls." *Washington Examiner* 15 August 2011. https://www.washingtonexaminer.com/remembering-nixons-wage-and-price-controls.

Holles, Everett R. "Thousands Bring in Meat from Canada and Mexico." *New York Times* 13 August 1973: 1.

Le Beau, Bryan F. *The Atheist: Madalyn Murray O'Hair*. New York: New York University Press, 2003: 85.

Lindsey, Hal (with C.C. Carlson). *The Late Great Planet Earth*. Grand Rapids, Michigan: Zondervan Publishing House, 1970: 15, 77, 102, 104, 115. 161.

Meadows, Donella H., et. al. *The Limits to Growth*. New York: Universe Books, 1972: 9, 10, 25-44, 190.

Mills, David. "Beware the Trilateral Commission!" *Washington Post* 25 April 1992. www.washingtonpost.com/archive/lifestyle/1992/04 /25/beware-the-trilateral-commission/.

Mulleavy, Kate and Laura. "Tobe Hooper Interview." *Interview* 14 July 2014. www.interviewmagazine.com/film/tobe-hooper.

Reich, Charles A. *The Greening of America*. New York: Bantam Books, 1971: 42, 379.

Rosow, Jerome M. "The Problem of the Blue-Collar Worker." Department of Labor, Washington, D.C., 1970: 7.

Ryan, Ted. "The Making of 'I'd Like to Buy the World a Coke.'" *Coca-Cola Journey*. 1 January 2012. http://www.coca-colacompany .com/stories/coke-lore-hilltop-story.

Skinner, B.F. *Beyond Freedom and Dignity*. New York: Penguin, 1971: 2, 13.

Sontag, Susan. "What's Happening in America." *Partisan Review*, Winter 1967.

Wright, Lawrence. "God Help Her." *Texas Monthly*. January 1989: 154. https://www.texasmonthly.com/articles/god-help-her.

Yergin, Daniel quoted from *Commanding Heights: The Battle for the World Economy*. "Episode One: The Battle of Ideas." Dir. William Cran, PBS and Zephyr Films, 2002.

CHAPTER SIX: "GRISLY WORK"

Allen, Bob. "Evangelicals and Abortion: Chicken or Egg?" *Baptist News Global.com* 6 November 2012. https://baptistnews.com /article/evangelicals-and-abortion-chicken-or-egg/# .W7kWm7iyL8w.

Bloom, John. "They Came, They Sawed." *Texas Monthly*. November 2004. https://www.texasmonthly.com/articles/they-came-they -sawed/.

Gonzalez, Lucky. "Lost Boy Larry—Hoax or Heartbreak?" *NewMexi.co* 7 August 2016. https://newmexi.co/articles/lost-boy -larry-hoax-heartbreak/.

Hollandsworth, Skip. "The Lost Boys." *Texas Monthly,* April 2011. 121-125, 182-89. https://www.texasmonthly.com/articles/the-lost -boys/.

Ladd, Chris. "Pastors, Not Politicians, Turned Dixie Republican." *Forbes.com* 27 March 2017. https://www.forbes.com/sites/chrisladd /2017/03/27/pastors-not-politicians-turned-dixie-republican /#49ea4e1a695f.

Olsen, Jack. *The Man with the Candy: The Story of the Houston Mass Murders.* New York: Simon and Schuster, 1974: 21, 129-30, 136,

"Resolution on Abortion." Southern Baptist Convention, St. Louis, Missouri, 1971. *SBC.net*, http://www.sbc.net/resolutions/13 /resolution-on-abortion.

CHAPTER SEVEN: "A WHOLE FAMILY OF DRACULAS"

Hansen, Gunnar. *Chain Saw Confidential: How We Made the World's Most Notorious Horror Movie.* San Francisco: Chronicle Books, 2013: 42, 48, 80, 86-7, 96-7, 126-7.

Hogue, Theresa. "Cult Survivors Share Their Experiences." *Gazette-Times Reporter* 4 August 2005. http://www.gazettetimes.com/news /local/cult-survivors-share-their-experiences/article_4e136ca3 -cf24-5ca7-becb-40ed05c4f80d.html.

Jaworzyn, Stefan. *The Texas Chain Saw Massacre Companion.* London: Titan Books, 2003: 39, 66.

Laing, R.D. *The Politics of the Family and Other Essays.* New York: Pantheon Books, 1971: 14, 16, 57, 68, 77, 87, 120.

Meadows, Donella H., et. al. *The Limits to Growth.* New York: Universe Books, 1972: 86.

Plateris, Alexander A. *Divorces and Divorce Rates: United States*.
National Center for Health Statistics. Series 21, No. 29. March
1978: 1 & 2: reprinted April 1980. https://www.cdc.gov/nchs/data
/series/sr_21/sr21_029.pdf.

Texas Chain Saw Massacre: The Shocking Truth. Dir. David Gregory.
Blue Underground, 2000.

CHAPTER EIGHT: THE COOK AND THE "CROOK"

Baumgarten, Marjorie. "Tobe Hooper Remembers 'The Texas Chain
Saw Massacre.'" *Austin Chronicle.com* 27 October 2000. https://
www.austinchronicle.com/screens/2000-10-27/79177/.

Farrell, John A. "The Most Abused Press Secretary in History." *Politico
Magazine* 19 March 2017. https://www.politico.com/magazine/story
/-2017/03/ron-ziegler-abused-press-secretary-sean-spicer-214922.

Greenberg, David. *Nixon's Shadow: The History of an Image*. New
York: W. W. Norton & Co., 2004: xv.

Hansen, Gunnar quoted from *The Texas Chain Saw Massacre: 40th
Anniversary Collector's Edition*, Audio Commentary. Dark Sky,
Blu-ray, 2014.

Healy, Paul. "Nixon Refuses to Give Tapes to Ervin Panel." *Daily
News* 4 January 1974: 2.

Hooper Tobe quoted from *The Texas Chain Saw Massacre: 40th
Anniversary Collector's Edition*, Audio Commentary. Dark Sky,
Blu-ray, 2014.

Hosch, William L. (Ed.). *The Korean War and the Vietnam War:
People, Politics, and Power*. New York: Britannica Educational
Publishing, 2010: 200.

Hunt, E. Howard (as David St. John). *The Coven*. Greenwich, CT:
Fawcett Crest, 1973: 73, 119-120.

Jerome, Jim. "Nixon's Psychotherapist Friend Warns That Dangers Face Him." *People* 7 October 1974. https://people.com/archive/nixons -psychotherapist-friend-warns-that-dangers-face-him-vol-2-no-15/.

Karnow, Stanley. *Vietnam: A History* (Revised and Updated). New York: Penguin Books, 1991: 669.

Nixon. Dir. Oliver Stone. Perf. Ed Harris as E. Howard Hunt. Hollywood Pictures/Cinergi, Blu-ray, 2008.

Nixon, Richard. Quoted in *Nixon by Nixon: In His Own Words.* Dir. Peter W. Kunhardt, HBO Documentary Films, 2014.

Nixon, Richard quoted from *Our Nixon.* Dir. Penny Lane, CoPilot Pictures, 2013.

"Nixon Abortion Statement." *The New York Times* 4 April 1971: 28.

Osborne, John. "The Nixon Watch: Shades of Meaning." *New Republic* 15 September 1973: 10-12.

Perlstein, Rick. *Nixonland: The Rise of a President and the Fracturing of America.* New York: Scribner, 2008: 419.

Robertson, Nan. "President Lauds Hoover." *The New York Times* 5 May 1972: 1.

Siedow, Jim. Quoted in *The Texas Chain Saw Massacre: A Family Portrait.* Dir. Brad Shellady, Film Four Entertainment, Year, 1988.

Sokolove, Michael. "The Unexpected Anchor: Jim McKay." *The New York Times.com* 24 December 2008. https://www.nytimes.com /2008/12/28/magazine/28mcKay-t.html.

Stripling, Robert quoted in *The Arrogance of Power: The Secret World of Richard Nixon,* by Anthony Summers (with Robbyn Swan). New York: Penguin Books, 2001: 67, 89.

Summers, Anthony (with Robbyn Swan). *The Arrogance of Power: The Secret World of Richard Nixon,* by. New York: Penguin Books, 2001: 89, 95, 169, 352, 363-5, 404. 451, 455, 466.

Watson, Andrew S. "The Watergate Lawyer Syndrome: An Educational Deficiency Disease." *Journal of Legal Education*, Vol. 26, No. 4 1974: 441–448.

Woodward, Bob, and Carl Bernstein. *The Final Days*. New York: Simon and Schuster, 1976: 164, 168.

CHAPTER NINE: YOU THINK THIS IS A PARTY??

Bloom, John. "They Came, They Sawed." *Texas Monthly*. November 2004. https://www.texasmonthly.com/articles/they-came-they -sawed/.

Bovson, Mara. "Taxidermist Murders Mormon Missionaries, Chops Up Bodies with Saw in Another 'Texas Chainsaw Massacre'—then walks off Death Row." *New York Daily News* 20 August 2016. http://www.nydailynews.com/news/crime/mormon-missionaries -murdered-texas-chainsaw-massacre-article-1.2759186.

Hansen, Gunnar. *Chain Saw Confidential: How We Made the World's Most Notorious Horror Movie*. San Francisco: Chronicle Books, 2013: 41, 51, 54, 72, 78, 90, 100, 108-9, 122-3, 125, 127, 145-6, 149.

Jaworzyn, Stefan. *The Texas Chain Saw Massacre Companion*. London: Titan Books, 2003: 42, 49-50.

Lennon, Troy. "Director Tobe Hooper Cut His Way Into Movie Fame with a Chainsaw." *Daily Telegraph.com* 28 August 2017. www .dailytelegraph.com.au/news/director-tobe-hooper-cut-his-way -into-movie-fame-with-a-chainsaw/news-story/.

"Missionary's Killer Sentenced to Death." *The New York Times* 4 June 1975: 21.

Reich, Charles A. *The Greening of America*. New York: Bantam Books, 1971: 329-31.

Texas Chain Saw Massacre: A Family Portrait. Dir. Brad Shellady. MTI Home Video, 1988.

Texas Chain Saw Massacre: The Shocking Truth. Dir. David Gregory. Blue Underground, 2000.

CHAPTER TEN: LEATHERFACE AND LOVELACE

Blumenthal, Ralph. "'Hard-Core' Grows Fashionable—and Very Profitable." *The New York Times* 21 January 1973: 28.

Bouzereau, Laurent. *Ultraviolent Movies: From Sam Peckinpah to Quentin Tarantino*. New York: Citadel Press, 2000: 212.

Canby, Vincent. "When Movies Take Pride in Being Second Rate." *The New York Times* 7 June 1981: 19.

Catholic Film Newsletter quoted in *The Texas Chain Saw Massacre Companion*. London: Titan Books, 2003: 106.

Hansen, Gunnar. *Chain Saw Confidential: How We Made the World's Most Notorious Horror Movie*. San Francisco: Chronicle Books, 2013: 33, 87, 163, 167.

Hansen, Gunnar. "A Date with Leatherface." *Texas Monthly* May 1985: 163-64 & 206.

Henry, Sarah. "Morbid 'Massacre' Pulled Off Screen." *Citizen: Ottawa* 12 February 1976: 3.

Jaworzyn, Stefan. *The Texas Chain Saw Massacre Companion*. London: Titan Books, 2003: 73, 78, 90, 106.

Key, Wilson Bryan. *The Age of Manipulation: The Con in Confidence, the Sin in Sincere*. New York: Rowman & Littlefield, 1993: 59-60.

Key, Wilson Bryan. *Subliminal Seduction*. New York: Signet, 1973: 6.

Koch, Stephen. "Fashions in Pornography." *Harper's*. November 1976: 108, 110-111.

McNeil, Legs, and Jennifer Osborne (with Peter Pavia). *The Other Hollywood: The Uncensored Oral History of the Porn Film Industry*. New York: Regan Books, 2006: 181-2.

Malcolm, Derek. "Derek Malcolm Reviews *The Texas Chain Saw Massacre*." *The Guardian* 18 November 1976. https://www.theguardian.com/film/2012/nov/18/texas-chainsaw-massacre-review-archive-1976.

Nixon, Richard quoted in "Statement About the Report of the Commission on Obscenity and Pornography" 24 October 1970. *The American Presidency Project*. http://www.presidency.ucsb.edu/ws/?pid=2759.

Parrish, Larry quoted from *Inside Deep Throat*. Dir. Fenton Bailey and Randy Barbato. HBO Documentary Films and Image Entertainment, 2005.

Texas Chain Saw Massacre: A Family Portrait. Dir. Brad Shellady. MTI Home Video, 1988.

CHAPTER ELEVEN:
YOU'RE GONNA MEET SOME MENTAL PEOPLE

Author Interview: Peter Bagatelos.

Alvarez, A. *The Savage God: A Study of Suicide*. New York: Bantam, 1972: 83, 262.

"Arms Raid in Maryland Leaves Collector Paralyzed." *The New York Times* 26 September 1971: 38.

Bovson, Mara. "Crazed Hippy Killer Caused Horror with 1970 Murder of California Doctor." *New York Daily News.com* 22 March 2009. http://www.nydailynews.com/news/-crime/crazed-hippy-killer-caused-horror-1970-murder-california-doctor-article-1.369122.

"Cabbie Slain in Presidio Heights." *San Francisco Chronicle* 12 October 1969: 1.

Caen, Herb quoted in *San Francisco Chronicle* 30 January 1974: 25.

Caldwell, Earl. "Symbionese Liberation Army: Terrorism from Left."
The New York Times 23 February 1974: 62.

"CBS Evening News for 1974-04-14: Zebra Crimes # 233843."
Television News Archive. https://tvnews.vanderbilt.edu/programs
/233841.

Faber, Nancy. "San Francisco's Alioto: Snarled in a Zebra Dragnet."
People 6 May 1974. https://people.com/archive/san-franciscos
-alioto-snarled-in-a-zebra-dragnet-vol-1-no-10/.

Fort, Charles. *The Book of the Damned.* New York: Tarcher/Penguin,
2016: 8.

Ginsberg, Allen. *The Fall of America: Poems of These States: 1965-1971.*
San Francisco: City Lights, 1972: 5-6.

Graysmith, Robert. *Zodiac Unmasked.* New York: Berkley Books,
2007: 5, 7, 9, 12, 39-43, 90-1, 151, 156, 455-6.

Hansen, Gunnar. *Chain Saw Confidential: How We Made the World's Most
Notorious Horror Movie.* San Francisco: Chronicle Books, 2013: 94.

Harrigan, Stephen. "A Double Date with Leatherface." *Texas Monthly.*
1 July 2014. https://www.texasmonthly.com/articles/a-double-date
-with-leatherface/.

Hearst, Patty. "The California Heiress Turned Hostage." *People* 1
February 1982. https://people.com/archive/cover-story-the
-california-heiress-turned-hostage-vol-17-no-4/.

Hooper, Tobe. "An American Freak Illumination: The Unofficial
Autobiography of Tobe Hooper." Notes to *Eggshells: An American
Illumination* (1971) DVD. Louis Black Productions and
Watchmaker Films, 2017.

Howard, Clark. *Zebra: The True Account of the179 Days of Terror in
San Francisco.* New York: Berkley Books, 1980: 3-8, 25, 65, 158-9,
218, 229, 240, 329-333, 338.

Israelian, Victor. "Nuclear Showdown as Nixon Slept." *Christian Science Monitor.com* 3 November 1993. https://www.csmonitor.com /1993/1103/03191.html.

Johnson, Cliff. "5 SC Slayings; Auto Only Clue." *Santa Cruz Sentinel* 20 October 1970: 1.

Karnow, Stanley. *Vietnam: A History* (Revised and Updated). New York: Penguin Books, 1991: 543.

Lunde, Donald T., and Jefferson Morgan. *The Die Song: A Journey into the Mind of a Mass Murderer.* New York: W.W. Norton & Company, 1980: 195, 207, 246.

Mann, E.B. "Our Endangered Tradition: Here We Go Again!" *Field & Stream.* April 1978: 20-22.

Mulleavy, Kate and Laura. "Tobe Hooper Interview." *Interview.* 14 July 2014. https://www.interviewmagazine.com/film/tobe-hooper.

"Nixon Has a Contract to Begin His Memoirs." *San Francisco Chronicle* 16 November 1974: 4.

Peary, Danny. *Cult Movies: The Classics, the Sleepers, the Weird, and the Wonderful.* New York: Delta Books, 1981: 28.

Rebello, Stephen. "Killer Buzz: a 'Massacre' Unleashed Nearly 30 Years Ago Set the Tone for Slasher Pics." *Variety* 6 October 2003. https://www.thefreelibrary.com/-Killer+buzz%3A+a+ %27massacre%27+unleashed+nearly+30+years+ago+set+the+tone -a0109085409.

Saxbe, William quoted in "William Saxbe Dies at 94; Former Senator was Attorney General under Nixon." *Los Angeles Times* 25 August 2010. http://articles.latimes.com/2010/aug/25/local/la-me-william -saxbe-20100825.

Schuyler, George S. *Black No More: Being an Account of the Strange and Wonderful Workings of Science in the Land of the Free A.D. 1933– 1940.* Boston: Northern University Press, 1931, 1989: 48.

Strand, Ginger. *Killer on the Road: Violence and the American Interstate*. Austin: University of Texas Press, 2012: 131.

Van Niekerken, Bill. "'Death of the Hippies': Haight-Ashbury's 1967 Funeral for Counterculture." *San Francisco Chronicle* 3 October 2017. https://www.sfchronicle.com-/thetake/article/Death-of-the -Hippies-Haight-Ashbury-s-12245473.php.

Vronsky, Peter. *Serial Killers: The Method and Madness of Monsters*. New York: Berkley Books, 2004: 151, 155.

Wallace Fard Muhammed. *FBI Records: The Vault*. Federal Bureau of Investigation. https://vault.fbi.gov/ 88, 98, 116, 125.

Wasserman, John L. "'Massacre': Not Only the FilmVictim Will Scream in Agony." *San Francisco Chronicle* 21 November 1974: 51.

Whittaker, Richard. "SXSW: Restoring the 'Texas Chain Saw Massacre.'" *Austin Chronicle.com* 7 March 2014. https://www .austinchronicle.com/daily/screens/2014-03-07/sxsw-restoring-the -texas-chain-saw-massacre/.

"Zodiac Killer Letters." *Wikisource.org*. https://en.wikisource.org /wiki/Zodiac_Killer_letters.

CHAPTER TWELVE: NO COUNTRY FOR "JUST AN OLD MAN"

Bearak, Barry. "Eyes on Glory: Pied Pipers of Heaven's Gate." *The New York Times* 28 April 1997. https://www.nytimes.com /1997/04/28/us/eyes-on-glory-pied-pipers-of-heaven-s-gate.html.

Barney Miller. "Field Associate." Dir. Norm Pitlik. ABC Television. Aired 15 January 1981.

Dracos, Ted. *Ungodly: The Passions, Torments, and Murder of Atheist Madalyn Murray O'Hair*. New York: Free Press, 2010: 196.

Ferguson, Marilyn. *The Aquarian Conspiracy: Personal and Social Transformation in the 1980s*. Los Angeles: J.P. Tarcher, 1980: 18, 23, 36-7, 41, 56.

Fort, Charles. *The Book of the Damned*. New York: Tarcher/Penguin, 2016: 105.

Good Riddance. Dir. T.R. Young. Synergy Films, DVD, 2011.

"Guide to the John Henry Faulk vs. AWARE, Inc., Laurence A. Johnson and Vincent Hartnett Case Records, 1939-1982." *Briscoe Center for American History*: The University of Texas at Austin. https://legacy.lib.utexas.edu/taro/utcah/01497/cah-01497.html.

Hafford, Michael. "Heaven's Gate 20 Years Later: 10 Things You Didn't Know." *Rolling Stone.com* 24 March 2017. https://www .rollingstone.com/culture/heavens-gate-20-years-later-10-things -you-didnt-know-w473560.

Hansen, Gunnar. *Chain Saw Confidential: How We Made the World's Most Notorious Horror Movie*. San Francisco: Chronicle Books, 2013: 94.

Jaworzyn, Stefan. *The Texas Chain Saw Massacre Companion*. London: Titan Books, 2003: 204-210.

Karnow, Stanley. *Vietnam: A History* (Revised and Updated). New York: Penguin Books, 1991: 40-41.

Leo, John. "The New Scarlet Letter." *Time.com* 2 August 1982. http:// content.time.com/time/subscriber/article/0,33009,1715020,00.html.

Lindsey, Hal. *The 1980s: Countdown to Armageddon*. New York: Bantam, 1981: 8.

MacCormack, John. "True Confession." *Dallas Observer* 10 July 2003. https://www.dallasobserver.com/news/true-confession-6387834.

McCarthy, Cormac. *No Country for Old Men*. New York: Alfred A. Knopf, 2005: 46, 195.Mulleavy, Kate and Laura. "Tobe Hooper Interview." *Interview*. 14 July 2014. https://www.interviewmagazine .com/film/tobe-hooper"Madalyn Murray O'Hair / Questions and Answers 1995 (within 6 Months of Her Murder)." *YouTube*. https:// www.youtube.com/watch?v=_O2cbjusltU&feature=youtu.be.

Markley, O.W., and Willis W, Harman (editors). *Changing Images of Man*. New York: Pergamon, 1982: vii, xix.

Meadows, Donella H., et. al. *The Limits to Growth*. New York: Universe Books, 1972: 148.

"A Mourning City Asks Why." *San Francisco Examiner* 28 November 1978: 20.Mull

No Country for Old Men. Dir. Joel and Ethan Coen. Miramax, 2007.

Pressley, Sue Anne. "The Voice of Atheism Turns Silent." *Washington Post* 22 October 1995. https://www.washingtonpost.com/archive/politics/1995/10/22/the-voice-of-atheism-turns-silent/bc6d0295-68a2-47f3-957f-8beec70bb71e/?utm_term=.d9135d471265.

"Proclamation 4771--Registration Under the Military Selective Service Act." *Federal Register*. National Archives. 2 July 1980. https://www.archives.gov/federal-register/codification/proclamations/04771.html.

Seaman, Ann Rowe. *America's Most Hated Woman: The Life and Gruesome Death of Madalyn Murray O'Hair*. New York: Continuum, 2005: 43, 261, 264, 295, 317-18.

Sullivan, Randall. "American Stonehenge: Monumental Instructions for the Post-Apocalypse." *Wired.com* 20 April 2009. https://www.wired.com/2009/04/ff-guidestones/.

Woodward, Richard B. "Cormac Country." *Vanity Fair*. August 2005. https://www.vanityfair.com/culture/2005/08/cormac-mccarthy-interview.

Wright, Lawrence. "God Help Her." *Texas Monthly* January 1989: 158. https://www.texasmonthly.com/articles/god-help-her.

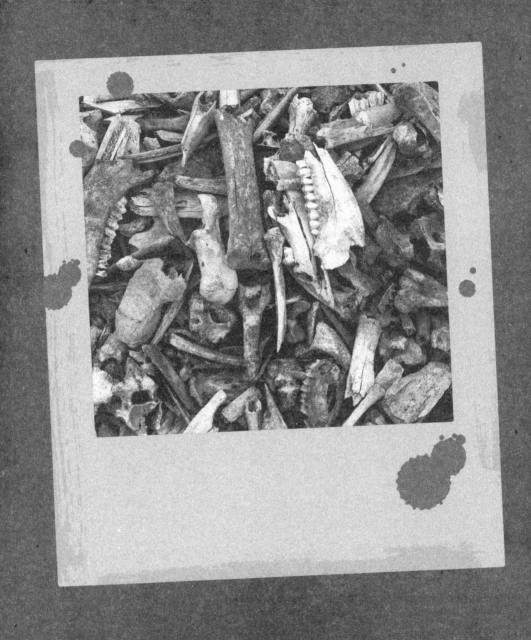

INDEX